BRITISH
ART
SHOW
6

Alex Farquharson, Andrea Schlieker

Hayward Gallery Touring

Published on the occasion of *British Art Show 6*,
a Hayward Gallery Touring exhibition

Presented in association with BALTIC Centre
for Contemporary Art and galleries across the cities
of Manchester, Nottingham and Bristol

Exhibition tour:

24 September 2005 – 8 January 2006	Gateshead
28 January – 2 April	Manchester
22 April – 25 June	Nottingham
15 July – 17 September	Bristol

Exhibition curated by Alex Farquharson and Andrea Schlieker
Exhibition organised by Emma Mahony, assisted by Clare Hennessy
and Alice Lobb

Book and typeface design by A2/SW/HK
Art Publisher: Caroline Wetherilt
Publishing Co-ordinator: James Dalrymple
Sales Manager: Deborah Power
Printed in Italy by Graphicom

Cover: Haluk Akakçe, *Birth of Art*, 2003 (still, detail) (cat.4)

Published by Hayward Gallery Publishing,
London SE1 8XX, UK, www.hayward.org.uk
© Hayward Gallery 2005
Texts © the authors 2005
Artworks © the artists (unless stated otherwise)

ISBN 1 85332 253 9

Hayward Gallery Publishing titles are distributed outside North
and South America by Cornerhouse Publications, 70 Oxford Street,
Manchester M1 5NH (tel. +44 (0)161 200 1503; fax. +44 (0)161 200 1504;
email: publications@cornerhouse.org; www.cornerhouse.org/publications).

Esmée
Fairbairn
FOUNDATION

CONTENTS

Now in its sixth incarnation, the *British Art Show* is widely regarded as an essential guide to the most significant art being made in Britain. As an expression of the recent and the imminent, it offers a wide-ranging account of contemporary British art, and is the most ambitious exhibition of its kind. Since its foundation in 1979, the *British Art Show* has established an impressive track record in identifying artists in the early stages of their careers who have gone on to attain considerable critical success. The exhibition is organised by Hayward Gallery Touring every five years and presented in cities across the UK.

Each *British Art Show* is shaped both by the culture of the moment, and by the ideological perspective of its curators. For *British Art Show 6*, the curators Alex Farquharson and Andrea Schlieker set out to distinguish key influences on current British practice, and in doing so, observed the increasingly diverse cultural makeup of what is considered as 'British' art. In recent years growing numbers of artists from across the globe have chosen to live and work in the UK, thus shifting the attitudes of contemporary art in this country and fostering a determinedly catholic (and international) outlook. The curators' selection reflects a multiplicity of ideas and intentions, framed principally by a range of artistic strategies, from references to art and archetypes of the Modernist era to critical engagement with broader political contexts and communities.

We are indebted to the curators for their dedication and engagement with this project. Their extensive knowledge of the contemporary art scene, underpinned by a clear-sighted determination and attention to all aspects of the exhibition-making process, has produced a timely and thought-provoking show. From the outset they have looked for ways to introduce a dynamic and changing element to this exhibition as it tours from one city to the next, achieved through the exchange of works between showings, and where feasible, the addition of new projects that find a specific context within a particular city. We would also like to express our gratitude to those artists who have made work especially for the exhibition.

We are immensely grateful to our colleagues in the host cities and galleries for their collaboration on *British Art Show 6*: BALTIC Centre for Contemporary Art in Gateshead; Castlefield Art Gallery, Chinese Arts Centre, Cornerhouse, International 3, Manchester Art Gallery, Urbis and The Whitworth Art Gallery in Manchester; Angel Row Gallery, Arts Exchange, The Bonington Gallery, Djanogly Art Gallery, Nottingham Castle and Yard Gallery in Nottingham; and Arnolfini, Bristol City Museum and Art Gallery, ROOM, Royal West of England Academy, Spike Island, Station and Watershed Media Centre in Bristol. We remain deeply indebted to the teams in each city for their enthusiasm, which has been crucial to the creation and delivery of the exhibition. Many individuals, organisations and galleries have also advised and assisted us throughout the research and development stage and we thank them all for their guidance and support.

As well as providing an introduction to artists featured in *British Art Show 6*, this book presents an overview of the conceptual propositions adopted by those artists in the form of three conversations, focusing on broad themes resonating through the exhibition. We thank Alex Farquharson and Andrea Schlieker for directing these illuminating discussions, and the 13 artists who participated. We are equally grateful to the authors of the individual artist's texts, to A2/SW/HK for their elegant design and to Caroline Wetherilt and her team at Hayward Gallery Publishing for the production and delivery of the catalogue.

Many individuals have been involved in the realisation of *British Art Show 6*. My sincere thanks go to colleagues in the Hayward Gallery's Public Programmes, Press, Marketing and Development teams for their commitment and drive; all have been individually acknowledged on pp. 8 and 9. I would like to express my particular thanks and appreciation to the Exhibition Organiser, Emma Mahony, who, with her colleagues Clare Hennessy and Alice Lobb, has worked tirelessly and with flair in organising this ambitious project. Roger Malbert, Senior Curator of Hayward Gallery Touring, has also provided invaluable advice and leadership. An exhibition of such technical complexity is reliant on the skill and expertise of specialist advisors and art handlers, and for this we would like to thank Tom Cullen, Peter Evans, Lian Harter (MITES), Mark Hornsby, Jem Legh and David Leister, along with the Hayward Gallery's Transport and Installation teams.

We are profoundly grateful to the Esmée Fairbairn Foundation for their generous support, which has enabled a significantly enhanced marketing campaign for *British Art Show 6*, and remain appreciative to Arts Council England for their continued support of the project and the Hayward Gallery.

Finally, we would like to express our heartfelt thanks, along with the curators, to the 50 artists and artist groups participating in *British Art Show 6*, and to the individuals and institutions who have so generously loaned work from their collections.

Susan May
Acting Director
Hayward Gallery Touring

ACKNOWLEDGEMENTS

Stephanie Allen
Marjorie Allthorpe-Guyton
Sepake Angiama
Caroline Ashworth
Lucy Atkinson
Sarah Baker
Sara Barker
Martin Barlow
Ruth Beale
Mark Beasley
Susanna Beaumont
Jo Beggs
Dave Bell
Ruby Bhattal
Lewis Biggs
Sarah Boiling
Johanna Bolhoven
Paul Bonaventura
Violetta Boxill
Fiona Bradley
Rachel Bradley
Daniel Brine
Chris Brown
Katrina Brown
Jenny Brownrigg
Lynda Bryant
Eleanor Bryson
Steve Bullas
Scott G. Burnham
James Bustard
Lucy Byatt
Nina Byrne
Martin Caiger-Smith
Julia Carver
Jayne Casey
Martin Clark
Sarah Clarke
Pollyanna Clayton-Stamm
Kim Coleman
Pippa Coles
Angela Conley
Jill Constantine
Chris Coppock
Mark Cosgrove
Suzanne Cotter
Stella Couloutbanis
Sophia Crilly

Katy Culbard
Penelope Curtis
Sorcha Dallas
James Dalrymple
Clare Davies
Deborah Dean
Graham Domke
Alyson Doocey
Claire Eddleston-Rose
Tim Facey
Kate Farmery
Helen Faulkner
Susan Ferleger Brades
Alex Finlay
Hannah Firth
Helen Forster
Annette Foster
Stephen Foster
Di Franklin
Michael Fullerton
Louise Gardner
Teresa Gleadowe
Kim Gowland
Mary Griffiths
Christoph Grunenberg
Jane Hall
James Hanks
Stuart Harris
Michael Harrison
Keith Hartley
Rebecca Heald
Jens Hoffmann
Jenny Hogarth
Judith Holmes
Nicola Hood
Gill Howarth
Natasha Howes
James Hutchinson
Kate Jesson
Megan Johnston
Helen Jones
Lois Keidan
Jo Kemp
James Kerr
Fiona Key
Mark King
Alan Knight

Sally Lai
Helen Legg
Yuen Fong Ling
Alison Lloyd
Phil Long
Sarah Lowndes
Helen Luckett
Michael Lynch
Karen MacKinnon
Sandie Macrae
Gary Malkin
Alison Maun
Susan McElroy
Declan McGonagle
Noirin McKinney
Chris McLean
Alicia Miller
Jamshid Mirfenderesky
Fiona Mitchell-Innes
Lynda Morris
Neil Mulholland
Marianne Mulvey
Sarah Munro
Andrew Nairne
Sofia Nazar
Colette Norwood
Fiona O'Connor
David Osbaldeston
Chris Osborne
Dave Palmer
Sean Parfitt
Linda Pariser
Dominic Parker
Andrew Patrizio
Helen Pearson
Alex Pollard
Deborah Power
Matt Price
Nigel Prince
Daniel Pyett
Zoe Renilson
Howard Rifkin
Alastair Robinson
Hannah Robinson
Ryan Rodgers
Nick Rogers
Eve Ropek

Sam Rose
Cathryn Rowley
Akinbole Sankofa
Sarah Sawkins
Sarah Shalgosky
Anthony Shapland
Mariam Sharp
Louise Short
Sarah Skinner
Dee Smart
Natasha Smith
Stephen Snoddy
Sandra Stancliffe
Lucy Steed
Sheena Stoddard
Kate Stoddart
Fiona Swadling
Miria Swain
Gillian Taylor
Dave Thomas
Emma Thomas
Judy Thomas
Tom Trevor
Lisa Urwin
Ronald Van de Sompel
Clare van Loenen
Gavin Wade
Neil Walker
John Wallace
Esme Ward
Jim Waters
Jonathan Watkins
Jude Watt
Mark Waugh
Karen Whitehouse
Tim Wilcox
Jo Wilson
Imogen Winter
Carly Wong
Jon Wood
Ashley Wright
Dawn Yates
Lesley Young

INTRODUCTION

Alex Farquharson and Andrea Schlieker

❃

PARAMETERS

Without doubt, this is an exciting moment to be assembling an exhibition that surveys new and recent tendencies in British art. Simply put, the art scene in Britain is exponentially larger, more vibrant, more diverse and more internationally orientated than at any other time in the *British Art Show*'s 26-year history.

The brief the Hayward Gallery gave us was generously open. Other than the practicalities of space, time and resources, our only parameters were the adjective 'British', which we took to mean any artist living in the UK, or British artists living abroad, and that the artists featured should number between 30 and 50 (*British Art Show 4* had 25 and *British Art Show 5* had 54). The third consideration was that the exhibition should be diverse in terms of artists and media, a notion we felt should allow for wide interpretation.

During the course of our research we began adding some parameters of our own, with the aim of ensuring that the range of concerns we wanted to address remained focused, comprehensible and interconnected.

The first parameter was temporal. The sixth *British Art Show*, we felt, had to be an exhibition that could not have been made the third, fourth or fifth time around – in terms of the selection of artists and works, in terms of tendencies we wanted to accentuate, and in terms of how we would go about doing that curatorially. The epoch (or mini-epoch) we were concerned with was 2001–05, seen from the perspective of 2005. For us, this meant that the purpose of *British Art Show 6* was not to spotlight brand new talent, a role fulfilled by two or three annual exhibitions held in this country. When faced with two or more artists of different degrees of experience working in a similar vein, we tended to favour the one who arrived there first and had pursued in greater depth what they had in common.

Another outcome of our focus on the recent past was that this show was not to be as inter-generational as others. We felt there was such an abundance of artists whose work had not yet received the exposure it merited that we decided to exclude the important but widely known 'anchors' from previous generations (*British Art Show 5*, for example, featured several senior figures). Although the artists in *British Art Show 6* range from their mid-twenties to early fifties, the overwhelming majority of artists are in their thirties. Artists in their forties and fifties are featured because their work has not come to prominence until recently, either because they are making their best work now, or because a sympathetic critical climate had previously been lacking. Either way, and apart from our own interest in the work, we felt a case could be made for their inclusion in this exhibition, rather than in previous editions. Gone are the days of an art scene dominated by artists fresh from college, as in the early 1990s.

The third parameter we added was the necessary inclusion of genres not represented in previous *British Art Shows*. Artists now work increasingly with communities and audiences outside the confines of the gallery. Others are extending their practice across a range of disciplines, mixing performance with sculpture and video, for example. We were therefore keen, within the available resources, that this exhibition should embrace elements of live art as well as special commissions for projects in the public realm.

Exhibitions delimited by nationality, continents and other geographical demarcations have been subject to vigorous critique over the last few years, for many of the right reasons. In a cosmopolitan art world, in which artists travel to make work and take part in exhibitions, the fact that an artist is British, Brazilian or Chinese is of diminishing significance. To compare artists from the perspective of their geographical origins is often to emphasise the most superficial aspects of their practices. The approach is fraught with the perils of reductiveness and stereotyping.

This is reflective of the situation internationally. The notion of the nation state, and with it national identity, has been progressively eroded with the globalisation of markets, by political and economic migration, cheap jet travel, the internet, the dismantlement of old empires and the emergence of new ones. The fates of peoples are now increasingly interconnected in dense and mutable webs of economic, political, technological and cultural power. The local, as we are often reminded, is global, and the global local. Some economies of the East will soon overtake the dominant economies of the West. Everything, so it seems, is on the move, not least in that most mobile of spheres, culture.

The UK epitomises this situation. The cultural diversity of Britain's population of artists can no longer be attributed to the post-colonial diaspora alone; globalisation, with which it often intersects, is at least as great an influence. Over the last five years or so London, in particular, has become a true *émigré* city. In all likelihood, only New York and Berlin have as international a demographic of artists. *British Art Show 6* reflects this: whereas only seven of the fifty-four artists last time were not born in Britain, this time it is 25. Over the last ten years London's art colleges have attracted students from all over the world, many of whom decided to stay on, attracted no doubt by London's booming art infrastructure: the explosion of new galleries, both gargantuan in scale and grass roots in nature, of magazines, studio complexes, lectures, debates, openings and parties. The London art scene is now enriched by artists of myriad nationalities – Turkish, German, French, Polish, Chinese, Brazilian, Canadian, Croatian (all represented in *British Art Show 6*) – and their work has often reached maturity during their time in the city. After London, Glasgow is perhaps the other city in the UK with an international profile independent of London's. It is true to say that, proportionally, most of the artists selected for *British Art Show 6* live and work in these two cities, yet of course only very few artists originate from them. Many other cities in the UK now have increasingly burgeoning art scenes, each with its own strengths (Manchester, its artist-run galleries, for example; Nottingham, its live art scene).

It was partly because we could select a truly international *British Art Show* with such ease from UK residents alone that we reluctantly decided, late in the process of selection, to exclude a number of British artists we were particularly interested in who currently live abroad.

Migration and travel have contributed to the global reach of issues one can now expect to find addressed in a trawl of exhibitions at any given moment in the UK. The 2004 Turner Prize was just one symptom of this shift. Where once the topographical content of British art was local – a shopping mall in Peckham, the racecourse in Ascot, the seafront in Margate, a council estate in the West Midlands – last year's nominees (Kutlug Attaman, Jeremy Deller, Langlands & Bell and Yinka Shonibare) set work in Istanbul, Texas, the Basque country, Afghanistan and Sweden. *British Art Show 6* reflects the globalisation of concerns in art today, especially in the area of film and video. The internationalism of our selection of both artists and works goes some way to address the apparent anachronism of the national survey show, particularly since we felt we were never consciously making internationalism a selection criterion.

In the survey exhibition's defence, we would argue that the spatio-temporal parameters of the *British Art Show* (five-year intervals; UK only) permit a degree of objectivity missing from other recurring exhibitions that are international in scope. These parameters allow one to measure changes in a situation with more sensitivity than if one has only a year or two and the whole world to choose from. Changes in art production over a five-year period can be profound, while changes occurring in a two-year period – the time that elapses between most recurring international exhibitions – tend to be slight. For this reason, the difference between one biennial and the next is almost entirely attributable to the subjective vision of their curators (which is one reason why *Documenta*, occuring every five years, has always been taken more seriously as an artistic barometer). This is not to deny that our own subjective positions permeate the decisions we have made. Subjectivity in curation, as in art, is both unavoidable and desirable (like art, curating should be driven by commitment and desire). The alternative would be a mode of curating that emulates the way the FTSE 100 tracks the fortunes of equities.

REFLEXIVITY AND RESPONSIVENESS

On the other hand, some of the most interestingly curated recent international exhibitions provided useful reference points while we were conceiving and developing *British Art Show 6*. When it comes to survey shows, often the perception is that the curator's job does not extend much beyond selection. In some ways this is indicative of conservative understandings of what curating is in general. The most memorable biennials have had strong thematic and conceptual identities; they have advanced arguments, sometimes provocative ones, and tried to make sense of shifting cultural and political landscapes. In some instances they have experimented with the form of the exhibition itself, extending its relevance (through discursive programmes, for example), and extending its reach (through off-site works, for instance, and interventions that precede and extend beyond the exhibition itself). Exhibitions that are simply about selection, about who and what is in and who and what is out, now appear repetitively formulaic and outdated.

Of course, on some level the *British Art Show* is unavoidably a survey exhibition of sorts, and selection is integral to establishing the formation of a curatorial discourse. At the same time, the work of a curator should not end there, and we have been actively concerned to shape the exhibition beyond that. In particular, we were keen to depart from some of the conventions that still linger around the conventional model of the touring exhibition. One is the assumption that the internal makeup of the exhibition should remain the same at each stage of the tour, irrespective of changing venues and audiences. This is based on the supposition that exhibitions are a timeless and autonomous medium, which they are not (for example, they begin and end and have to adapt to architecture). We have played with this, where relevant and possible, in several ways: by deliberately alternating works in each city, by adding works where meaningful and relating to the specific city, and by commissioning work that responds to specific sites. This way, the exhibition ceases to be a fixed entity shipped wholesale from venue to venue for one year, and, at least in part, is modified to its various sites, reacting to their idiosyncrasies, and is thereby kept alive and energised over its duration.

The notion of a 'static' exhibition also arises from the assumption that exhibitions are solely collections of images and objects. To counteract this, we have included a small live art programme as an important and dynamic extension of *British Art Show 6*, in addition to the various 'relational' works, which also have a live, performative element. A number of artists who feature in *British Art Show 6* with sculpture, collage and film also cross disciplines into performance: Mark Leckey's high-decibel art band 'Jack too Jack' will play a set while

his film *The Destructors* is being shown; David Thorpe presents a callisthenic New Age musical; Chris Evans is planning police recruitment talks in art colleges in the four cities; Doug Fishbone will give a fast-paced lecture evoking the spirit of his mentor Spalding Grey, and juneau/projects/' *Luddite* gig promises a combination of music and destruction. In each case, these performances are consistent extensions of the artists' otherwise more object-based preoccupations and disclose the current hybridisation of different art forms (at the time of writing, this is the planned Live Art programme).

We have been eager to make a potentially rather conventional kind of exhibition as self-reflective (and self-reflexive) as possible. To this end, we have enlisted the help of a few of the artists. Some of the works directly reflect on the conditions of the exhibition: its institutional processes, its relationship with the cities it visits. As part of a work by Carey Young, staff from the Hayward Gallery, and the two of us, have undertaken a negotiation skills workshop with an expert trainer, with the intention that it should influence the process of developing the exhibition and future activities. By participating in Adam Chodzko's shoe-exchange piece, visitors physically become part of the exhibition itself, as do the inhabitants of Nottingham and Bristol who have donated their footwear. Public works' and Neil Cummings and Marysia Lewandowska's projects accumulate material from the four cities (from their businesses, museums or film archives) in a manner that mirrors the growth of the exhibition as it travels over the year.

DISCUSSIONS AND EMPHASES

During our discussions with artists in studios around the UK, a number of themes or interlocking preoccupations, which were to form the main co-ordinates of the exhibition, began to emerge. It became clear very early on that we did not want to present a mere hit-list of recent best works, but – given the striking connections within the encountered diversity – an exhibition that made the revelation of these links its *raison d'être*. Amongst a roster of different ideas and issues, the dominant characteristics of much of the current art we encountered were frequent references to specific moments in the history of Modernism, a personal and dynamic engagement with politics in the international arena, and new collaborative and participatory models for creating alternative artistic interventions. These focal points, whilst not excluding other trends and concerns, inform much of our selection for this exhibition as well as the structure of this catalogue. To viewers of the exhibition (and readers of the catalogue) it will become clear that some of the artists might display affinities to two or more of these areas, whereas others might not relate strongly to any. These strands do not therefore represent absolute categories or didactic thematic divisions; rather they are areas of emphasis or intensity within the scope of the whole.

Part of our general ambition and conceptual approach has been the desire to create, wherever possible, a more fluid relationship between artist and curator, a stronger involvement of the artist that could foster a sense of alliance and partnership. One way we felt this could be achieved was through a collaborative generation of texts for this publication. We wanted to get away from the convention of the curator having exclusive say over how art works are framed and mediated by setting up a more polyphonic and democratic situation, one in which the artists participated in the vocalisation of the show.

The round-table discussions form the crests of three discursive waves within the run of artists' pages in this publication. Instead of offering monolithic readings, they represent dense clusters of ideas, open to multiple interpretations. They also touch on other and related territories: the corruption of formalist abstraction; uncharacteristic uses of strategies inherited from Conceptual Art; the prevalence in the exhibition

of both ecological and natural references on the one hand, and architectural and urban themes on the other. In each discussion, the positions of difference within a shared ground are decisively articulated.

Each of the three discussions tends to relate to one medium in particular. The exhibition is particularly strong on an idiosyncratic and promiscuous form of sculpture, which has absorbed the languages of other media, especially painting, and tends to hover uncertainly between abstraction and figuration. Much of this work falls within the ideas explored in the 'Revisitations' conversation in the catalogue, which is particularly representative of certain dominant concerns in British and American art of the last five to ten years. *British Art Show 6* is also particularly strong on film, more often than not single-screen film, generally with a beginning, middle and end, often relating to politically-loaded locations and recent events. Though there is virtually no photography in the exhibition, many of the films are indebted to its dominant genres – reportage and landscape, for example – which they extend into the dimension of time. 'Love and War', the second conversation, relates closely to work of this kind. The third, 'Relations', takes its cue from so-called 'relational' practice, a term developed in the 1990s by French critic and curator Nicolas Bourriaud for work that transforms viewers into active participants, though the artists in the discussion tend more often than not to depart from his model. This way of working has loomed large elsewhere in Europe for a number of years, but has received little attention in the UK until recently.

The breadth of our discussions indicates an apparently paradoxical situation. This edition of the *British Art Show*, compared with some of its predecessors, is one of extremes: it is overtly aesthetic, subjective and physical on the one hand, and political, social and dematerialised on the other. Too often in criticism and curating these sets of characteristics are segregated, as if mutually exclusive on some fundamental level. In this exhibition and this catalogue we have been more concerned to emphasise the threads of connection between these positions than in asserting their particularities.

TOMMA ABTS
HALUK AKAKÇE
PHILLIP ALLEN
TONICO LEMOS AUAD
CLAIRE BARCLAY
ANNA BARRIBALL
BREDA BEBAN
ZARINA BHIMJI
ERGIN ÇAVUŞOĞLU
GORDON CHEUNG
ADAM CHODZKO
MARCUS COATES
NATHAN COLEY
PHIL COLLINS
NEIL CUMMINGS AND MARYSIA LEWANDOWSKA
ENRICO DAVID
CHRIS EVANS
DOUG FISHBONE
SIOBHÁN HAPASKA
ROGER HIORNS
MATTHEW HOULDING
RICHARD HUGHES
MARINE HUGONNIER
GARETH JONES
JUNEAU/PROJECTS/
KERSTIN KARTSCHER
JANICE KERBEL
MARK LECKEY
HEW LOCKE
CHRISTINA MACKIE
GOSHKA MACUGA
DARIA MARTIN
ANDREW MCDONALD
HEATHER AND IVAN MORISON
ROSALIND NASHASHIBI
NILS NORMAN
SASKIA OLDE WOLBERS
SILKE OTTO-KNAPP
TOBY PATERSON
PUBLIC WORKS
PAUL ROONEY
EVA ROTHSCHILD
ZINEB SEDIRA
LUCY SKAER
ALIA SYED
DAVID THORPE
MARK TITCHNER
REBECCA WARREN
GARY WEBB
CAREY YOUNG

GOSHKA MACUGA

Born in Warsaw, Poland, in 1967
Lives and works in London
Graduated with a BA in Fine Art (Painting) from
Central Saint Martins College of Art and Design,
London, in 1995, and with a MA in Fine Art
from Goldsmiths College, London, in 1996

Solo exhibitions include: Kate MacGarry, London
(2005); *Kabinett der Abstracten*, Bloomberg Space,
London (2003); *Picture Room*, Gasworks Gallery,
London (2003); and *Friendship of the Peoples* (with
Declan Clarke), Project, Dublin (2002)

Group exhibitions include: *Communism*,
Project, Dublin (2005); *From A to B and back again*,
Chez Valentin, Paris (2005); and *Perfectly Placed*,
South London Gallery, London (2004)

Goshka Macuga's practice upturns the conventions that define exhibition structures
by hosting the work of other artists within her own immersive environments.
Her installations and displays question authorship and the hierarchies of value
inherent within 'High Art'. Artworks are often displayed alongside the artefacts,
souvenirs, memento and scrap that she collects, finds, borrows and purchases.
In essence she is an enthusiast, a fan who carefully and considerately creates engaging
displays of her favourite things. Personalities play a large part in her selection process:
many of her loans are brokered on trust and mutual respect and displayed in a context
that is very personal and uncompromising. In effect, the work becomes hers for the
period of its display. Her artwork becomes a gallery within a gallery, and the gallery
becomes an artwork.

Her installations are often homages to historic figures, architects and collectors
who have inspired her. For a 2003 group exhibition at the Royal College of Art, London,
The Straight or Crooked Way, Macuga assembled maquettes and models by artists and
architects which she exhibited on a series of plinth-like structures of varying heights
in an attempt to recreate the soaring landscape of J.M. Gandy's painting *Architectural
visions of early fancy, in the gay morning of youth, and dreams in the evening of life* (1820).
Gandy's watercolour painting, which hangs in Sir John Soane's Museum in London,
depicts a landscape dotted with the unrealised monumental buildings proposed by Soane.
An earlier solo show at Gasworks Gallery also revealed Macuga's fascination with Soane,
this time by focusing on the display methods employed in his famous Picture Gallery.
Soane designed an ingenious display structure of three hinged panels, each folding aside
to reveal the next, as a solution to showing numerous pictures within a confined space.
Macuga recreated his unfolding gallery at Gasworks to showcase borrowed and found
works by 40 artist friends. The visitor was invited to contemplate priceless originals
and worthless curios, antiques and contemporary artworks as each panel was opened
and closed by a gallery assistant.

A homage to Kasimir Malevich's 'architectonic' experiments in three dimensions,
Macuga's *Arkhitectony – after K Malevich* (2003/05) includes towering wooden plinths designed
for the display of objects, artefacts and sculptures. Originally commissioned for a show
at Bloomberg Space, Macuga will reuse these structures in *British Art Show 6* to display
artworks she has borrowed from museum and gallery collections together with her
own miscellaneous artefacts and works by artist-friends also featuring in the exhibition.

Emma Mahony

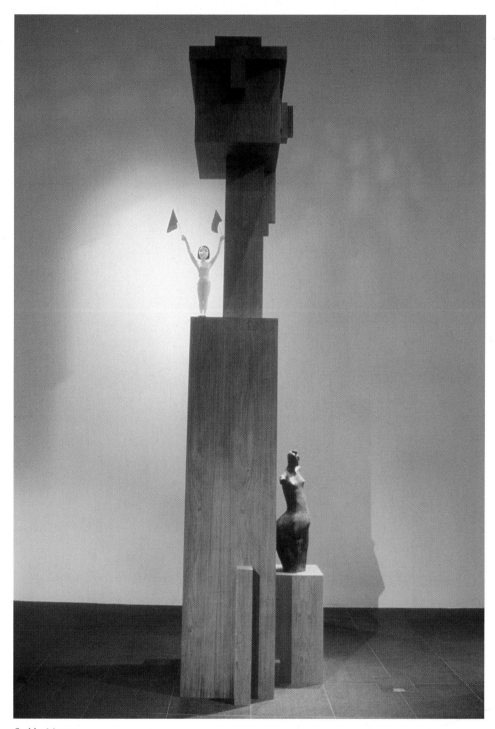

Goshka Macuga
Arkhitectony – after K Malevich,
2003 (cat. 83)
Mixed media
2 parts: 600 × 100 × 100; 450 × 100 × 100 cm
Photo: courtesy the artist, Bloomberg Space,
London, and Kate MacGarry, London

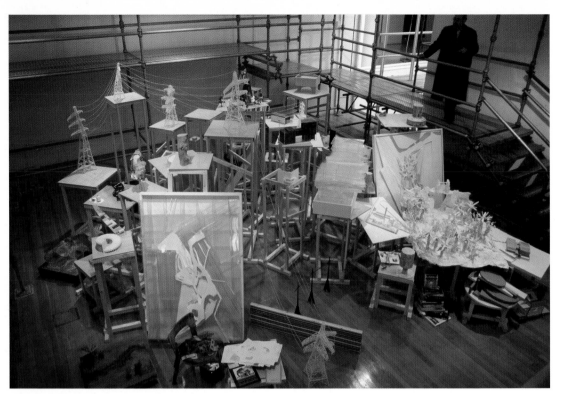

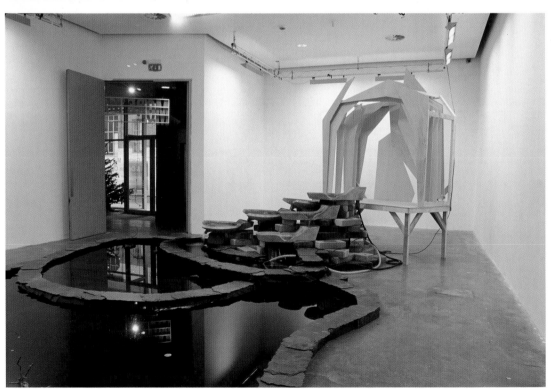

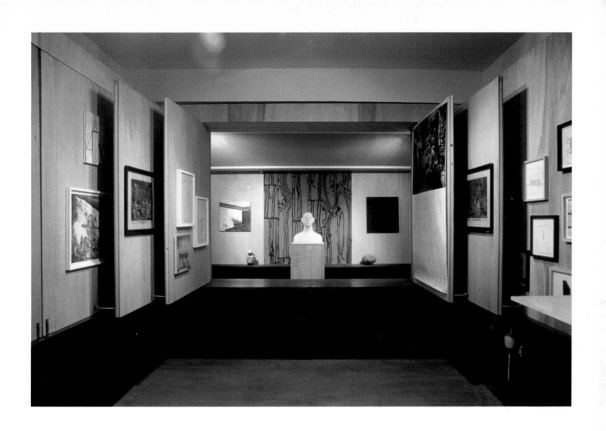

Top left
Goshka Macuga
*After 'Architectural visions of
early fancy, in the gay morning
of youth, and dreams in the evening
of life' 1820 by J.M. Gandy*, 2003
Mixed media
Dimensions variable
Photo: courtesy the artist,
Royal College of Art
Curating Course, London,
and Kate MacGarry, London

Bottom left
Goshka Macuga
Friendship of the Peoples, 2002
Mixed media
Dimensions variable
Photo: courtesy the artist,
Project Space, Dublin,
and Kate MacGarry, London

Above
Goshka Macuga
Picture Room, 2003
Mixed media
Dimensions variable
Photo: courtesy the artist,
Gasworks Gallery, London,
and Kate MacGarry, London

GARETH JONES

Born in 1965
Lives and works in London
Graduated with a BA in Fine Art from Newcastle-
upon-Tyne Polytechnic in 1987

Solo projects include: Cubitt, London (2003);
Helmut Jacoby: Milton Keynes Drawings, 38 Langham Street,
London (2003); and *Seven Pages From a Magazine
1975–2001*, Platform, London (2002)

Group exhibitions include: *Expo 21: Strategies of Display*,
Angel Row Gallery, Nottingham, and Mead Gallery,
University of Warwick, Coventry (2004); *Renderings*,
Delfina, London (2003); and *East International*,
Norwich Gallery (2003)

Gareth Jones makes structures and installations, often using low-fi or found materials, that draw on the experience of growing up in the Modernist utopia of Milton Keynes. In *Seven Pages From a Magazine* (1975–2001) he takes a forgotten advertising campaign for Lambert & Butler cigarettes – as found in old copies of *The Observer* colour supplement from the 1970s – and uses it to 'charge' a space with the social environment depicted in the adverts. The setting is a world of handsome sophisticates posed in Modernist interiors, toned in shades of beige, silver and black. Echoes of these spaces, and the monolithic design of the cigarette packet, can be found in his work *Modular Plinth* (2003), which is comprised of geometric components based on a design for a harlequin. As in a three-dimensional puzzle, these can be taken apart and fitted together again in numerous different configurations, changing each time the work is exhibited. Made from lacquered plywood the component parts seek to emulate the smooth, impersonal surface of a manufactured product.

Modular Plinth forms part of a large group of works in which different means of display – such as plinths, cubes and shelves – become the object that is shown. Working with an 'ideal' scale for a standard plinth (90 cm high × 30 cm wide × 30 cm deep), Jones explodes this given form into a series of elaborations and distortions, playing on its non-art status and inviting the viewer to reconsider its function. In *Reversed Plinth* (2000–03), a plinth made from chipboard and white emulsion paint has been pulled apart and turned inside out. The four sides are re-assembled in a cross formation, leaving the top panel to lean at floor level. When grouped together with two other structures from the series *Open Plinth* (1995–2000) and *Light Plinth* (2003), a performative logic starts to emerge. In the former, the upper section of a triangular plinth has been fitted with a mirror, creating an illusory space that reflects the viewer and the surrounding room, while the latter is a plinth turned upside down into which a fluorescent tube has been inserted, emitting a radiant glow.

More recently, *Untitled Structure* (1987–2005) returns to the world of Lambert & Butler via the language of display. A fully-grown Swiss cheese plant is presented in the gallery as an icon for a particular way of life and an open sculptural situation. Originally part of Jones' degree show in 1987, this work uses an item familiar from office foyers, domestic interiors and mid-twentieth century modern art galleries as a culturally-coded readymade.

Emma Mahony

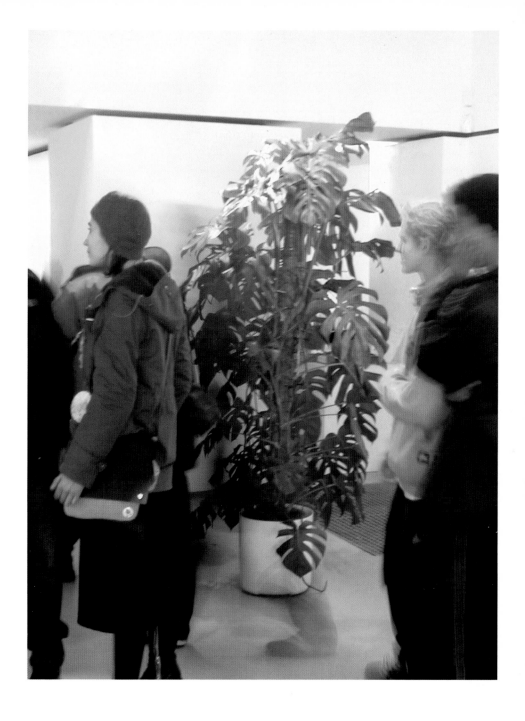

60
Gareth Jones
Untitled Structure, 1987–2005
Swiss cheese plant, pot

Overleaf
Gareth Jones
Installation view from Cubitt,
London, 2003
Photo: courtesy the artist

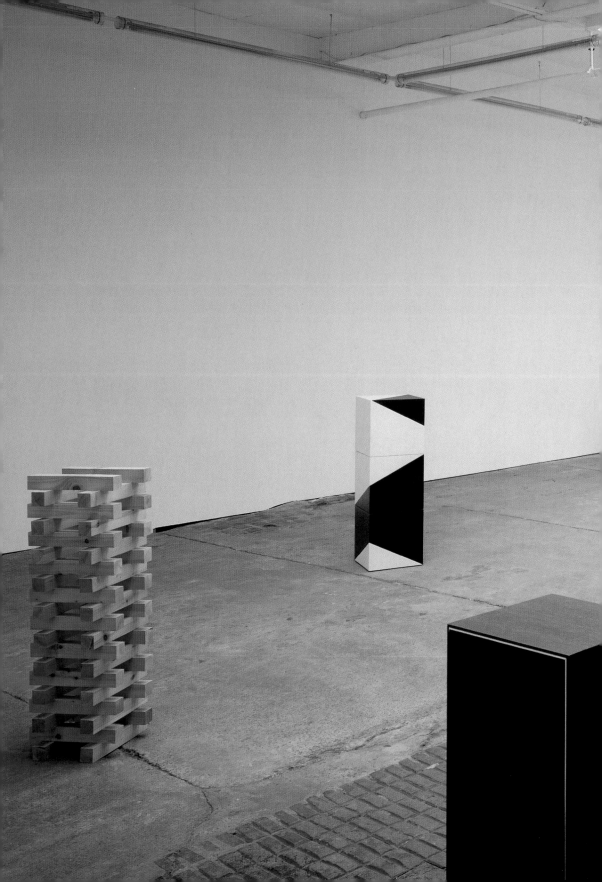

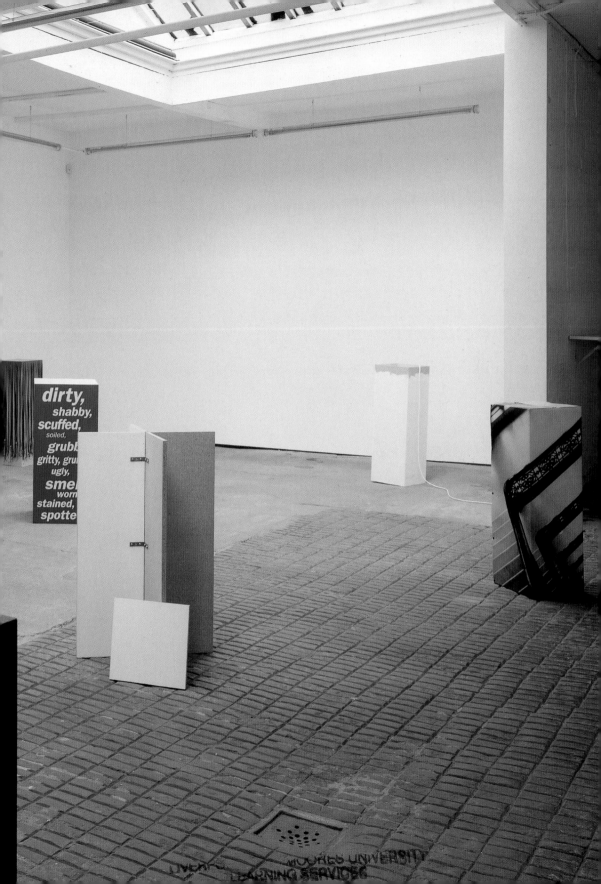

Born in Plymouth in 1972
Lives and works in London
Graduated with a BA in Fine Art from Winchester
School of Art in 1995, and with a MA in Fine Art
from Chelsea College of Art, London, in 2000

Solo exhibitions include: Gasworks Gallery, London,
and Newlyn Art Gallery, Penzance (2005); Frith Street
Gallery, London (2004); and *Recognition: Anna Barriball
and David Musgrave*, Arnolfini, Bristol (2003)

Group exhibitions include: *Frequencies*, Frith Street
Gallery, London (2003); *Turpentine*, Studio Voltaire,
London (2003); *STILL LIFE in contemporary British art*,
British Council Touring Exhibition (2002–03); and
Superfluity: British Artists at Latvijas Makslas Akademija,
Riga, Latvia (2002)

Anna Barriball is interested in exploring the interface between two and three-dimensional
space: between drawing and sculpture. The surfaces of things, a dimpled glass window
or section of a brick wall, may be covered with paper and drawn over entirely with dense
repetitive pencil strokes until the sheet becomes a palpable impression. The result is both
a drawing and a sculptural representation of the original. A piece of domestic furniture,
a wardrobe or a chair, is tightly bound with tape or ribbon; completely concealed, its
contours are nevertheless exactly defined. It becomes a memorial or fetish, removed from
use, inaccessible, but wholly present and identifiable. In *green + blue = cyan* (2001) Barriball
endeavours to draw light and the way colour behaves as light. Two desk lamps, one coloured
with green marker pen and one with blue, illuminate a drawing of green and blue circles
interlocking to make the third colour, cyan. Despite her attempt to capture the subject
through the combined means of drawing and the physical object, the visual phenomenon
remains elusive.

The performative process involved in the making of these pieces is painstakingly
repetitive and exhaustive. In other of Barriball's works, it is the opposite – the action
is instantaneous. A rubber ball coated with graphite dust is hurled at a sheet of paper and
the explosion of powder immortalises its impact, a fragile memento of a throwaway gesture.
Chance and instantaneity are also deployed in *Untitled* (2004), a series of found black-and-
white snapshots onto which the artist has blown inky soap bubbles. The black, ectoplasmic
traces spatter the images, menacing their spectral (because long past), smiling or pensive
subjects. By her intervention, Barriball adds another level of graphic incident, compounding
the anecdotal content of the photographs with evidence of an equally fleeting event,
captured as the floating bubbles land or explode above the image. The economy of means,
and the play between the performative presence of the artist and the painterly effects
of light and liquid, are characteristic. In *Projection* (2003) the artist is standing in profile
by a window. The sunlight catches the sequins on her T-shirt, and their reflected pattern
dances on the wall opposite as she breathes.

Roger Malbert

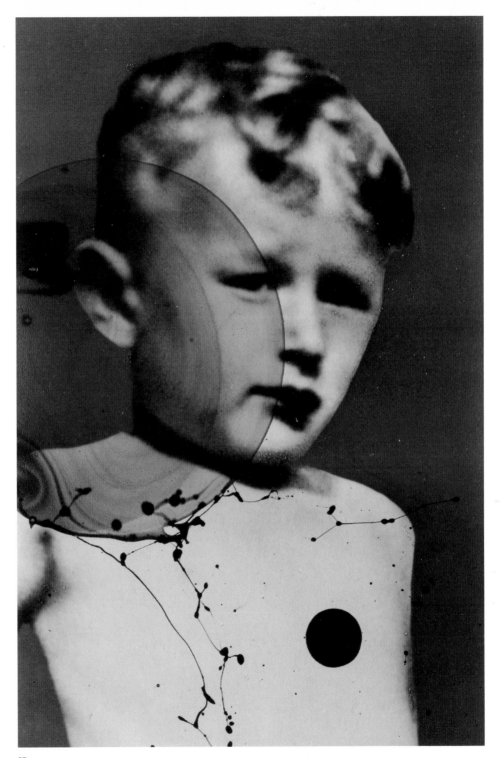

17
Anna Barriball
Untitled III, 2004
Ink and bubble mixture
on found photograph

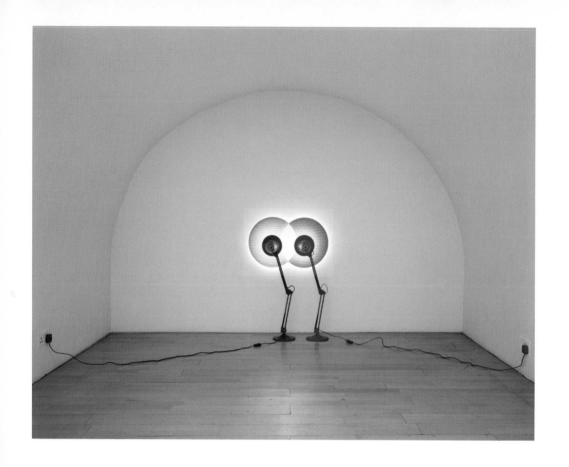

14
Anna Barriball
green + blue = cyan, 2001
2 single poise lights,
felt tip pen, paper

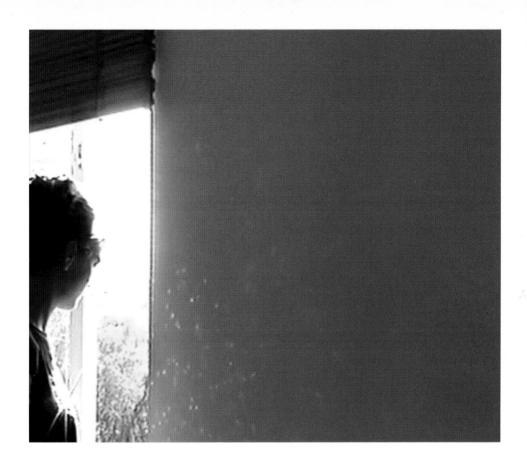

15
Anna Barriball
Projection, 2003 (still)
DVD video projection,
edition of 3

Born in Belém, Brazil, in 1968
Lives and works in London
Graduated with a BA in Architecture and Urbanism
from the Universidade de Arquitetura e Urbanismo
São Paulo-USP in 1998, and with a MA in Fine
Art/Associate Research from Goldsmiths College,
London, in 2000

Solo exhibitions include: Galeria Luisa Strina, São Paulo,
Brazil (2003); Project Gallery, Dublin (2003); and *Lyric
Underground. Launch*, Gasworks Gallery, London (2002)

Group exhibitions include: *Material Matters*, Herbert F.
Johnson Museum of Art, New York (2005); Yokohama
Trienalle, Japan (2005); *Beck's Futures*, Institute of
Contemporary Arts, London, and CCA, Glasgow (2004);
Adaptive Behaviors, The New Museum, New York (2004);
and *Fluxo de Arte Belém Contemporanea*, Museu de Arte de
Belém, Brazil (2004)

Tonico Lemos Auad makes drawings and sculptures that often explore the passing of time
and its cycles. His work evokes a sense of the fleeting moment, and imbues the physical
world with a strangely discomforting and ephemeral beauty. Developing both figurative
and abstract forms, Auad reveals the diverse and transient nature of much of his preferred
media, which varies from organic materials such as grape stems and bananas, to precious
stones, gold chains and fitted carpets. All are transformed by Auad's subtle interventions,
forming environments that have their own unpredictable cycle of events.

Auad's carpet installations begin by the artist's delicate gathering and repositioning
of minute strands of fluff, teased patiently from newly-laid carpet. They become like
ghostly apparitions, half-formed animal or human shapes, emerging from the surface
of the carpet, held together by static electricity. Auad sees these works as three-dimensional,
site-specific drawings that create a space in which the viewer can enter and engage with
the settings. The rigour behind the works is often evident in the trace of score marks
left on the carpet, almost implying that these animal-like forms actually move around
and scratch the carpet's surface once the viewer's back is turned.

Grape stems act as another unlikely material in Auad's work. In the wall-mounted
piece *Skull Grapes* (2004/05) a skull form materialises, fighting its way through an
entanglement of grapes and stems. Specks of gold glitter appear where a grape is removed;
this tiny unexpected sparkle makes one wonder if gold can be found in ordinary places.
In *Aimless Drawing* (2004/05) a delicately looped pattern unfolds on the floor from a gold
chain hanging down from the ceiling. The same looped pattern is repeated throughout
the work. For the artist, the repetitive action used to produce the piece and the ornamental
quality of the drawing shift the attention away from considered decision making into
'a flowing motion of inception'.

Clare Hennessy

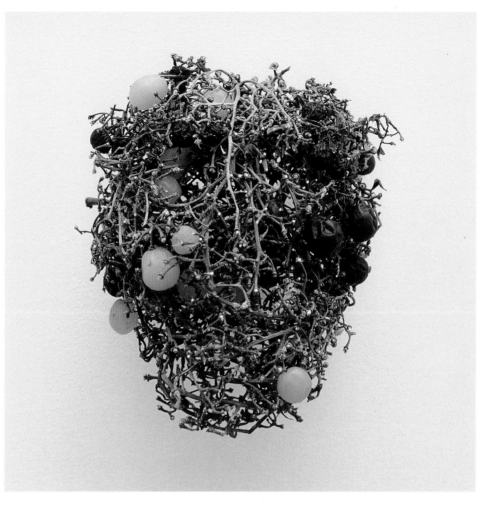

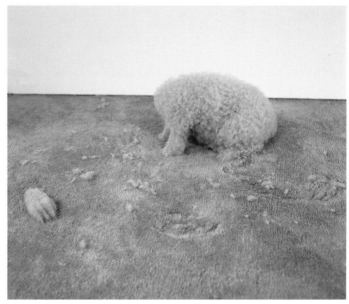

9
Tonico Lemos Auad
Skull Grapes, 2004/05
Grapes, grape stems,
gold sparkles

Tonico Lemos Auad
Fleeting Luck, 2004 (detail)
Carpet, carpet fluff
Dimensions variable
Photo: Lisa Byrne.
Courtesy the artist and
Galeria Luisa Strina

31

limbless

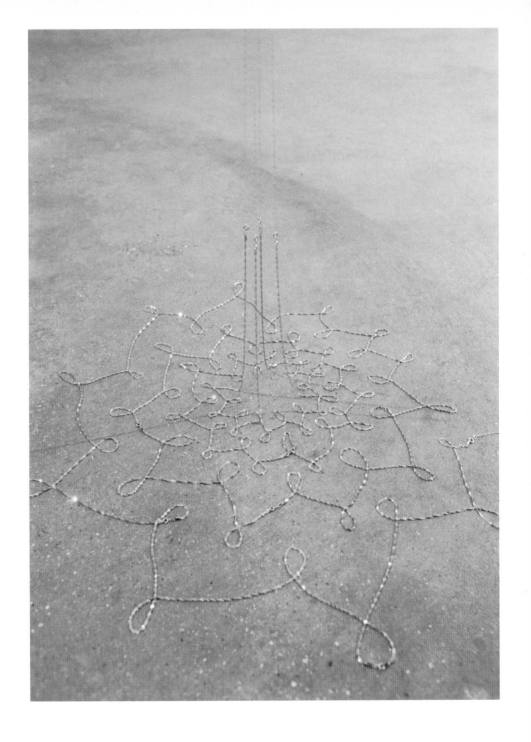

8
Tonico Lemos Auad
Aimless Drawing, 2004/05 (details)
Gold chains, pendant

33

CHRISTINA MACKIE

Born in Oxford in 1956
Lives and works in London
Graduated with a BA from Saint Martins School of Art,
London, in 1979

Solo exhibitions include: Herald Street, London (2005);
Magnani, London (2003); and *interzone*, Gallery 4,
Henry Moore Institute, Leeds (2002)

Group exhibitions include: *fünfmalskulptur*, Westfälischer
Kunstverein, Münster (2005); *Beck's Futures*, Institute
of Contemporary Arts, London (2005); and *Real World*,
Modern Art Oxford (2004)

Christina Mackie's assemblages consist of elements of sculpture, painting, drawing
and video, which come together to form a whole. Her hybrid compositions are physical
expressions of abstract lines of enquiry which appear to originate in the landscape,
particularly that of the West Coast of Canada, where she grew up. For Mackie,
an understanding of 'wilderness' is mediated through the domestic, and her work
explores the conflicting relationships between nature and refinement.

Mackie comes from a family of zoologists and, as such, she is fascinated by the
combination of high-end theory and makeshift apparatus that science uses to test its
ideas. For one of her earlier works, *IIP* (1999), she brought 50 poplar trees into leaf early
in her studio with an artificial spring synthesised by full-spectrum, 1000-watt lamps.

The concept of repetition, echoed by the natural forces and cycles present in nature,
is another important reference point in Mackie's practice. *Xing* (2004) takes these ideas
as its starting point. The installation is centred on a collection of timbers in various states
of refinement, from a gnarled and knotted rotting branch to a planed plank intended for
the building industry. These elements are variously propped, leant and placed around the
gallery creating an angular three-dimensional configuration in space into which Mackie
has incorporated areas of colour on the gallery walls and floor and a drawing made up
of stickers, which traces the outline of a mountain lodge. Three video loops depicting a
motorless reaction ferry crossing a river are projected on the walls. Central to the overall
composition is a yellow Plexiglass pin, which serves as an anchor for all these disparate
elements.

British Art Show 6 brings together a number of recent discrete sculptural and video
elements including *Irrig* (2005), a video loop which focuses on a mechanical jet spray
as it turns back and forth on its axis, hypnotically spitting forth a steady stream of water.
In *Shakeman* (2005) an anthropomorphic figure made out of Plexiglass and red cedar
sits on the gallery floor, its crude wooden legs pulled into its chest. Affixed to a winch
by a series of fabric ropes, this puppet-like figure can be extended, collapsed, lowered
to the floor or hoisted up to the ceiling.

Emma Mahony

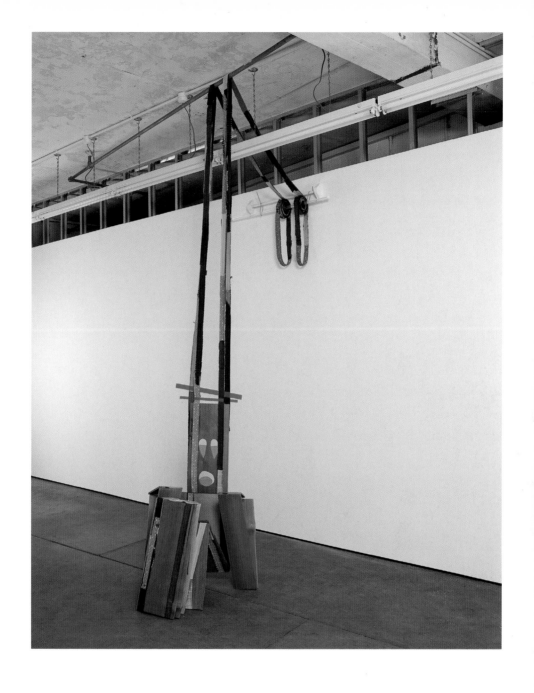

82
Christina Mackie
Shakeman, 2005
Cedar wood, fabric, Perspex,
fittings

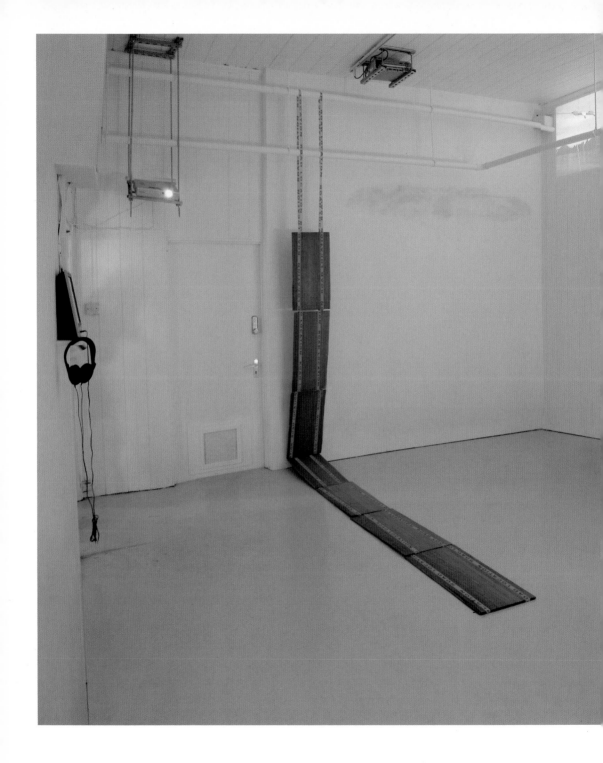

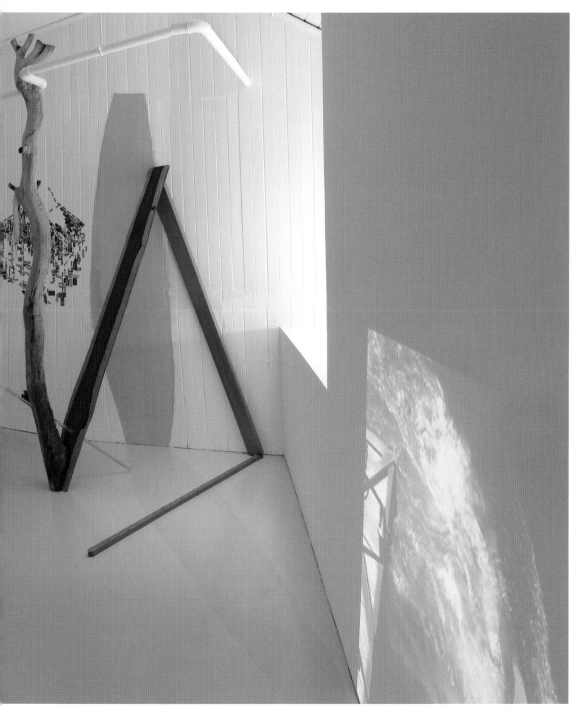

Christina Mackie
Xing, 2004
Cedar, willow, cherry, Perspex,
paint, printed material, survey tape,
2 DVD projections, 1 DVD
single channel monitor, metal piping
Dimensions variable
Photo: courtesy the artist

ANDREW MCDONALD

Born in London in 1963
Lives and works in Manchester
Graduated with a BA in Fine Art from Liverpool
Polytechnic in 1985, and with a MA in Fine Art from
University of Northumbria, Newcastle-upon-Tyne,
in 1995

Solo exhibitions include: *Every Day is Different*,
International 3, Manchester (2004); and *One Person Show*,
Chapter, Cardiff (2004)

Group exhibitions include: *Mostyn Open Exhibition*,
Oriel Mostyn Gallery, Llandudno (2005); *Drawing*,
Mjalby Arts Centre, Halmstad, Sweden (2003);
Not Always The Same, Hammer Sidi Gallery, London
(2003); and *Perspective 2002*, Ormeau Baths Gallery,
Belfast (2002)

It is the elementary act of drawing that is at the centre of Andrew McDonald's practice.
Though he might speak of it in terms of escape, it is an uneasy one coupled with a sense
of impossibility. He knowingly subscribes to the Modernist notion of drawing as a mode
of pure expression, an insight into the artist's inner angst and turmoil, and almost by
way of complement his visualisations are bleak, gravity-laden, filled with melancholy,
often playing on the idea of the artist in isolation.

For the last few years, McDonald has been working predominantly in animation,
an intensely laborious process, the result of a dedicated, cumulative effort to set hundreds
of drawings into a motion series. Capitalising on the intensity of the medium, the artist
creates his own claustrophobic world in which he sets simple, repetitive and frequently
unsettling actions.

In *John's Country* (2003) a headless man clambers into sight over the back of a rocky
landscape. He staggers across a ravine only to disappear again. Without a head, John is
free: he has no capacity for morals, guilt or love – the implication is that he can do whatever
he wishes, good or bad. It is an absurd presentation, neurotic and darkly humorous. Alive
with movement, the lines flicker and shimmer relentlessly as the main action takes place:
it is impossible to forget they are hand-drawn.

While *John's Country* is set under an apocalyptic black sky, in McDonald's work it
is often light rather than dark that causes fear, just as in *Lightning* (2002). Seen in isolation,
the lightning bolts appear exaggerated and melodramatic. Yet without sound they fuel
an eerie tension as the viewer gets caught in an involuntary guessing game about when
the flash will come; they are in the artist's hands.

Rebecca Heald

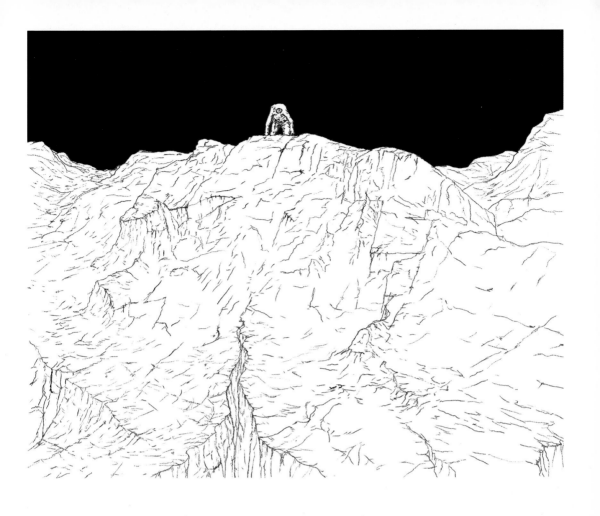

86
Andrew McDonald
John's Country, 2003 (still)
Hand drawn animation
on DVD

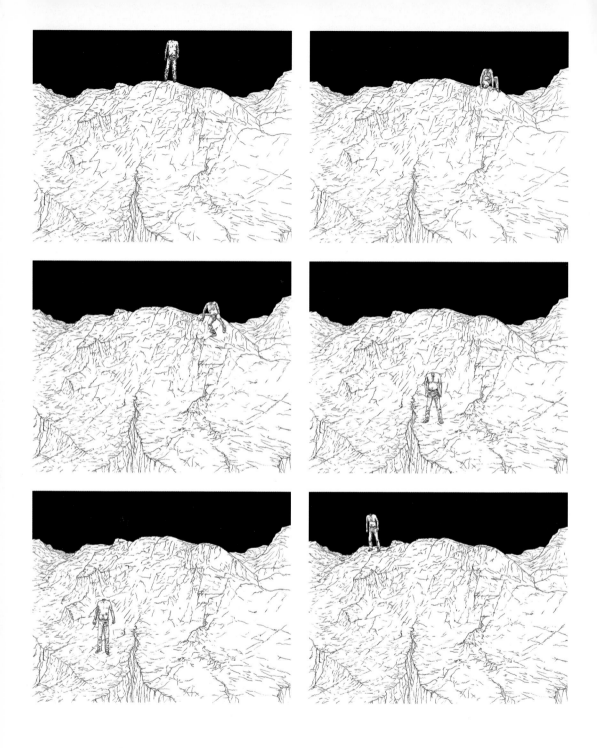

86
Andrew McDonald
John's Country, 2003 (stills)
Hand drawn animation
on DVD

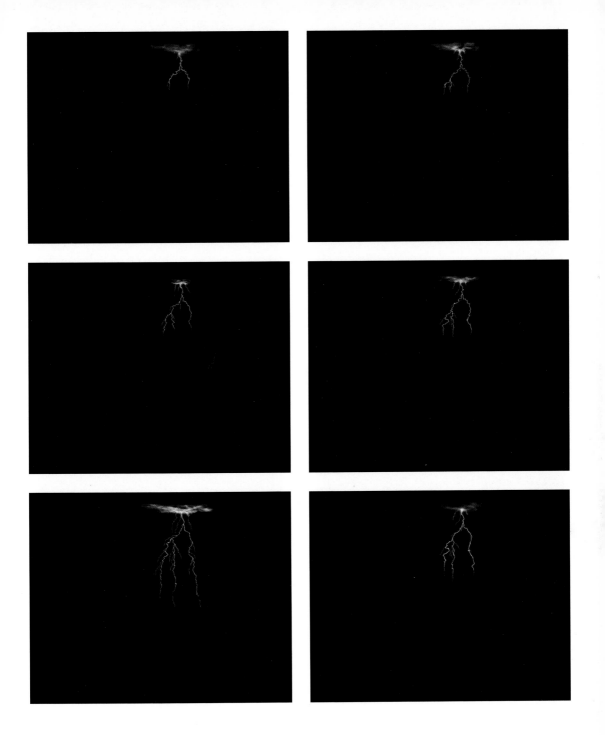

85
Andrew McDonald
Lightning, 2002 (stills)
Hand drawn animation
on DVD

41

RICHARD HUGHES

Born in Birmingham in 1974
Lives and works in London
Graduated with a BA in Fine Art from Staffordshire
University, Stoke-on-Trent, in 1995, and with a MA
in Fine Art from Goldsmiths College, London, in 2003

Solo exhibitions include: The Modern Institute,
Glasgow (2005); *The Shelf-life Of Milk*, The Showroom,
London (2004); and *RomaRomaRoma*, Rome (2003–04)

Group exhibitions include: *Showcase*, City Art
Centre, Edinburgh (2005); *Genesis Sculpture*, Domaine
Pommery, Rheims, France (2004); and *East International*,
Norwich Gallery (2003)

Richard Hughes' work fuses a slacker aesthetic with meticulously high production values and attention to detail. His sculptures display a 'gritty materiality' and a youthful idealism inspired by nostalgia for his youth in Birmingham's hinterland – an ambiguous, grimy, no-man's land in between town and country. This peripheral position greatly informs his practice. His material is the flotsam and jetsam that ends up in this landscape, discarded plastic bags, bicycle tyres, old clothes and well-worn mattresses. But rather than recycling found material, Hughes creates facsimiles of these objects, painstakingly carved, cast, moulded or modelled.

In *Roadsider* (2003) a plastic drink bottle filled with a golden coloured liquid sits innocuously in the corner of the gallery. At first it appears as though it was left there by a careless visitor, but its title, *Roadsider*, suggests that it might be referring to the phenomenon whereby motorists who have been taken short deposit bottles of urine on the roadside. By casting a replica of it in poured resin Hughes elevates the status of this base object to 'High Art'. A 'lowly' match receives similar treatment in *Untitled (Match)* (2003) when the artist recreates it in aluminium and modelling clay. Here we are presented with a match resting on a Formica shelf captured in the last flicker of life before it burns out. It is this precise moment, after the flare of ignition and just before it disintegrates, that fascinates the artist.

Hughes' work is concerned with a parallel cultural moment, the point at which a subculture, a trend, a style, a genre becomes outmoded and is cast into the dustbin of history. *Dad's Bags of Rags* (2003) is a tribute to the end of the psychedelic era. Hughes marks its passing with a homage to the Californian band Love. A pile of bin bags, stuffed with unwanted clothes, is heaped in the corner of the gallery. The contents of a clear plastic bag appears, by a remarkable instance of chance, to have come together to form an image of Love's *Forever Changes* album cover. Like the clothes it is made out of, Hughes suggests that this one-time seminal album is ready for the shelves of a charity shop, reminding us that everything has a limited life span.

Emma Mahony

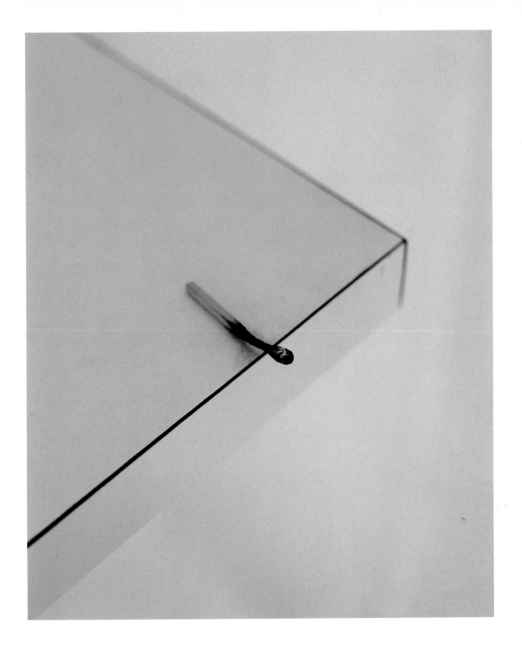

57
Richard Hughes
Untitled (Match), 2003
Mixed media

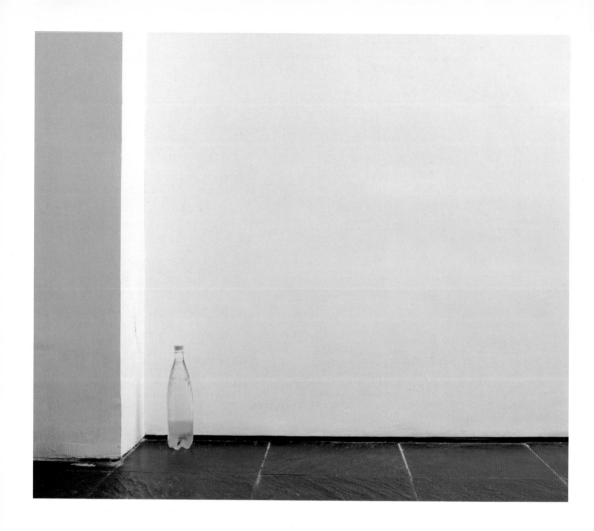

56
Richard Hughes
Roadsider, 2003
Resin

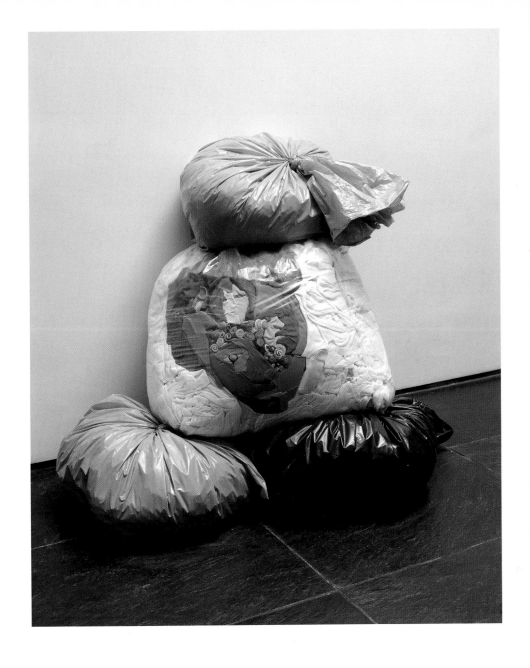

Richard Hughes
Dad's Bags of Rags, 2003
Plastic bags, clothes
Dimensions variable
Photo: courtesy the artist and
The Modern Institute, Glasgow

GARY WEBB

Born in Bascombe, Dorset, in 1973
Lives and works in London
Graduated with a BA in Fine Art from Goldsmiths
College, London, in 1997

Solo exhibitions include: Centre d'Art Contemporain,
Geneva (2005–06); *Mirage of Loose Change*, Kunsthaus,
Glarus, Switzerland, touring to Le Consortium, Dijon,
France (2005); and *Deep Heat T Reg Laguna*, Chisenhale
Gallery, London, touring to Mead Gallery, Warwick
(2004–05)

Group exhibitions include: *It's All An Illusion*,
Migros Museum für Gegenwartskunst, Zürich
(2004); *The Moderns*, Castello di Rivoli Museo d'Arte
Contemporanea, Rivoli, Turin (2003); and *Early One
Morning*, Whitechapel Art Gallery, London (2002)

Gary Webb's sculptures hover between abstraction and a subtle form of figuration.
His often-overloaded structures create curious unions of disparate elements, often
combining found objects with industrially fabricated and handmade components.
While they are clearly rooted in Modernist Abstraction, Webb's sculptures are accessorised
with readymade representational elements: gizmos, children's toys and jewellery, which
serve both to 'complete' the work and drag it kicking and screaming into the twenty-first
century. Americana is an important reference point in Webb's work. He claims to have
'grown up with a relationship with huge indoor shopping malls, indoor drive-in areas,
indoor everything'. This aesthetic is evidenced in his choice of synthetic materials such
as acrylic, resin, neon and rubber, and also follows through to the display of his works,
which are ideally shown illuminated by bright fluorescent lights in windowless spaces.
Another constant running throughout Webb's work is a wry sense of humour, apparent
in his often gibberish soundtracks as well as in his half-baked titles, which, at best,
communicate a general mood or ambience and, at their most obtuse, further confound
the reading of his work.

In *Mrs Miami* (2005) a tree-like structure acts as a support for multi-coloured
fibreglass 'rocks' strung from the 'branches' with coloured cables, resembling something
between a giant abacus and an elaborate child's mobile. Perching along its brow sit four
mini-speakers embedded in blown glass shapes, resembling at once eyes, ears or tongues
emitting the mumblings of an invented language and human beat box recordings by
the artist.

Emma Mahony

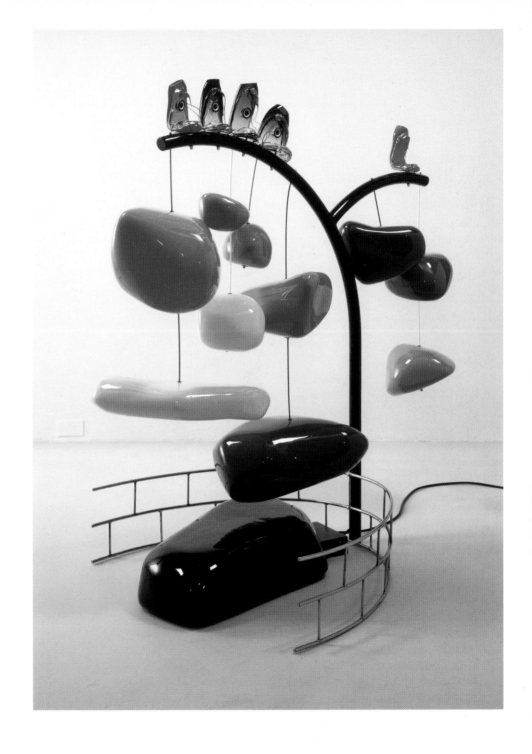

124
Gary Webb
Mrs Miami, 2005
Steel, Q-Cell, glass, electronics,
speakers

125
Gary Webb
Dom, 2005
Aluminium, spray paint, fabric

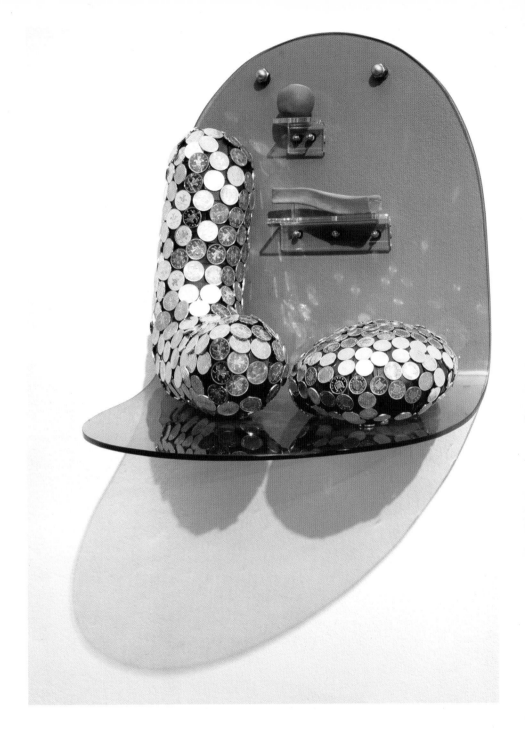

Gary Webb
Pooing Dutchman, 2004
Glass, magnetic sheeting, wire,
coins, clay, Perspex
44 × 46.5 × 44 cm
Photo: courtesy The Approach,
London

PHILLIP ALLEN

Born in London in 1967
Lives and works in London
Graduated with a BA in Fine Art from Kingston
University, London, in 1990, and with a MA in Fine Art
from the Royal College of Art, London, in 1992

Solo exhibitions include: The Approach, London (2004);
Xavier Hufkens Gallery, Brussels (2003); and P.S.1,
Long Island City, New York (2003)

Group exhibitions include: *Supernova*, British Council
Touring Exhibition (2005); *Reflections*, Artuaca
Kunsterfgoed Festival, Tongeren, Belgium (2004);
and *Post Flat: New Art from London*, Lock's Gallery,
Philadelphia (2003)

Phillip Allen's paintings are investigations into the substance and nature of paint itself.
Uniting two diametrically opposite types of abstraction, they maintain a constant dialogue
between thick and thin paint, rough and smooth textures, gesture and pattern, three-
dimensional paint and painterly illusion. Each canvas is bordered at the top and bottom
by swirling rosettes, dollops and smears of raw oil paint reminiscent of an artist's palette.
The heaped up paint is sometimes mixed and flecked with other colours, and sometimes
squeezed straight from the tube. In the wide, flat space between these thickly-clotted
margins a completely different sort of painting appears; thinly-brushed, decorative,
more obviously ordered and illusionary. These middle-grounds seem to carry oblique
references to the world of design or graphic media: Art Deco-esque shapes, Modernist
architecture, comic-book imagery. All the paintings have their genesis in small felt-tip
drawings, where everything – from the apparently improvised borders to the detail of
the central areas – is sketched out.

　　Beezerspline (Light Version) (2002), Contacts and Beliefs (Extended Version) (2005) and
the much smaller-scale *Densequalia* (2005) all conform to this *modus operandi*. There are
ongoing sequences of recursion, repetition and rhythms that run through the paintings,
mutating and evolving throughout. The moods and motifs of *Beezerspline* and *Contacts and
Beliefs* are strikingly different, though both share certain formal concerns. In *Beezerspline*
a thin rainbow of overlapping blobs arch over the horizon, back-lit by radiant solar light.
Contacts and Beliefs summons up allusions of a cityscape with brightly-coloured blocks
interconnected within a number of tilted and recessed planes and angles.

Helen Luckett

5
Phillip Allen
Beezerspline (Light Version), 2002
Oil on board

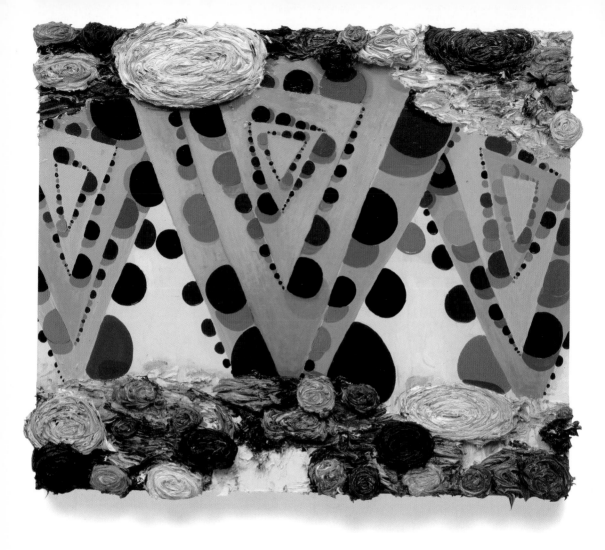

7
Phillip Allen
Densequalia, 2005
Oil on board

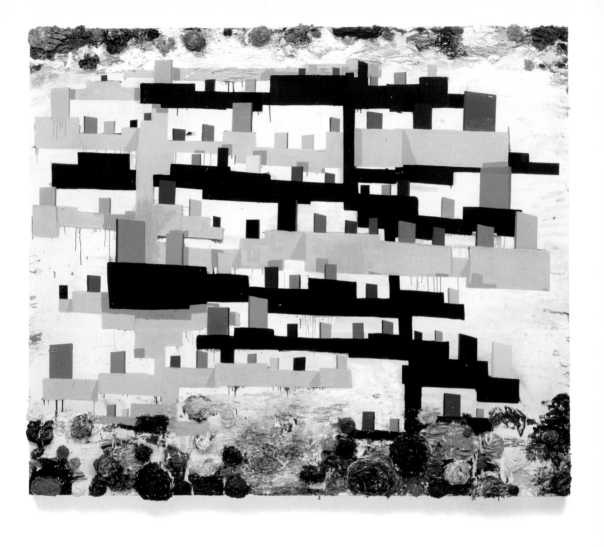

6
Phillip Allen
Contacts and Beliefs
(Extended Version), 2005
Oil on board

REVISITATIONS: IDEOLOGY, FICTION, STYLE

❊

INTRODUCTION
Alex Farquharson and Andrea Schlieker

The work of many artists in this exhibition makes deliberate reference to specific moments of cultural history. The period they connect with in particular is that of Modernism, from the mid-nineteenth century, around the time of the first world fairs and the onset of Impressionism and Symbolism, to the 1960s, when formalist abstraction in fine art and academic Modernism in architecture came under heavy attack. The artists' sources are eclectic: they vary from socially-progressive and (supposedly) clear-minded movements such as the Arts and Crafts movement, the Bauhaus, Russian Constructivism and the International Style on the one hand, to Symbolism, Art Nouveau, Art Deco and Psychedelia – tendencies associated with fantasy, exuberance and excess – on the other. Often elements of these two strains are present in single works, the one complicating or corrupting the terms of the other, recalling their forgotten interrelationships: for example, the roots of geometric abstraction in Symbolism and Arts and Crafts in Romanticism.

It is important to note that these artists choose their reference points, or 'elective affinities', not as naïve appropriation, nostalgic gesture or 'cultural regression', as Frederic Jameson would have it, but in awareness of the aspirations and ultimate failures of the movement. Modernism's claim to universal validity, the unswerving belief in progress and rationality held by many of its dominant movements, has long been discredited. At the same time, the attitude of this generation of artists differs from that of the Postmodern heyday in the 1980s, which was characterised by irony and relativism, and a dismissive attitude towards Modernism's lofty ideals. Instead, in these post-Postmodern days, artists are retrieving certain Modernist tropes and inspecting them under the light of contemporary values to see to what use they may be put in very different times. Unexpected hybrids result from these experiments: fusions of different media; combinations of abstraction and figuration; the eroticisation of the rational; collectivity built on difference; recollections of the future as envisionised in the past. Often what these have in common is the attempt to translate specific moments of Modernism into individual and private spheres of experience.[1]

Formalist abstraction, for example, has made a return in painting and sculpture, but its idealist doctrine of purity and autonomy, as advanced by Clement Greenberg, has been contaminated to varying degrees and in different ways. Next to 1950s and 1960s precedents, Gary Webb's sculptures would seem wilfully eccentric and gauche, while Phillip Allen's paintings would seem too lumpen and romantic (they could be early nineteenth-century landscape paintings of failed mid-twentieth-century Modernist sculptures, combined with

scrapings from the palette of a COBRA painter). In Eva Rothschild and Roger Hiorns' work, the legacy of Minimalist sculpture and Anthony Caro is paradoxically infused with the esotericism of alchemy and the occult, subculture and secret societies. Amongst this company, Tomma Abts appears to play it straight, yet exhibited alongside formalist precursors her quiet, stylised and intensely worked paintings would seem out of place.

The notion that design and architecture can rival the old hegemony of fine art, together with the related desire for a union of 'higher' and 'lesser arts', famously advocated by William Morris and his followers, now finds echoes (literally or conceptually) in the work of David Thorpe, Mark Titchner, Nathan Coley and Gareth Jones (Neil Cummings and Marysia Lewandowska have also made specific reference to them.[2]) Other progenitors of the Modern movement have provided similar inspiration at specific times for Daria Martin (Oscar Schlemmer's *Triadic Ballet*), Haluk Akakçe (Henry van der Velde), Goshka Macuga (Kasimir Malevich's *Architectrons*), Toby Paterson (Victor Pasmore's *Peterlee Pavilion*) and Mark Leckey (the dandy as interpreted by Charles Baudelaire, Oscar Wilde, Robert de Montesquiou, et al).

Often these dialogues with avant-garde forebears are filtered through pop cultural tropes: Secessionist painting and Diaghilev's choreography, via Las Vegas showgirls, in Silke Otto-Knapp's paintings; Picasso and de Kooning's sculptural output, via underground comics, in Rebecca Warren's irrepressible life-size women in clay.

Frequently, these revisitations trigger a re-introduction of craft elements into the work. The carefully handmade, the modest and low-tech have gained new currency, which becomes visible in David Thorpe's organic collages, Claire Barclay's loom-like and crochet-covered sculptures, Enrico David's furniture and giant hand-sewn dolls, Richard Hughes' and Tonico Lemos Auad's painstakingly crafted objects or Daria Martin's make-shift props and costumes. Undertones of folk, tribal and outsider art in some of these artists' practices – Tonico Lemos Auad, Claire Barclay, Enrico David and Goshka Macuga, for example – further complicate their idiosyncratic explorations of the Modernist epoch's legacy.

The artists not only renegotiate the forms, but also the ideologies which underpinned the movements they reference. Concepts of utopian Socialism, as popularised by Fourier, St Simon and Robert Owen in the nineteenth century, with their fusion of social thinking and urban planning, become useful paradigms once again at a time largely considered spiritually void.[3] In particular, the emphasis on architecture, often in fragmentary form, signals a preoccupation with the distance between reality and utopia, desire for the creation of possible worlds away from a dysfunctional society (Matthew Houlding, Kerstin Kartscher, David Thorpe), or is emblematic for a failed utopia (Gordon Cheung, Nathan Coley, Toby Paterson).

The utopian is frequently enhanced by futuristic or sci-fi elements (Kerstin Kartscher, Daria Martin, David Thorpe, Saskia Olde-Wolbers) or, alternatively, by what psychedelic guru Terence McKenna termed 'Archaic Revival' (Roger Hiorns, Eva Rothschild, Mark Titchner, David Thorpe). Yet such retreats to a state of rapture are underpinned by the knowledge and acceptance of its impossibility: allusions to Modernist design and architecture in many of these works appear as fantastical as the trans-historical creations of Ludwig II of Bavaria or Des Esseintes' bizarre experiments in interior design.[4] For all these artists, the late-nineteenth and twentieth century canon of high art is to be re-scripted, made malleable and injected with subjectivity – not simply cited, but performed.

1 See in particular Carolyn Christov-Bakargiev's essay 'The Moderns', in *I Moderni*, Skira, Milan, 2003;
 or Jan Verwoert 'World in Motion', in *frieze*, June 2004, Issue 84.
2 For their project *Free Trade* in Manchester, Neil Cummings and Marysia Lewandowska re-staged famous
 lectures by John Ruskin and William Morris.
3 Joseph Rykwert, *The Seduction of Place. The City in the Twenty-First Century and Beyond*, Weidenfeld & Nicholson,
 London, 2000.
4 Des Esseintes is the hero of J-K Huysmans' quintessentially decadent *fin-de-siecle* novel *A Rebours* (1884).

ALEX FARQUHARSON AND ANDREA SCHLIEKER IN DISCUSSION WITH ENRICO DAVID, DARIA MARTIN, DAVID THORPE AND MARK TITCHNER

Andrea Schlieker
Many of the artists in this show, yourselves included, make reference to a range of art movements of the past, especially those of the Modern age, which we might say ran from the mid-nineteenth century – around the time of the Great Exhibition of 1851 – to the end of the 1960s, when it was begun to be felt that Modernism had run its course. These movements include the Arts and Crafts movement, Symbolism, Aestheticism, Art Nouveau, Art Deco, Bauhaus, Constructivism and Brutalism. What affinity do you have with any of these particular movements?

Mark Titchner
I think primarily that it is about being able to take parts of these movements, which represent recognisable social frameworks, and look at them again. The most important from my point of view are the ones where you have a built-in social policy or strategy. So something like Constructivism couldn't exist as it did without a direct relationship to what the new materials and processes meant in terms of Communism.

Daria Martin
My work draws from the language of Bauhaus (i.e., Oskar Schlemmer) and Constructivism (i.e., Varvara Stepanova), as well as 1960s performance art (i.e., Carolee Schneeman and Joan Jonas), to cite moments of aggressive avant-garde thinking. But these moments are treated in a soft, pliable way and are bent to my own desires and language. Because of this 'soft' and sometimes erotic treatment, my works might at times recall, on a secondary level, the romantic roots of Modernism: Symbolism, for example.

David Thorpe
When I first begin my work, I initially have no direct interest in any of these art movements. The interest emerges from the act of making. Only then have I had to think in terms of the histories these practices are linked to. It's at that moment that I ask myself what it means to be doing this, and through that questioning I begin to find connections to other writers and artists with whom I appear to share common ground. I have never had an interest in, say, the Bauhaus or Arts and Crafts, and then tried to make work. It's always been the other way round.

The result is that I am never very historically specific. My interest in, for example, the Arts and Crafts movement is for the most part a fictional interest. I read very few books. As soon as you begin to acquire too much knowledge about a particular subject it becomes static and you stop playing. Often it's individual bits of a movement I find interesting rather than the whole – it's more about intimate levels of meaning than huge ideological structures. This

means I end up making connections between apparently disparate movements from different epochs: from Arts and Crafts to Folk Rock, or sixteenth-century Radicalism or the Adamites, for example.

Enrico David
For me, like for David, the relationship with historical movements occurs through the process of developing work, almost like an accidental encounter. Sometimes I recognise a relationship between my personal history and certain historical moments, but I wouldn't say that it is intentional or ideologically pre-meditated – it is performative rather than academic. It is about the possibilities arising from this encounter between the development of a process and certain pre-exisiting models, the relationship between found images and working methods. To instigate this dialogue reveals certain elements and highlights certain intentions; the exchange of different languages gives me the chance to understand more about my relationship with the world. Borrowing from historical languages has given me the opportunity to observe my tendency to interfere, to disrupt and misuse. I am not consciously interested in a particular narrative in connection to my process, but I am drawn towards the theatrical, which isn't to say theatre *per se* – more the moment when culture becomes histrionic, whether through complex ideologies or simply through the qualities of materials. In Art Deco, for example, I find the diversity of applications and processes and the general sense of excess relevant to my interests.

I have always felt that my embroidered works manifest a lament for a lack of an identifiable belief or ideology that might deliver the promise of becoming a better artist. Art for me is something that allows me to make the best of a bad job. I don't think I consciously set out to become an artist. For me, art has almost become this area entered into by default, not having fulfilled other spiritual goals in life. It's almost a 'make do' thing, which isn't to say there's something else that's better.

Alex Farquharson
Rather than simply citing this historical material, there's the sense that you are actively redeploying it. How does your use of the past act as an intervention in the present?

Mark Titchner
My interest in revisiting history is entirely linked to my desire to suggest alternatives to the actual way things have turned out. Often this means revisiting certain ideas that have been forgotten or suppressed as a by-product of globalisation and the homogenisation of culture.

David Thorpe

It becomes like participating with friends in the present. You begin to come across people or a story with which you have affinities and develop a relationship with them. It's almost like having these guys wandering around the studio – Charles Robert Ashbee, for example. He was interested in Socialism of the romantic kind. He took a bunch of people out of the factories in London and moved them to the countryside where there was enough time for working, singing and swimming – jolly fellows all together. But when you read further you discover that during this experiment in isolation and exile he visited South Africa and became pro-Apartheid, concluding that the blacks weren't ready for Socialism and Socialism wasn't ready for them. These figures that you begin working with can become unbearable. Then again there are elements of Ashbee that I really like.

Daria Martin

Each of us is creating a series of fictions in our artwork, but at the same time we're not making paintings of unicorns, are we? We have to take responsibility for the fact that we are citing particular cultural movements. Obviously, when we're doing that we aren't playing out the manifesto of a fascist ideology (in the case of one or two examples we've been discussing); we are playing with a transformed, hybrid fantasy of these moments rather than restating or reinforcing history.

Alex Farquharson

At a time of overtly socio-political work, particularly on the continent and in the so-called peripheries of the art world (the quasi-documentary strain in recent video art, for example, or 'relational aesthetics'), what you do seems overtly introspective. Is this 'super-subjective' strain in recent American and British art, as some people have called it, something you recognise and identify with?

Daria Martin

I think in all our practices there is a struggle for a balance between an intimate and intuitive exploration on the one hand and on the other a playful bouncing off of historical moments as a means to see what can be salvaged – what might resonate or be reinterpreted now. I would guess that we are all struggling with that juncture between Postmodernism and what happens afterwards. We may be looking back to Modernist models in our desire to express something subjective and possibly autobiographical, but at the same time we are hyper-aware of the historical context and political reality in which we're making this work. Perhaps our work does come across as super-subjective to some because in citing Modernist movements our distance from their original social meaning is underlined.

Mark Titchner
That raises an interesting point regarding ideology. When you are using
these figures there is basically little connection with the reality of their
worlds. You can take aspects from these people that you are sympathetic
to and ditch other parts according to what fits into the work. I think it
is an expression of a post-ideological condition. We are attracted to these
groups from the past that had a clearly defined ideology and methodology.
As Enrico said earlier, the work laments this loss.

David Thorpe
The lineage of ideas that stems from William Morris and the Ashbee
circle was defeated. The evolutionary branches of that family tree have
been cut off. For me it becomes a question of trying to regraft some
of these branches as well as indicating how they might have grown.

Andrea Schlieker
At the same time there tends to be an esoteric dimension to many of the individuals,
groups and movements that the four of you refer to. Their politics are permeated by
mysticism. Spiritualism, secret societies, New Age communes and cult figures are variously
alluded to in a lot of current art practice. What characterises your interest in these things?

Daria Martin
These intimate worlds that we're creating aren't just for
ourselves: we give that work to the public. They're meant
to communicate something. They sometimes seem esoteric,
but I don't think any of us intend for them to be opaque.

Enrico David
For me it might have to do with manifesting a lament
for a lack of specific belief or clear ideology, and at the
same time almost mimicking by creating a set of rules
that seem to 'belong' with my early embroidered works.
For example, I think that, in retrospect, I was trying
to construct a visual world that might make me feel
unquestionably included in it. But, again, it's also about
deviating from the rules, diverting the course of ideology
and the assumptions that come with it to the theme
of one's own personal drama. The erotic quality of Art
Deco, I realised along the way, could serve as a fertile
ground for certain aesthetic manoeuvres that are
appropriate to my own emotional concerns. In the
servile guise of the revival, it is likely to get to the
heartbeat of a movement, and from there you might
develop something that had not been attempted in
its day. That might mean dealing with political and
religious material that is dictatorial, but it's all there
to be used and played with.

Alex Farquharson
Mark, for example, why the connection between Socialism and Spiritualism in some of your works?

Mark Titchner
I think it's important to point out that a lot of the artists and art movements I refer to aren't the obvious candidates of art history. They represent alternative strands of Modernism. Often that's to do with the utility of the art object, sometimes in terms of how it might function psychologically or scientifically. One example I have returned to many times is Brion Gysin's *Dreamachine* and more recently I have been working with psychic wishing machines, both of which ask technology to behave in a non-Modernist way. It seems extremely odd to ask a machine to generate spirituality but of course one thing the Modern age has created is an unflinching faith in technology. You form a romantic attachment to these powerful historical individuals because of the potential they can offer. At the same time there's a sense of decadence in the way we play with their lives – after all, some died for their beliefs.

Andrea Schlieker
Although most of the work in *British Art Show 6* that relates to this discussion takes the form of sculpture, painting and drawing, the historical references you make tend to concern other visual disciplines: architecture, interior design, textiles, fashion, theatre design, typography. Why your particular interest in these applied art forms when the orthodox history of Modernism tends to downplay them? For example, Daria, you deal with staging and theatricality.

Daria Martin
I'm interested in playing with the idea of the total artwork – the *Gesamtkunstwerk* – which is an aspiration that was introduced prior to Modernism with Wagner and was picked up again at the Bauhaus. That image of the romantic totality of the arts is appealing to me, partly because it makes sense from the perspective of artists working across disciplines today, but particularly because culturally we are part of such fragmented times now. László Moholy-Nagy was actually quite opposed to the idea of the *Gesamtkunstwerk* because he thought that within the context of a very fragmented society and the division of labour at the beginning of the industrial age, the *Gesamtkunstwerk* was actually a kind of denial of reality. And I think all of our work has this fantastic, resistant vision – there is a certain retreat from the reality of the world today, but because we're not in the business of building fictional castles our work also represents a covert struggle with the fragmented state of things.

Performance is not obviously an applied art, but it is a visual art that has been shunted out of the official narratives of Modernism. Even Oskar Schlemmer, the director of the Bauhaus theatre, felt that his performance work was somehow shameful in comparison with his painting, a sort of country

cousin. I think all of us are looking at the underside of
these canonised movements for something that is a bit more
mobile. Gender ambiguities and sexuality, for example, are
undercurrents in Modern performance and dance.

Andrea Schlieker
Enrico, you use embroidery, and David, in your recent collages you use a lot of organic
materials. The theory of the Arts and Crafts movement, as well as of the Bauhaus,
is concerned with the democratisation of the arts. In which way are those ideologies
harnessed to your own practice when you use applied arts in your work?

David Thorpe
I am attracted to the notion of self-sufficiency. When I began to read
about the Arts and Crafts movement it seemed to be an appropriate
ideology for a survivalist. It had to do with making do and mending
things, but also suggested you could delve into almost anything
with enthusiasm without any kind of values being put on you.
It was essentially about you making these things and that had a
strong appeal. It was almost a back-to-the-land thing, not having
to use heavy industry to produce work. It seemed to relate to elements
of the DIY culture that began to emerge in the 1990s where you were
essentially just in a studio by yourself, creating. It's a way of survival
and building up your own picture, your own environment, as a sort
of act of protection from the world.

Mark Titchner
Sixty per cent of what I do is digital work. To me that is a contemporary
craft movement. Digital music, digital imagery, all the technology and
software you need is available. You can do it in your bedroom. That, to
me, is the direct analogy to and heritage of the craft movement.

Daria Martin
In my work this runs in the opposite direction: the fantasy
worlds in my films are built with physical rather than digital
means. One sees that very clearly in the seams, the shadows,
the tenuous way the costumes and props are constructed.
It's not a seamless, airtight vision but rather something that
is intimately and physically made by a single artist.

Andrea Schlieker
The low-tech element of your work always foregrounds the artifice of your set-ups.

Alex Farquharson
Returning to how you cite history in your work, would you distinguish it from
the Postmodern parody and quotation of the 1980s, which was often characterised
by an ironic attitude and relativistic outlook?

Daria Martin

I do think it is pretty widely recognised that Postmodernism has run its course and something else is coming in now. Curators and critics are trying to find a word for it: ultra-modernism, neo-modernism, alter-modernism... There is clearly some kind of a shift going on.

Speaking personally, when preparing for this conversation, I had to go back and think about why I would be pursuing images that had any kind of utopian slant at all. And I had to think back to why I became an artist in the first place. For me the beginning of it all is the romantic impulse to make something that I can't name, can't put words to. The pursuit of utopian imagery was in large part an intuitively appropriate way to actualise that internal, emotional 'no place'.

David Thorpe

Instead of revivalism, it is as though you are working as a remnant of some defeated army from generations long gone. Instead of an interest in returning to some idea of utopia, or trying to develop a better way of life for a whole community, you persist in a state of exile.

Alex Farquharson

Of the four of you, Mark, you address ideology in the most contemporary terms and in the most public arena. I'm thinking particularly of your billboards that fuse revolutionary slogans with the rhetoric of free market Capitalism.

Mark Titchner

I think this connects back again to my interest in the Arts and Crafts movement: this ideal of being able to reconfigure the world around you using the same tools that the multinationals use to put their messages across. I'm more interested in that aspect of ideology than tying it to party politics or issue politics. The billboards are there as a really simple exchange between ideas and people.

Daria Martin

In creating these very personal worlds, fantasies and fictions, it is curious that we draw on vast, over-inflated twentieth-century ideologies and movements as our material. We seem to be turning the monumental back into something very intimate and individual.

Mark Titchner

I am totally aware of myself being a child of the Thatcherite age with that idea of society only existing as a collection of individuals. My interest lies in connectivity, but it's hard to think in terms of consensus now.

David Thorpe
I don't intend my work to be for general participation. I have no
great interest in making work available for all. I quite like minority
groups; I think my own work comes from those milieus. You also
hope that certain individuals, groups and communities get into it,
but that others don't.

Mark Titchner
Sometimes when looking at your work, David, it's difficult to know which
side you're on: whether you're there as a sort of compatriot or on the outside
looking in. I do the same: virtually all of the text I use is from someone else's
mouth (Black Panther; Bible; advertising; global mission statements, etc.).
I don't try and get too close to the material.

Daria Martin
As my work develops, it is embracing real world scenarios.
Yet there remains a flickering between fantasy and
documentary: there is a tension between a subjective inner
reality and a seductive social network.

REBECCA WARREN

Born in London in 1965
Lives and works in London
Graduated with a BA in Fine Art from Goldsmiths
College, London, in 1992, and with a MA in Fine Art
from Chelsea College of Art and Design, London, in 1993

Solo exhibitions include: Galerie Daniel Buchholz,
Cologne (2005); *Dark Passage*, Kunsthalle Zürich (2004);
and *SHE*, Maureen Paley, London (2003)

Group exhibitions include: *Sculpture, Precarious Realism
between the Melancholy and the Comical*, Kunsthalle Vienna
(2004/05); *Summer groupshow*, Matthew Marks Gallery,
New York (2003); and *New Labour*, Saatchi Gallery,
London (2001)

Rebecca Warren works with the traditional craft material of clay to produce fragmented,
larger than life mutant figures, which say as much about the nature of sculpture as they
do about the female form. Often presented on studio trolleys, her unfired and tactile
clay figures foreground the process of their making and the hands-on nature of sculpture.
Drawing inspiration from early Modernists – most notably Rodin, Degas, Picasso,
Dix and Giacometti – she also refers to more contemporary artists like Helmut Newton,
Robert Crumb and Fischli & Weiss.

Warren's work brings into question the predominantly male Modernist canon's
approach to expression and gender. In this regard there is a strangely fascinating dichotomy
in her work: her treatment of the female nude is both exuberant and voluptuous, playing
to clichés of the male gaze, while simultaneously repelling it with its monstrous and
grotesque half-formed aesthetic.

Writing about her work, the critic J.J. Charlesworth has described Warren's approach
as '...humorously performing the act of wrestling natural likeness from the amorphous body
of clay. That Warren's figures do not emerge fully formed, or exist on the limits of formation,
suggests a serious dialogue about the narcissistic value at the heart of the sculptural act,
and of the nature of asserting a coherent visual form as the final goal of sculpture.'[1]

In tandem with her figurative clay sculptures, Warren is also engaged with informal
sculptural assemblage, gathering together found and hand-crafted objects and displaying
them on plinths or in vitrines. Her method of display serves to consolidate the status
of ephemera as sculpture, despite the seemingly haphazard nature of its construction;
in *Journey into the Heart of the Night* (2000) the vitrine is propped precariously against
a wall with a length of wood as its only support.

'Warren's tactile, protoplasmic bodies, or her fugitive, mis-organised ephemera
propose a kind of sculpture that's not simply there to offer up an easy or immediately
gratifying visual sense for the viewer. Her work mixes ways of thinking that shift from
'what's this sculpture about?' to 'what's sculpture about?'[2]

Clare Hennessy

1 J.J. Charlesworth, 'The Maker's Mark', in *Spike Art Quarterly*, December 2004.
2 J.J. Charlesworth, 'Twisted Sister', in *Art Review*, June 2004.

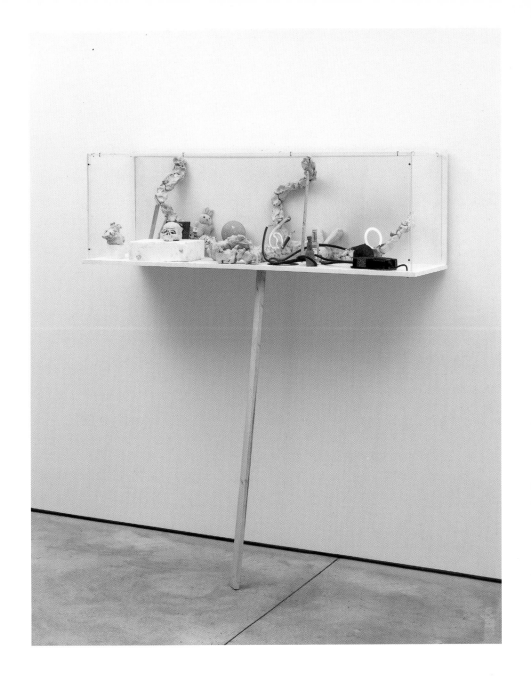

122
Rebecca Warren
Journey into the Heart of the Night,
2000
Unfired clay, neon, mixed media

Rebecca Warren
Dark Passage, 2004
Self-firing clay, MDF, wheels
195 × 198 × 45.5 cm
Photo: courtesy Maureen Paley,
London

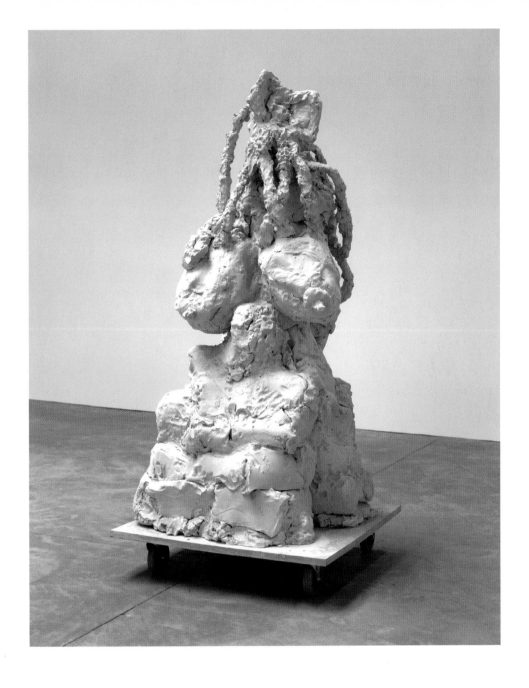

Rebecca Warren
Teacher (R), 2003
Self-firing clay, MDF, wheels
189 × 89 × 89 cm
Photo: courtesy Maureen Paley,
London

Born in Birmingham in 1975
Lives and works in London
Graduated with a BA in Fine Art from
Goldsmiths College, London, in 1996

Solo exhibitions include: Corvi-Mora, London
(2003 and forthcoming 2006); UCLA Hammer
Museum, Los Angeles (2003); and Art Now,
Tate Britain, London (2003)

Group exhibitions include: Still Life, British Council
touring exhibition (2005); The Fee of Angels, Man
in the Holocene, London (2004); and Heart and Soul,
60 Long Lane, London (1999)

Roger Hiorns approaches his art with an experimental and ritualistic methodology. His sculpture, collage and drawings are rooted in an examination of how matter is transformed from one state to another, and the 'philosophical implications' of such a pursuit – how an object becomes art. His sculptures locate themselves in the territory between the representational and the non-representational, combining found objects with rigid geometrical forms. Unstable organic and chemical materials and processes such as copper sulphate, liquid detergent, perfume and fire are employed in his works to introduce an element of chance and allow the object to take on a life of its own.

The use of copper sulphate is a recurring motif in Hiorns' sculptures. Fascinated by the unpredictable and uncontrollable growth patterns of this inorganic substance, he began submerging objects in copper sulphate solutions, allowing them to become slowly barnacled with a thick coating of blue crystals. In Discipline (2002) beautiful cerulean blue mineral formations seem to bloom, as if by magic, on thistle branches. Hiorns' own brand of ritualistic alchemy has transformed this neutral motif almost beyond recognition, from a weed into a bejewelled and precious looking object. Affixed with Velcro to slender steel rods, the thistle branches hang upside down, suspended between the gallery wall and the floor, isolated and detached from their surroundings by virtue of the process of transformation that they have undergone.

Another ongoing body of work consists of ceramic vessels that are suspended from the ceiling and filled with detergent. Compressors on the floor feed oxygen into the base of the vessels, causing the liquid detergent to froth up. Once activated, the sculptures begin to spew forth white columns of foam that steadily flow upwards until they can no longer support themselves and slump impotently towards the floor, leaving a sticky 'entropic' residue behind. In these, as in the copper sulphate works, there is a palpable tension between the functional and the decorative. They have a function but not one that is easily defined; they exist simply to produce foam in an endless cycle of self-replication until they inevitably wear themselves out, fulfilling the law of entropy, which states that all matter must come to a state of rest.

Emma Mahony

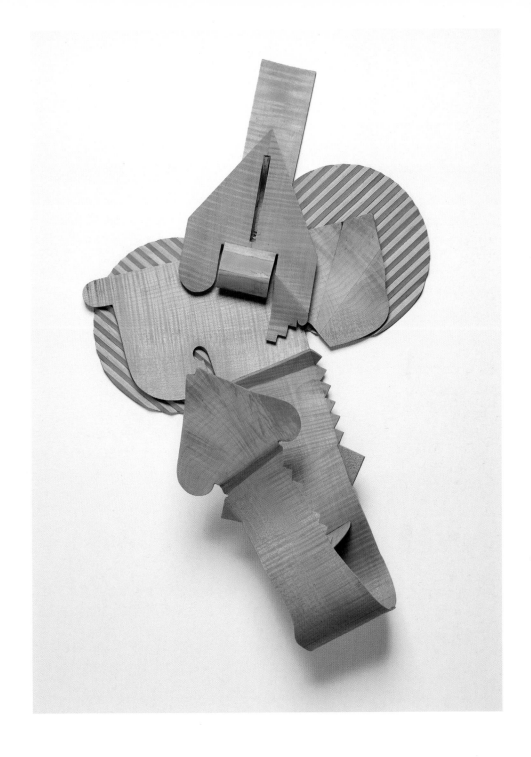

52
Roger Hiorns
Leaving London, 2004
Wood

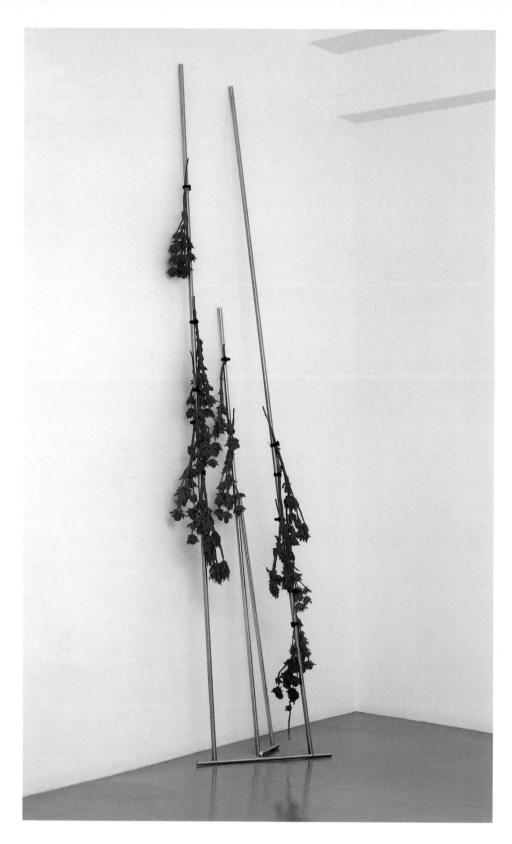

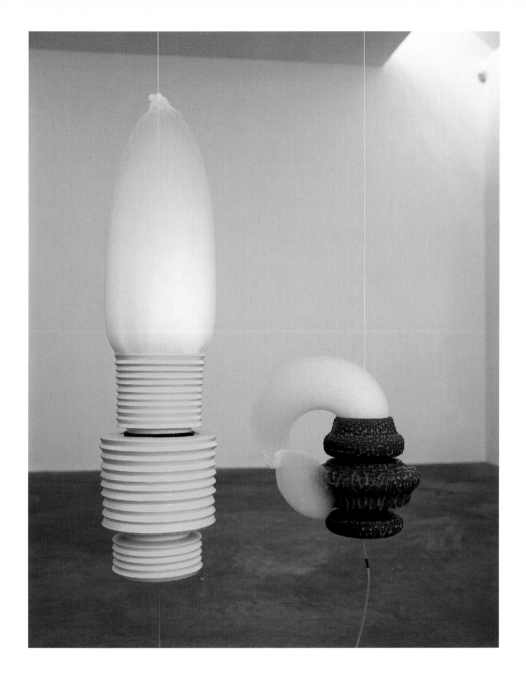

Left
51
Roger Hiorns
Discipline, 2002
Steel, thistles, copper sulphate,
Velcro

Above
Roger Hiorns
Beachy Head, 2003 (detail)
Ceramic, nylon, felt,
compressors, foam
2 parts; 58 × 30, 34 × 30 cm
Photo: courtesy Corvi-Mora,
London

71

TOBY PATERSON

Born in Glasgow in 1974
Lives and works in Glasgow
Graduated with a BA in Fine Art from Glasgow
School of Art in 1995

Solo exhibitions include: *After the Rain*, Barbican Centre,
London (2005); *New Festival*, Glassbox, Paris (2004);
and *New Façade*, CCA, Glasgow (2003)

Group exhibitions include: *Britannia Works*, Ileana
Tounta Contemporary Art Centre, Athens, Greece
(2004); *There's No Land but the Land, Up There is Just
a Sea of Possibilities*, Meyer Riegger Galerie, Karlsruhe,
Germany (2003); and *Happy Outsiders*, Zacheta Museum,
Warsaw, Poland (2002)

Toby Paterson is concerned with architecture and how places are shaped into looking as
they do. As he posits, 'What cultural, political and economic situation had made that place
exist?' His work comprises large-scale wall-paintings, sculptural assemblages and paintings
on the back of thick sheets of transparent Perspex, which are then sandwiched with
another layer of Perspex so that the image appears to float. This is a mode of presentation
that has been described as 'museum-like', rendering the works akin to 'artefacts of a
bygone era'. Indeed, Paterson is as progressive as he is historically grounded: he openly
and consistently references the art and architecture of figures such as Berthold Lubetkin,
Mary Martin, Richard Seifert, Victor Pasmore and Denys Lasdun. Yet Paterson's predilec-
tion for Modernist forms primarily grew, not of any developed utopian vision, but of riding
around concrete buildings on a skateboard. His work constitutes not a critique but rather
an enquiry, an interpretation of his adventures on the ramps and ledges of skateable
architecture. Paterson says, 'All the works are inspired by specific places, but the site
is only the beginning. The references are pulled together and blurred, so that nothing
is made explicit. My works are landscape painting – of all the things I am interested in.'
 A collision of real and imagined spaces, the works sometimes literally spill
chaotically onto the floor. The pieces chosen for *British Art Show 6* come from Paterson's
recent solo show at the Barbican Art Gallery in London, *After the Rain*. Part of his ongoing
investigation into how cities are shaped, the exhibition was made in response to three
cities seriously damaged during the Second World War – Coventry, Rotterdam and
Hamburg. The artist says, 'I think that at the heart of my engagement with these three
places lies a feeling of pathos. The honourable motivation to transcend the aftermath
of war is, unfortunately, hardly ever enough to guarantee the success of the products of
that motivation. Coventry, Rotterdam and Hamburg all contain buildings and areas that
could be said to have "failed", but one cannot deny a little hint of jealousy at the perceived
clarity of the situation facing those tasked with reconstruction. I know that in the current
cultural miasma I'm envious of the blank slate and a chance to escape conflicted histories
– envious of the flawed but alluring *tabula rasa* of Modernism.'

Rebecca Heald

106
Toby Paterson
Rotterdam Relief, 2005 (detail)
Acrylic paint on Perspex

Toby Paterson
Installation view from
After the Rain, Barbican Art Gallery,
Curve, London, 2005
Photo: Lyndon Douglas.
Courtesy the artist and
The Modern Institute, Glasgow

101
Toby Paterson
Station Stairs, 2004/05
Acrylic on Perspex

Born in Nuremberg, Germany, in 1966
Lives and works in London
Studied Fine Art at Akademie für Bildende Künste,
Nuremberg, from 1987–89. Graduated from Hochschule
für Bildende Kunst, Hamburg, with a BA in Fine Art
in 1994, and with a MA in Fine Art in 1996

Solo exhibitions include: *The Beauty They Started
With*, Galerie Giti Nourbakhsch, Berlin (2004);
Tanya Bonakdar, New York (2004); and *refuse
to know*, Galerie Karin Günther, Hamburg (2001)

Group exhibitions include: *Gelegenheit und Reue*,
Grazer Kunstverein, Graz, Austria (2004); *Zwischenwelten*,
Museum Haus Esters, Krefeld, Germany (2004);
and *The Collective Unconsciousness*, Migros Museum,
Zürich (2002)

In Kerstin Kartscher's drawings, past and future intermingle in a hybrid realm of
dislocation and folding. Her choice of medium, pen and ink, is significant, politically
as well as technically: drawing is demotic, it evades the expectations surrounding artistic
genres; technically, it allows fluidity and continuity between disparate styles and varieties
of imagery. Kartscher admires drawing as the simplest and oldest form of image-making
– everybody does diagrams, doodles, maps, cartoons and plans. Drawing is not weighed
down by its status or lineage. Her ambivalent respect for the past, its art and its aura,
is evident in her appropriation of historical engravings of women, solitary, placid women,
in elegant dress, dwelling in exotic landscapes, their apparent detachment from their
surroundings suggesting an idealised, timeless reverie. For Kartscher, these images
of femininity borrowed from the past are a means of probing contemporary freedoms.
In her drawings the figures are displaced and out of time; notwithstanding their 'ladylike'
demeanour, they are wanderers or adventurers, whose homelessness is sometimes
emphasised by the presence of futuristic architecture or Native-American tepees.

If the past is supremely exotic, an imagined elsewhere, it has a special value,
calling for a recognition of the vitality of other forms of understanding and an admission
of our ignorance about them. Kartscher mixes historical sources with imagery inspired
by digital architectural designs, of interest to her because they are limitless – they can
move into multi-dimensional spaces which she favours for their fluidity and boundlessness.
And in these boundless spaces she introduces violent ruptures, dark chasms that signal
nature's refusal to be dominated. The landscapes are thus realms of possibility that
insinuate, though never quite state, the utopian.

Roger Malbert

Top
70
Kerstin Kartscher
Mrs Radio, 2001
Ink marker on paper

Bottom
72
Kerstin Kartscher
Divine irresponsibility
backed by unlimited gold,
2003
Ink on paper

71
Kerstin Kartscher
Untitled (Target), 2001
Pigment ink marker
and hybrid pen on paper

Born in Dublin, Ireland, in 1972
Lives and works in London
Graduated with a BA in Fine Art from University
of Ulster, Belfast, in 1993, and with a MA in Fine Art
from Goldsmiths College, London, in 1999

Solo exhibitions include: Douglas Hyde Gallery,
Dublin (2005); Kunsthalle, Zürich (2004); and
Heavy Cloud, The Modern Institute, Glasgow (2003)

Group exhibitions include: *Extreme Abstraction*, Albright-
Knox Museum, Buffalo, New York (2005); 54th Carnegie
International, Carnegie Museum of Art, Pittsburgh
(2004); and *My head is on fire but my heart is full of love*,
Charlottenberg, Copenhagen (2003)

Eva Rothschild believes that art should not be limited by any particular discipline,
observing that 'sculpture seems to allow openness; it has become a very wide area,
it can be anything.' Her works hang on walls and from ceilings, or are free-standing:
earth-bound or towering in space. Combining industrial processes with traditional
crafts, she works with both artificial and natural materials, often in combination with
each other. MDF, Plexiglas, resin and steel are united with wood and leather. Paper
reliefs are woven from printed and photocopied images in day-glo colours. Found objects
such as tyres are sanctified with incense sticks. Her work embraces abstract geometrical
forms and representational objects, and for both types of sculpture the precedents lie
in the art and culture of the late 1960s: the austerity of Minimalism and the flamboyance
and permissiveness of psychedelia and New Age spirituality.

High Times (2004) and *Heavy Cloud* (2003) illustrate the polarities within which
Rothschild operates and are provocative in entirely different ways. In *Heavy Cloud*
black resin hands reach from the ceiling holding three interconnected triangles above
the heads of the viewers. *High Times* is a collection of trophy heads that suggest both
modern fetishism and ancient ritual. The leather heads, with their dizzying elevation
and decadently elongated fringes, require us to look up to them, suggesting euphoria
or a heightened level of consciousness. Rothschild remarks that, unlike her abstract
sculptures, the head pieces 'stay in an incomplete state; they're almost existing,
and there could always be more work done on them.'

Helen Luckett

112
Eva Rothschild
High Times, 2004
Leather, steel support

Eva Rothschild
Stairway, 2005
Paint, wood, resin
Dimensions variable
Private collection, London
Photo: courtesy Stuart Shave /
Modern Art, London

Born in Birkenhead, Merseyside, in 1964
Lives and works in London
Graduated with a BA in Fine Art from Newcastle
Polytechnic in 1990

Solo exhibitions include: Gavin Brown's Enterprise,
New York (2004); Migros Museum, Zürich (2003);
and *Parade*, Cabinet Gallery, London (2003)

Group exhibitions include: *Manifesta*, San Sebastian,
Spain (2004); *Teil 1 "Mullberg"*, Galerie Buchholz,
Cologne, Germany (2004); and *Sound Systems*, Salzburg
Kunstverein (2003)

Mark Leckey uses dance music and performance as ways of looking at systems of
contemporary art production. His subjects range from club culture and high-street fashions
to *fin-de-siècle* decadence and the poise of the *flâneur*, though his work can also be read
as being about the artist himself, his life in London and being a man. He is also, with
Ed Liq, a founder-member of the band donAtteller (named after fashionista Donatella
Versace). Leckey's output is unhurried and measured. To date he is perhaps best known
for his video essay *Fiorucci Made Me Hardcore* (1999), a weaving together of found-footage
charting the rise of the British dance scene from the 1970s onwards. He shakes up
his themes like a kaleidoscope. They fall together in brightly-coloured constellations
punctuated with moments of silence or darkness reminiscent of the amnesia of an
indulgent night out.

 Leckey consistently strives to make sense of chaos. In *Made in 'Eaven* (2004)
he focuses on one of the most iconic pieces of the 1980s art boom: Jeff Koons's *Rabbit*
(1986). An inflatable bunny made of steel, Koons's sculpture transforms a childhood toy
into a lasting commodity. Leckey chooses not video but the outdated medium of 16 mm
film to portray the work, evoking an era of artisanal manufacture rather than the slick
surfaces of neo-geo, and complimented by the bashed-up door and stripped floorboards
by which it is surrounded. In *Made in 'Eaven*, Koons' sculpture is given the job of reflecting
distorted views of Leckey's studio and front room in Windmill Street. Past and present
collide to create a disorientating spectacle of nostalgic chaos. Meanwhile Leckey's piece
The Destructors (2004/05), based on Graham Greene's short novella of the same name,
similarly negotiates the descent of order into chaos. Slide images taken from the popular
1975 TV adaptation of the story about juvenile delinquents are shown interspersed with
pictures and dialogues from a collage of sources ranging from the films *Donnie Darko*
and *Quadrophenia* to the photographs of Gordon Matta Clark. Incorporating an appearance
by his current band, Jack too Jack, Leckey overloads the audience with information,
bombarding them with an increasingly frenzied audio-visual assault.

Rebecca Heald

Mark Leckey
Made in 'Eaven, 2004 (cat.76)
16 mm film
Running time: 2 hour loop
Photo: courtesy Cabinet, London,
Galerie Daniel Buchholz, Cologne,
and Gavin Brown's enterprise,
New York

77
Mark Leckey
The Destructors, 2004/05 (stills)
DVD

SILKE OTTO-KNAPP

Born in Osnabrück, Germany, in 1970
Lives and works in London
Graduated with a BA in Cultural Studies from
the University of Hildesheim, Germany, in 1995,
and with a MA in Fine Art from Chelsea College
of Art and Design, London, in 1996

Solo exhibitions include: greengrassi, London (2004);
25th Floor, Galerie Daniel Buchholz, Cologne (2003);
and Orange View, Kunstverein für die Rheinlande
und Westfalen, Düsseldorf (2003)

Group exhibitions include: Thinking of the Outside,
Situations, Bristol (2005); Istanbul Biennale, Istanbul
(2005); and The Undiscovered Country, Hammer Museum,
Los Angeles (2004)

The lush, cultivated vegetation of tropical gardens and the formally-landscaped European garden act as starting points for many of Silke Otto-Knapp's paintings. For the past two years the artist has also painted figures on the stage, starting with the showgirls of Las Vegas, and moving on to Hollywood, to Busby Berkeley – the great US movie musical choreographer – and to ballet choreography. These motifs have a commonality of being artificially constructed environments that are illusionistic and decorative, and at times exotic. Otto-Knapp translates the spatial organisation of these 'artificial' motifs into painted space, using details of the images to construct the composition.

The artist creates these paintings by placing layer-upon-layer of dripped, stained and sprayed watercolour paint onto canvas, working and often reworking the paint. This creates a density that belies the natural quality of the material. Because canvas doesn't absorb the paint as paper would, the pigments seem to float on its surface, exposed and translucent. A horizon line is absent in most of the artist's paintings, and if one is visible it is often high on the picture plane, intensifying a spatial uncertainty. In Golden Garden (Conifers) (2005) the viewer is presented with a landscape that is illuminated with golden light. The images float and dissolve, like a mirage in the desert heat. There is a sense of being denied entry into Otto-Knapp's internalised world. The latticed barrier, which runs horizontally across the lower half of Golden Garden (Conifers), intensifies this exclusion.

In Showgirls (Blue) (2004) vaudeville dancers gaze outwards at the viewer as if from a sepia-toned photograph that has been left out in a hot summer rain. These still, elegiac figures are caught in the lights of a ghostly, out-of-focus world that seeps and dissolves around them. A wide arch rises above; one column stands outside the picture plane while the other begins to vanish before it reaches any discernable base. This arch is the only architectural element in the painting and acts to fix the figures in the picture plane, and at the same time creates a dense, claustrophobic and uncertain space. In Fans (2004) the showgirls wave shell-like fans with undulating languor in a space veiled in blue paint. The dancers appear to use these fans to physically push the crowded, internalised space outwards beyond the picture.

Clare Hennessy

100
Silke Otto-Knapp
Golden Garden (Conifers), 2005
Watercolour and gouache on canvas

98
Silke Otto-Knapp
Fans, 2004
Watercolour on canvas

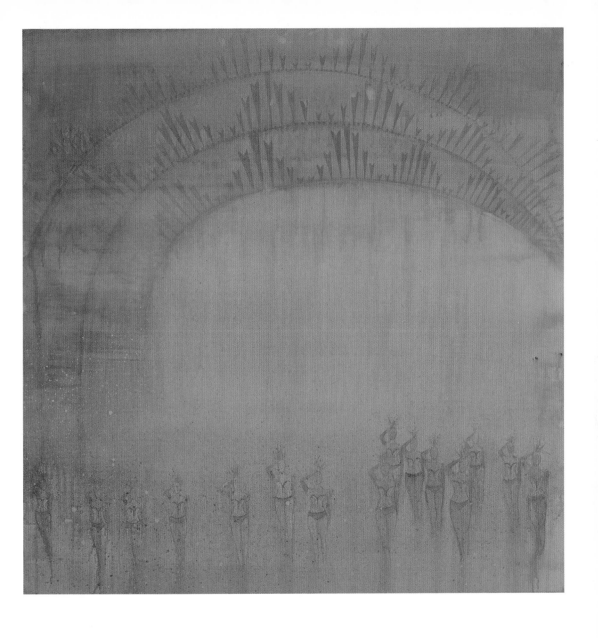

99
Silke Otto-Knapp
Showgirls (Blue), 2004
Watercolour on canvas

DARIA MARTIN

Born in San Francisco, USA, in 1973
Lives and works in London
Graduated with a BA in Humanities from Yale
University, New Haven, Connecticut, in 1995,
and with a MA in Fine Art from University
of California, Los Angeles, in 2000

Solo exhibitions include: *Soft Materials*, The Showroom,
London (2005); Kunsthalle Zürich (2005); and *Daria
Martin, Art Now, Lightbox*, Tate Britain, London (2003)

Group exhibitions include: *Beck's Futures*, Institute of
Contemporary Arts, London (2005); *In the Palace at 4am*,
Alison Jacques Gallery, London (2004); and *The Moderns*,
Castello di Rivoli Museum of Contemporary Art,
Turin (2003)

Daria Martin's 16 mm films are gentle constructions of fantasy. They revisit forgotten
moments in art history, notably movements associated with aggressive avant-garde thinking
such as Constructivist set design, Futurist fashion and performance art, and revive them
from a contemporary perspective. Rather than displaying a nostalgia for this period,
her work explores what it might mean to be Modern now, and in the process acknowledges
the aspirations and failures of the Modern.

Martin is drawn to film as a medium that is suited to actualising and sharing
imagined worlds and one that can contain and mobilise her many areas of research.
In earlier works such as *In the Palace* (2000) and *Closeup Gallery* (2003) she delves into
the territory of the total artwork. The starkly-lit geometric set of *In the Palace* is a scaled-
up version of Giacometti's 1933 surrealist sculpture *The Palace at 4am*, and the dancers
that populate it adopt poses from Oskar Schlemmer's *Slat Dance* performed at the Bauhaus
in 1927. The magician who deftly wields cards in *Closeup Gallery* recalls the early modes
of popular entertainment that were the precursors of film, such as vaudeville.

Her films explore themes of deception and revelation, and she describes them as
'...magic acts that show how the trick is done'. They are deliberately low-tech illustrations
that expose the artifice that went into their making. The costumes that her performers
wear are constructed from materials such as paper, foil, tinsel, cardboard and plastic
and they are situated within overtly artificial sets. There is little narrative structure to
these films; instead the artist relies upon the exchange of glances and gestures between
her performers to convey a story of sorts and, in both, it is the camera and the sets
which move, turning viewers into voyeurs, to examine the captive, still bodies.

Soft Materials (2004) is filmed in the Artificial Intelligence Lab at the University
of Zürich. The lab specialises in 'embodied artificial intelligence', designing robots that
function through a learned experience of their physical bodies. In Martin's film two
performers trained in body awareness interact with the robots. Naked, they perform a series
of dances and the robots respond by mimicking their movements. Martin was particularly
drawn to the sculptural quality of the robots and to the manner in which their artifice is
foregrounded by their crude mechanical structures. The film explores the balance between
physicality and the ephemeral and how it is leveled as the robots and humans dance
side by side.

Emma Mahony

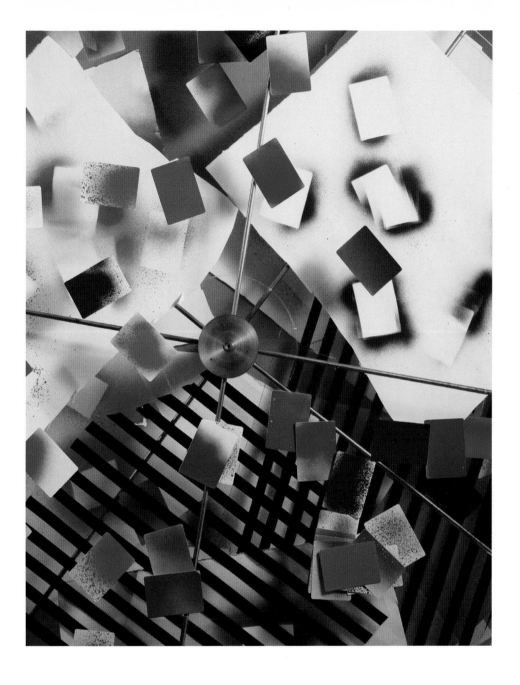

Daria Martin
Closeup Gallery, 2003 (still)
16 mm film
Running time: 10 minutes
Photo: courtesy the artist

84
Daria Martin
Soft Materials, 2004 (stills)
16 mm film

Born in Kiel, Germany, in 1967
Lives and works in London
Graduated from Hochschule der Künste Berlin
with a Diploma in Visual Communication in 1994,
and with a MA in Experimental Film in 1995

Solo exhibitions include: Douglas Hyde Gallery, Dublin
(2005); Kunsthalle, Basel, Switzerland (2005); Journal#7,
Van Abbemuseum Eindhoven, The Netherlands (with
Vincent Fecteau) (2004); and greengrassi, London (2002)

Group exhibitions include: the 54th Carnegie
International, Carnegie Museum of Art, Pittsburgh
(2004); Formalismus: Moderne Kunst Heute, Kunstverein
Hamburg (2004); and Müllberg, Galerie Daniel Buchholz,
Cologne (2004)

Tomma Abts paints relatively small, self-contained oil and acrylic canvases. On cursory
inspection they can appear to be simple exercises in shape and colour, perhaps lending
themselves to the term 'abstraction'. Yet though they draw heavily on a collective graphic
consciousness, the textural surfaces of the work force the viewer to reconsider hasty
categorisation. The flat surface traditionally associated with abstraction is nowhere
in evidence: some sections are layered thick, others are washed-over, barely pigmented.
The results are often illusory: what appears big is small, shadows aren't where one expects
them to be, what looks below is really above. But perhaps most frequently they give the
illusion of movement. Abts makes no attempt to conceal her pursuit of a new language,
a drive congruent with the desire to endow the paintings with life. She speaks of rendering
the work self-sufficient, and upon completion each piece is given a proper name.
 The evolution of Abts' canvases is slow but rigorous and looking at the work it
becomes apparent that the control she exercises over the paintings is the same that is later
exerted over the viewer's eye. Sight is playfully directed within the bounds of the canvas
and then pushed beyond. Nomde (2004) navigates the eye around a shiny, angular diagram,
leading it sharply out of the top part of the painting (either side can be chosen); Soko (2004)
seductively forces the eye to slither and slide; and the static forms of Emo (2003), once
described by artist Peter Doig as 'a living thing', invite the viewer to peel back the work's
rough layers, each one a protective membrane guarding a history of experience, decisions
made and undone. Though unassuming at first, once drawn into Abts' paintings, the works
grant the spectator a rare and valuable exploration of space, texture and vision.

Rebecca Heald

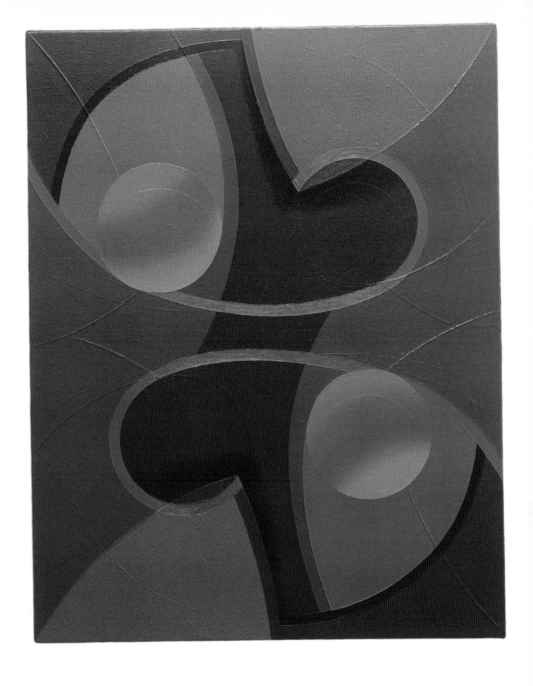

1
Tomma Abts
Emo, 2003
Acrylic and oil on canvas

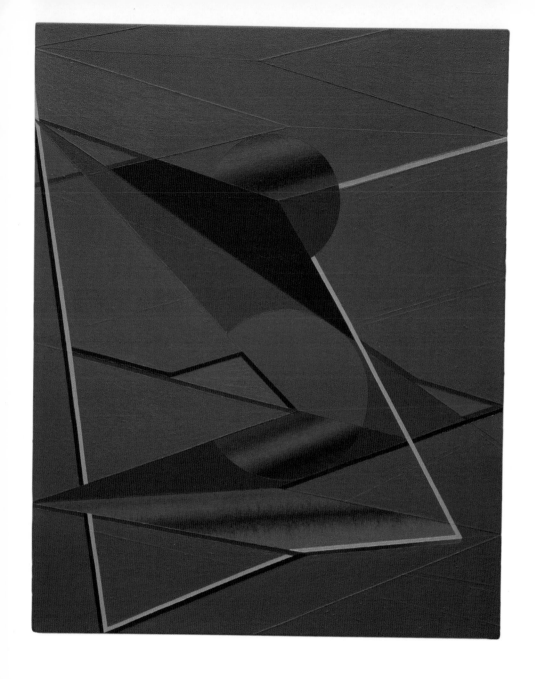

2
Tomma Abts
Nomde, 2004
Acrylic and oil on canvas

3
Tomma Abts
Soko, 2004
Acrylic and oil on canvas

ENRICO DAVID

Born in Ancona, Italy, in 1966
Lives and works in London
Graduated with a BA in Fine Art from
Central Saint Martins College of Art and Design,
London, in 1994

Solo exhibitions include: *Douche That Dwarf*,
Transmission, Glasgow (2004); *David*, Project
Art Centre, Dublin (2003); and *Madreperlage*,
Cabinet, London (2003)

Group exhibitions include: *Flesh at War with
the Enigma*, Kunsthalle, Basel, Switzerland (2004);
In the Palace at 4am, Alison Jacques Gallery, London
(2004); and *Vernice*, Centro d'Arte Contemporanea
Villa Manin, Udine, Italy (2004)

Enrico David's practice encompasses a vast array of media to focus on the thin threshold
that separates art from craft. Unabashedly handcrafted, his work forefronts the decorative,
but in scale and subject matter it clearly references high art. A body of work from the late
1990s consists of figurative embroideries on canvas. The stylised, life-size female figures
that populate these works were mostly culled from the fashion pages of *Vogue* and, using
the rag trade's own impersonal means, were painstakingly stitched with wool onto dyed or
raw canvas grounds. More recently his work has diversified into a range of media including
sculpture, cabinet making, batique, glass painting and works on paper. These discrete objects
come together to form hallucinatory *mise-en-scènes*, which invite the viewer to conjure up
their own interpretation of the events that may have led to their realisation.

The relationship between desire and design is a powerful undercurrent in David's
practice. He uses the language of design to give voice to homoerotic innuendo. This
sexually-charged atmosphere is very much present in *Madreperlage* (2003), an installation
of disparate elements that borrow heavily from the Art Deco style. Central to *Madreperlage*
is a nine-foot-tall rag doll that sits slumped on the floor. Meticulously hand-stitched with
embroidered detail, the doll is one in a recurring series of *Alter Ego* dolls, which appear
to 'stand in' for the artist in his hormone-fuelled environments. The figure leans against
a dark wood cabinet that has been constructed of panels held in place with four vertical
wooden dowels which appear to have penetrated the structure. A central void creates a
peephole vista on the room with connotations of voyeurism. An Art Deco-style globe lamp
completes the installation in which a sleek looking male figure clad in a black-and-white
striped shirt leans casually against the supporting upright, as though wistfully standing
under a streetlamp anticipating a chance encounter. Similarly stylised businessmen
figure again and again in David's recent work, alluding to the members of the all-male
secret society that the artist has conjured up as the background for his *Spring Session Men*
installation (2003).

Emma Mahony

Above
40
Enrico David
Untitled (door), 2003
Glass, metal, paint

Overleaf
39
Enrico David
Madreperlage, 2003
Mixed media

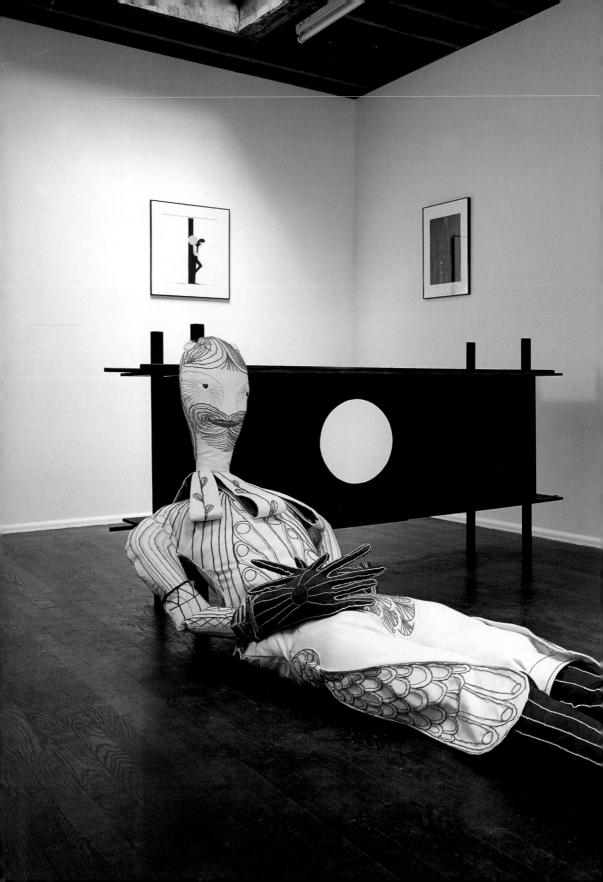

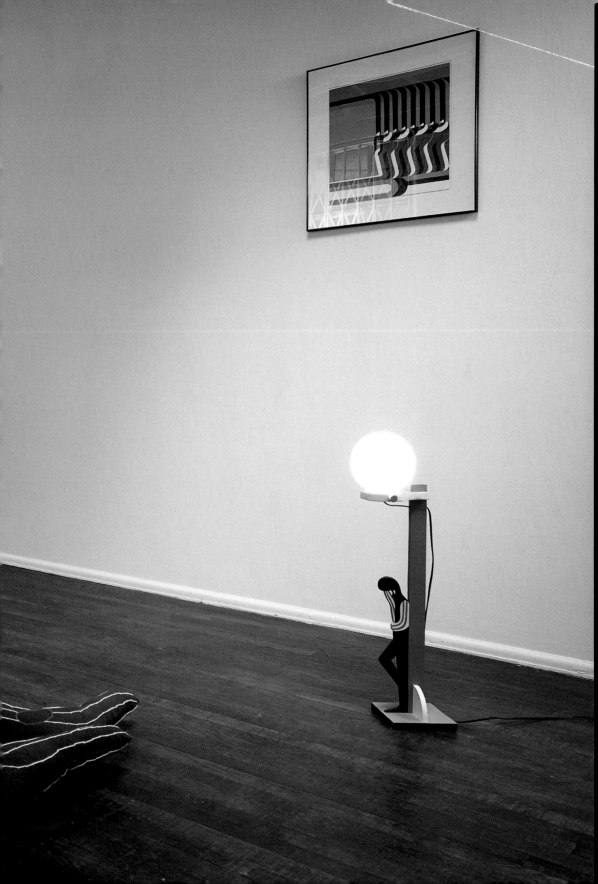

CLAIRE BARCLAY

Born in Paisley, Scotland, in 1968
Lives and works in Glasgow
Graduated from Glasgow School of Art with
a BA in Environmental Art in 1990, and with
a MA in Fine Art in 1993

Solo exhibitions include: *Half-Light, Art Now,*
Tate Britain (2004); *Ideal Pursuits,* Dundee Contemporary
Arts (2003); and *Some reddish work done at night,*
doggerfisher, Edinburgh (2002)

Group exhibitions include: *Zenomap,* Palazzo Guistinian-
Lolin, Venice Biennale (2003); *Early One Morning,*
Whitechapel Art Gallery, London (2002); and *Tra-La-La:
British Sculpture in the Sixties,* Tate Britain, London (2002)

Claire Barclay's sculptural installations combine industrially-produced materials with
hand-crafted elements that have been moulded, thrown, turned and spun. She exploits
the physical qualities of her chosen materials and their potential to communicate and
trigger emotional and psychological responses in the viewer. In early work she explored
the fetishistic nature of materials such as rubber, leather and feathers. Her work also
examines the 'role of craft' in contemporary art and how handmade objects inform identity
and lifestyle. But rather than mastering craft skills, she is, as she says, more interested
in '...the processes of hand crafts, both traditional and improvised, in particular, the point
of merger between thinking and making.' As such, the craft elements in her work are often
poised between making and unmaking, half-finished basketwork is left to unravel, woven
fabric hangs uncompleted on the loom and groups of hastily thrown ceramic pots balance
precariously on a cross beam.

Barclay's composed environments take their cue from the space in which they
locate themselves. According to the artist, 'the logistics of the space start to suggest
ways of organising something within it'. She improvises wood and steel structures that
function both as integral supports for her sculptures and as constituent parts of her overall
composition. Often likened to three-dimensional drawings in space, where each pole,
plank and rope represents a carefully placed line drawn between the floor, the ceiling
and the walls, her sculptural environments are held in place by their own tension. Within
this environment she carefully places, hangs or props her discrete sculptural objects, which
have been fabricated in the studio from a combination of machined and crafted materials.
She has crocheted sleeves for metal poles, wrapped a twig in a contour-hugging PVC
suit and encased large metal hoops in tightly-sewn leather sleeves. It is this unique use
of materials and how they interact with one another and suggest possible interpretations
that leaves one with a sense of unease and disorientation without understanding its
exact root.

Emma Mahony

11
Claire Barclay
Untitled, 2003
Black wool crochet over
aluminium pole

Overleaf
Claire Barclay
Installation view from *Ideal Pursuits*,
Dundee Contemporary Arts, 2003
Photo: Ruth Clark

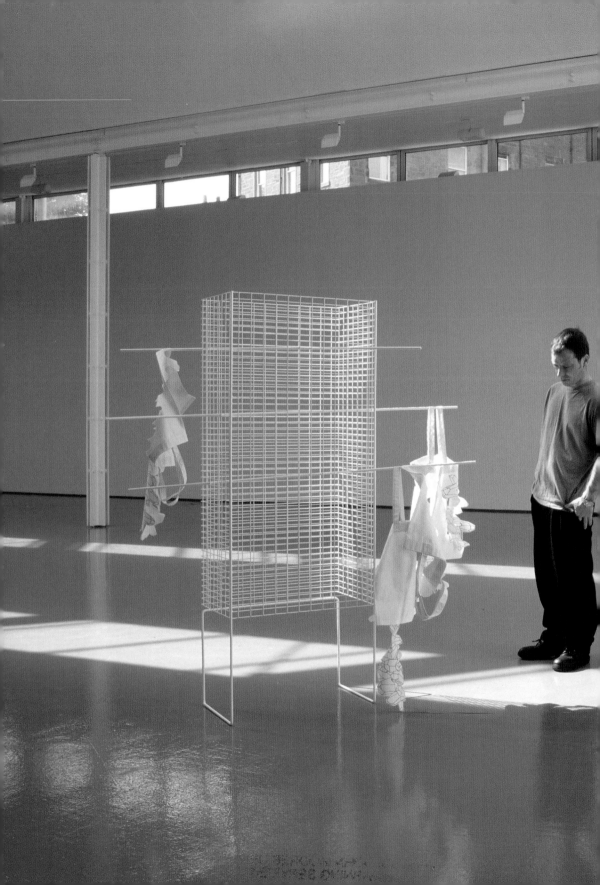

HALUK AKAKÇE

Born in Ankara, Turkey, in 1970
Lives and works in London
Graduated with a BFA in Architecture from Bilkent
University, Ankara, Turkey, in 1993, and with
a MFA in Video from The School of the Art Institute
of Chicago in 1997

Solo exhibitions include: Centro Nazionale per le
Arti Contemporanee, Rome (2002); Whitney Museum
of American Art at Philip Morris, New York (2001);
and P.S.1, Long Island City, New York (2001)

Group exhibitions include: *Expander*, Royal Academy,
London (2004); *Beck's Futures*, Institute of Contemporary
Arts, London (2004); and *The Moderns*, Castello di Rivoli
Museo d'Arte Contemporanea, Turin (2003)

Haluk Akakçe, who trained in both Fine Art and Architecture, has made digitally animated videos, paintings, works on paper and wall drawings. His videos variously draw on the languages of Minimalist painting, two-dimensional renderings of architectural spaces and virtual reality simulations. Some are accompanied by specially-composed soundtracks made in collaboration with musicians, others loop existing musical fragments.

'When the work is not abstract, Akakçe's digital animation draws imagery from human, mechanical and botanical sources, usually fusing one with another or hybridising all three. Often the future is evoked, but through a vocabulary lifted from the present day (swish office interiors, recent scientific discoveries, digital technology) or borrowed from the past (sinewy Art Nouveau lines, William Morris-like wallpaper, billowing nineteenth-century costume). Even the abstract works, or the abstract passages in otherwise representational films and paintings, reverberate with cultural history: Suprematism, de Stijl, Minimalism and Op Art are all evoked. A feature that runs through both the abstract and figurative work is an elastic treatment of space that defies the way we usually perceive things and situate ourselves in relation to them. The films, too, anticipate the physical space of the viewer: typically, the space of the projected image and the room form a heady continuum. The illusion is reinforced by Akakçe's technique of projecting onto black surfaces, to dissolve the frame of the image further: the areas of the picture that weren't subjected to light appear as black on black, lending them a velvety thickness, a quality described by that enigmatic notion of black snow.'

'*Birth of Art* (2003) features tulip-like forms floating and rotating balletically in a blurred, sepulchral environment that could be a Moreau-esque cathedral or grand mosque. Their petals are perfectly reflective, like so many things thought beautiful in culture – precious metals and minerals, especially – seemingly without substance in themselves. When they open up, the petals' undersides are suffused with a brilliant red, as we are ourselves under the knife. It's a red like the red of all those jewel-like wounds in Western religious art, as beautiful as the flowers' polished silver exteriors. Akakçe's cyborg fauna don't symbolise suffering anywhere near as directly as anything in the service of religion, of course, but there's still a cruelty to their elusive opulence that makes them digital descendants of Baudelaire's *fleurs du mal*.'

Alex Farquharson

Extracts from Alex Farquharson, 'Out of Time', in *frieze*, March 2004, Issue 81.

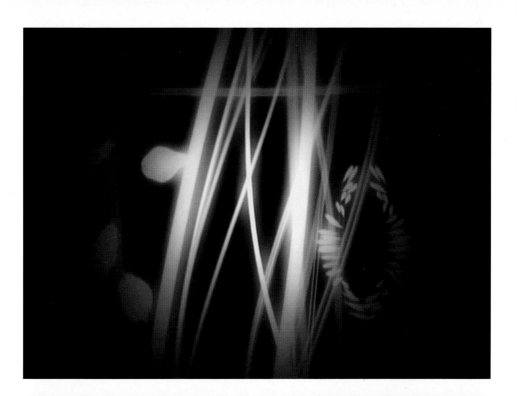

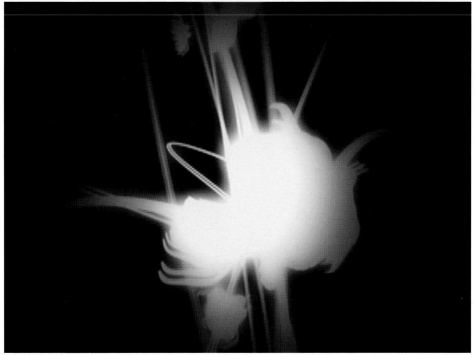

Above and overleaf
4
Haluk Akakçe
Birth of Art, 2003 (stills)
Single channel projection DVD

DAVID THORPE

Born in London in 1972
Lives and works in London
Graduated with a BA in Fine Art from Humberside
University, Hull, in 1994, and with a MA in Fine Art
from Goldsmiths College, London, in 1998

Solo exhibitions include: Maureen Paley, London
(2005); *The Colonists*, Meyer Riegger Galerie, Karlsruhe,
Germany (2004); and *The Colonist, Art Now*, Tate Britain,
London (2004)

Group exhibitions include: *Ideal Worlds: New Romanticism
in Contemporary Art*, Schirn Kunsthalle, Frankfurt (2005);
Into My World, The Aldrich Contemporary Art Museum,
Connecticut (2004); and *Twisted. Urban and Visionary
Landscapes in Contemporary Painting*, Van Abbemuseum,
Eindhoven, The Netherlands (2001)

David Thorpe's work includes sculpture, installation, performance and wall-mounted
texts, but his main medium is collage. He invents fantasy worlds for imagined alternative
societies, featuring isolated citadels for separatist communities set in post-apocalyptic
wildernesses or sublime landscapes. His early collages exploring this terrain were made
from intricately cut paper. More recently, he has extended his technique to include a
vast variety of materials – oxidised copper, slate, glass, modellers' wood, dried flowers
and bark, pebbles, Play-Doh, bits of net curtain, costume jewellery – which echo the
actual substance of his subject-matter. He explains that 'it seems like common sense
that if I'm constructing a tree I should do it in bark. You can also get different spatial
levels, starting with tissue paper, using harder materials as you build it up; and usually
the materials also get thicker so it's like this shallow relief. The technique also seems
appropriate to the subject matter – these obsessive, hick communities. These pictures
are images of things, but they could also potentially be manufactured within these worlds.
They could be the types of images that would be seen inside these buildings ... As in
the last few years the subject matter has become more esoteric so the materials have
become odder.'

 While his collages have become increasingly 3-dimensional and mimetic,
David Thorpe has begun to use other media to explore the lifestyles and communities
of his invented world. His book, *A Rendezvous with My Friends of Liberty*, published
in 2004, contains hymns and celebrations of this realm, its precursors and its heroes.
In the same year, his exhibition at Tate Britain included objects and constructions,
in a space divided and defined by dark wooden screens with frosted windows which
provided points of entry and exclusion. It was on this occasion that he first presented
his choreographic performance work *The Mighty Lights Community Project*.

Helen Luckett

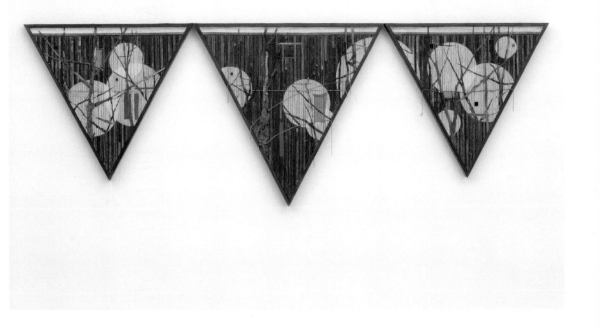

David Thorpe
The Hidden Language, 2004
Mixed media collage
42 × 146 cm
Photo: courtesy Maureen
Paley, London

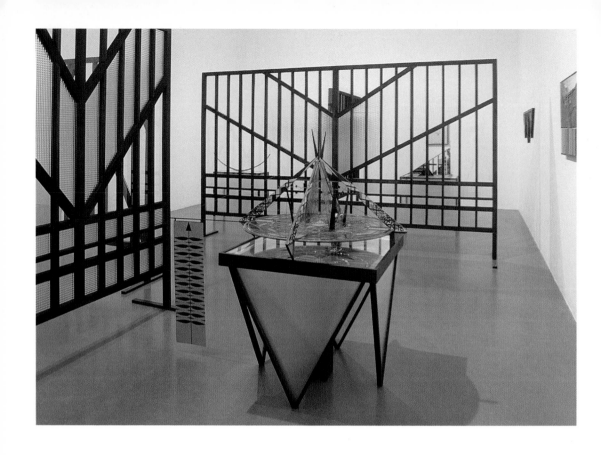

David Thorpe
Installation view from *Art Now*,
Tate Britain, London, 2004
Photo: courtesy Maureen
Paley, London

David Thorpe
The great usurper, 2005
Watercolour on paper
113.5 × 76.5 cm
Photo: courtesy Maureen Paley,
London

MARK TITCHNER

Born in Luton, Bedfordshire, in 1973
Lives and works in London
Graduated with a BA in Fine Art (Painting) from
Central Saint Martins College of Art and Design,
London, in 1995

Solo exhibitions include: *Behold the man, waiting
for the man*, Peres Projects, Los Angeles (2005);
Twentieth-century Man, Vilma Gold, London (2004);
and *Be angry but don't stop breathing*, Art Now,
Tate Britain, London (2003)

Group exhibitions include: *Sodium and Asphalt*, Museo
Tamayo, Mexico City & Museo de Arte Contemporáneo
de Monterrey (2004); *Musik Total III*, De Appel,
Amsterdam (2004); and *Expander*, Royal Academy
of Arts, London (2004)

Mark Titchner's sculptures, installations, wall paintings, light boxes, vinyl banners, billboards and digital animations present us with eclectic samplings from twentieth-century culture and counter-culture. Launching fragmentary missives from the past into the here and now, his works carry allusions to early abstract art, 1970s interior design, revolutionary graphics, obscure cults and eccentric ideologies. This accumulated salvage is stripped of context, morphed and reconfigured into strident and hallucinatory images emblazoned with slogans and off-beat messages. His texts are derived from sources ranging from rock music and corporate mission statements to philosophy, theology and sociology. 'In general,' he explains, 'I use titles that I find rather than create so, like each work's aesthetic, they are always embroiled in an historical moment.'

With the sculpture *Resolving Conflict by Superficial Means* (2002), Titchner borrows words from 'Eclipse', from Pink Floyd's 1973 album *The Darkside of the Moon*, ('probably the biggest-selling example of popular music produced on the theme of life and death'). The revolving central disc – reminiscent of Marcel Duchamp's kinetic *Rotoreliefs* – is a copy of the original Vertigo record's label. Visitors are invited to grasp an outstretched concrete hand and into it '...pour all of [their] fear, pain and hatred, let it wash down into the rock below...' - the rock allegedly being rubble from a decommissioned munitions factory. Titchner's lightbox slogan work, *Tomorrow Should Be Ours* (2005), also adopts words from rock music, using a line from the song 'The Triumph of Our Tired Eyes' by the Canadian band A Silver Mt Zion.

The giant billboards that Titchner created in 2004 for London Underground's *Platform for Art* programme took utopian statements from the manifestos of the world's top ten multinational corporations. Each was prefixed by the words 'We Want', taken from the ten-point plan of an anti-Capitalist revolutionary group. These rallying cries were superimposed on backgrounds recalling trade union banners. For an offsite *British Art Show 6* commission in Newcastle/Gateshead Titchner will produce a series of four billboard posters for display at sites across the cities. The designs will be based on requests made to local authorities by the public which he has put through the occult system of sigilisation, invented a century ago by the artist and magus Austin Osman Spare.

Helen Luckett

120
Mark Titchner
Tomorrow Should Be Ours, 2005
Duratrans in lightbox

Mark Titchner
*¿Por Qué Hay Algo En Lugar
De Nada?*, 2004
Inkjet print on vinyl
Dimensions variable
Photo: courtesy the artist,
Vilma Gold, London,
and The British Council

119
Mark Titchner
Resolving Conflict By Superficial Means,
2002
Concrete, carved wood, electric
motor, paint

HEW LOCKE

Born in Edinburgh in 1959
Lives and works in London
Graduated with a BA in Fine Art from Falmouth
School of Art in 1988, and with a MA in Sculpture
from the Royal College of Art, London, in 1994

Solo exhibitions include: The New Art Gallery Walsall
(2005); *House of Cards*, Luckman Gallery, California
State University, Los Angeles, and Atlanta Contemporary
Art Center, Georgia (2004); and *King Creole*, installation
on façade of Tate Britain, London (2004)

Group exhibitions include: *Hew Locke and Diana Cooper*,
The Drawing Room, London, Chapter Arts Centre,
Cardiff, and The City Gallery, Leicester (2004–05);
Boys Who Sew, Crafts Council, London, and UK tour
(2004–05); and *Somewhere – places of refuge in art and life*,
Angel Row Gallery, Nottingham, Towner Art Gallery,
Eastbourne, and the Bury St Edmunds Art Gallery (2002)

Hew Locke's carnivalesque sculptures have been described as 'monumental, trashy,
postcolonial, baroque'. Created out of mundane and glitzy gleanings from streets, markets
and pound shops, their basic medium is often cardboard, which he uses both for vast
installations and as the supports for some of his smaller works. He has constructed immense
architectural sculptures from packaging and made monumental reliefs bristling with fake
weapons, plastic creepy-crawlies and artificial flowers. The recurrent theme is legacies
of empire; emblems of royalty and government are subverted and overlaid with signs and
traces of the cultures that British imperialism sought to overwhelm. This partly reflects
Locke's own background in Britain and the Caribbean. After spending the first seven years
of his life in Edinburgh, he grew up in newly independent Guyana, returning to Britain
to study sculpture 25 years ago.

 Locke describes his huge cut-out relief *King Creole* (2004) as 'a voodoo-esque version
of a national icon'. Based on the House of Commons coat of arms, a design of literally
common currency since it appears on the back of every one penny coin, it metamorphoses
into a skull and cross-bones; a 'giant funeral wreath' festooned with plastic chrysanthemums
entwined with English roses and cannabis leaves. 'King Creole is King Death', he explains.
'It refers to buccaneering, piratical attitudes that have existed in British history, as well
as the often vicious cut and thrust of "debate" in the House, and of the real wars that
can result.' The equally flamboyantly fetish-like and ambiguous *Black Queen* (2004) and
El Dorado (2005) are part of an ongoing series investigating icons of glamour and power
and the ways in which these have changed over the last 50 years. 'My feelings about
the Royals are ambivalent', Locke admits. 'I am simply fascinated by the institution and
its relationship to the press and public. My political position is neither republican nor
monarchist. I am interested in producing powerful, magical images of the Royal Family
and I find it strange that this could be viewed as being a perverse act for a Black artist.'

Helen Luckett

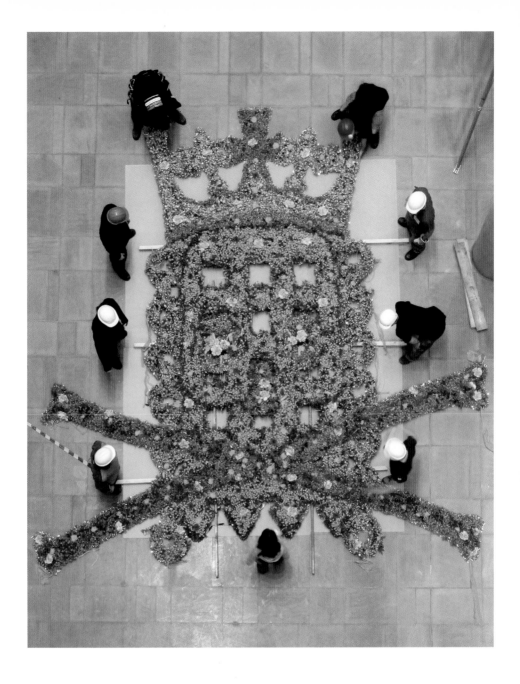

Hew Locke
King Creole, 2004
Steel frame, plastic flowers, tinsel,
plastic ties
630 × 480 cm
Commissioned by the BBC, London
© DACS 2005
Photo: courtesy Hales Gallery

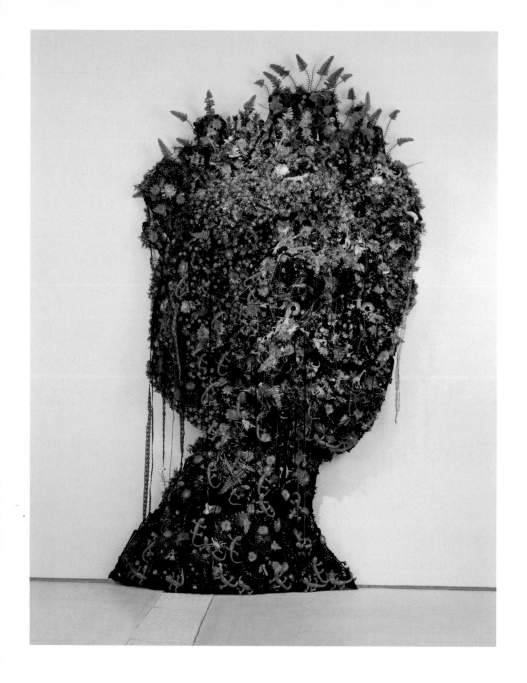

78
Hew Locke
Black Queen, 2004
Wood and cardboard base,
glue gun, screws, mixed media
(plastic, fabric)

79
Hew Locke
El Dorado, 2005
Wood and cardboard base,
glue gun, screws, mixed media
(plastic, fabric)

123

SIOBHÁN HAPASKA

Born in Belfast, Northern Ireland, in 1963
Lives and works in London
Graduated with a BA from Middlesex Polytechnic
in 1988, and with a MA from Goldsmiths College,
London, in 1992

Solo exhibitions include: *Playa de los Intranquilos*,
Peer, London (2004); *Cease Firing On All Fronts*,
Kerlin Gallery, Dublin (2003); and Tanya Bonakdar
Gallery, New York (2002)

Group exhibitions include: *Extreme Abstraction*,
Albright Knox Museum, Buffalo (2005);
Mood River, Wexner Center For The Arts,
Ohio (2002); and *Something Else: Irish Contemporary
Art*, Turku Art Museum, Finland (2002)

'Siobhán Hapaska's sculptures are informed as much by the ubiquity of our information
age as by the landscapes of subjective memory. They seem to float in a sea of elusiveness,
where bodies are both high speed and stationery. Shying from the cynicism of an
anti-aesthetic, Hapaska has opted for a beguiling irony of objects. Described as "weird"
and likened to a road movie full of U-turns and fragmented narratives, her works are
as disturbing as they are engaging, critical as they are physical, located within a concrete
dimension while jettisoning our imaginations into a dream space of their own.'[1]

 All the ingredients and clichés of paradise are present in Hapaska's installation
Playa de los Intranquilos (2004) or, as it translates, 'beach of the restless'. The glow of sunshine
on a white sandy beach, palm trees and the sound of waves gently breaking on the shore
construct an Eden that is not as it seems. The walls are painted a slightly too lurid shade
of orange, more akin to a warning beacon than a tranquil sunset. The seemingly luxuriant
green fronds of the palm trees are plastic and their trunks are constructed of other dead
palms pieced together and planted in concrete. Her simulation of a tropical island is
foreboding and garish, a synthetic anti-paradise. In the centre of this fabricated mirage
a sleek, black, half-formed fibreglass monstrosity looms with a sheepskin mantle draped
on its back. With stunted arms and an LCD screen for a face, it stands sentinel over
a toughened glass cube filled with sand and coconuts. The coconuts gaze warily at the
screen which depicts their kin being violently smashed open with a stainless steel bar
on an endless production line of destruction. This comic brutality relies somewhat on
our empathy for the plight of the coconuts. But if we perceive the coconuts as standing
in for humanity then we can read this ensemble as a model of terror. 'It is as if this
simulacral place can no longer hide the unrest and aggression that characterises the
psychological disposition of individuals and nations today. Holidays at sunny resorts
offer the illusion of escape from this social malaise; but the more desperately we seek
peace of mind and of community, the more imprisoned we are by a logic of tension,
fear and violent release. The "beach of the restlessness" we might say, is nothing other
than the human condition, our existential destination.'[2]

Emma Mahony

1 Suzanne Cotter, *Siobhán Hapaska*, exhibition catalogue, saison art programme, Tokyo, 1999.
2 Joel Robinson, *Art Papers*, Sept/Oct, 2004.

Siobhán Hapaska
Sunlight, 2004
Fibreglass, 2 pack acrylic paint,
spent cartridges, wheat, hay;
edition of 3
103 × 84 × 88 cm; plinth:
38 × 103 × 103 cm
Photo: courtesy Kerlin Gallery,
Dublin

50
Siobhán Hapaska
Playa de los Intranquilos, 2004
Fibreglass, sheepskin, sand,
coconuts, artificial palm trees,
stainless steel fittings, concrete,
glass, LCD screen, speakers,
fluorescent paint

126

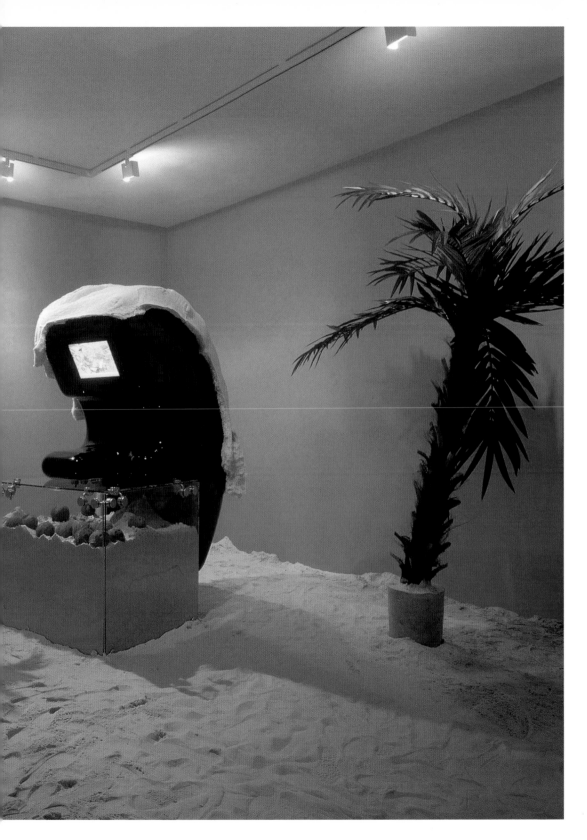

Born in Keighley, Yorkshire, in 1966
Lives and works in Todmorden, West Yorkshire
Graduated with a BA in 3-Dimensional Design
(Specialising in Silversmithing and Metalwork)
from Loughborough College of Art & Design
in 1989

Solo exhibitions include: *Clearwater*, Unit 2 Gallery,
London Metropolitan University (2005); *Victory Park*,
Leeds City Art Gallery (2005); *Archipelago*, Art Buero,
Berlin, and Buero Fur Kunst, Dresden (2004–05);
and *Continental Drift*, The Lowry, Salford (2004)

Group exhibitions include: *Rouge*, A Street Gallery,
Santa Rosa, California (2005); *From A Distance*, Bluecoat
Gallery, Liverpool (2002–03); and *East International*,
Norwich Gallery (2002)

Matthew Houlding's sculptures are a reaction to the mass of spectacular images,
designer culture and material excess that surround us. His works allude to architectural
models and places. Dream homes and fantastic buildings are created from scrap materials;
miniature worlds created from the detritus of everyday life, its origins – cardboard and
plastic packaging, Burger King boxes, chipboard, plywood, Perspex, vinyl, foam, plastic
flowers and formica – disguised by layers of paint or cladding. Having spent his childhood
in Africa, where 'people would just fashion things out of whatever they found,' he finds it
extraordinary that in our consumer society such a high degree of design should be invested
in packaging that is made to be discarded. 'I grew up in Tanzania and Kenya, where what
you didn't have you invented. There was that sort of reusage of everything and nothing
was thrown away.' After his return to the UK he took his degree in 3-D Design and
then worked in a variety of jobs, from steel fabrication to interior building, which gave
him additional practical skills that would later have relevance for his work. Besides his
intricately constructed architectural sculptures he has also devised ephemeral 'design
interventions' in city centres, parks and buildings, and in 2003 created a walk-in sculpture,
Sapphire EX 15 (The Long Journey Home), an escape module containing a model fantasy
environment designed for quietness and solitude, which was commissioned by EastWork
in Norwich.

 Houlding's island development, *It was hard to believe that just 24 hours earlier I had
been sitting at my desk wrestling with the next round of deadlines* (2004), makes reference to
an exclusive tropical holiday resort and the lure of the blue lagoon, while *Happy Ever
After* (2004) presents a very different fairy-tale domain. These sculptures combine ideas,
objects and materials in ways impossible in the real world, creating zones of suspension
between industry, leisure and everyday life.

Helen Luckett

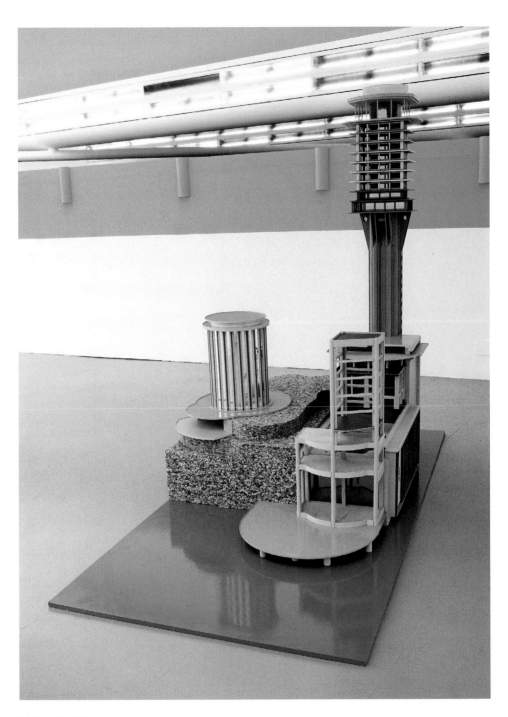

Matthew Houlding
Fall and Rise, 2004
Mixed media (including various
cardboard and plastic packaging,
paint, wood, heather branches,
plywood, formica, paper, model
cars, plastic flowers, foam, Perspex)
240 × 122 × 160 cm
Photo: courtesy the artist

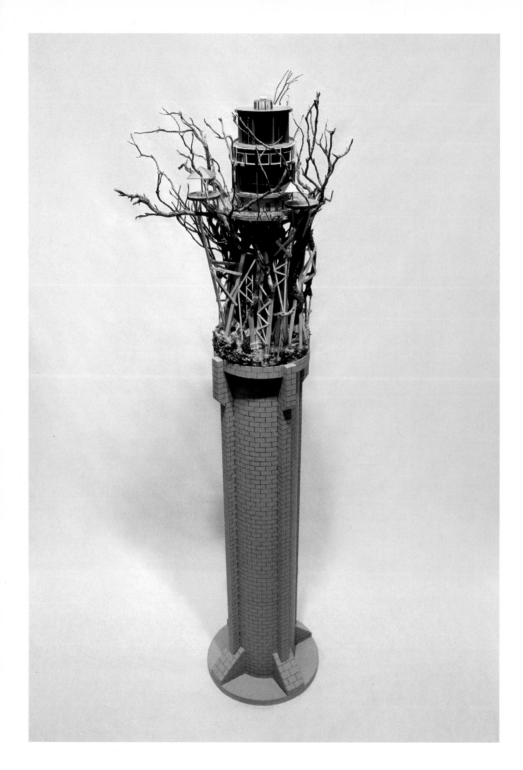

54
Matthew Houlding
Happy Ever After, 2004
Timber, heather branches,
cardboard, foam, plastic, paint

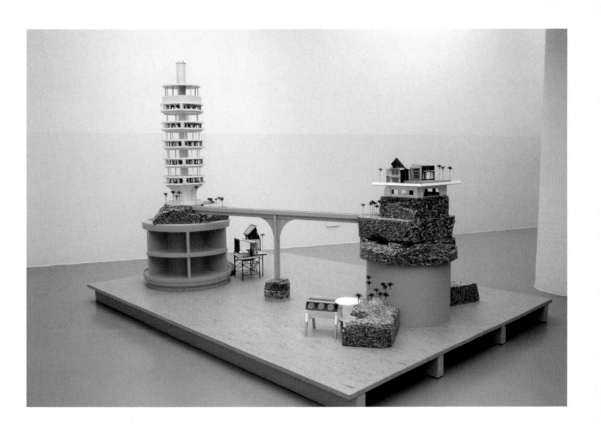

55
Matthew Houlding
*It was hard to believe that just
24 hours earlier I had been sitting
at my desk wrestling with the
next round of deadlines*, 2004
Timber, vinyl, cardboard,
foam, plastic, fibreglass tub,
model trees, paint

SASKIA OLDE WOLBERS

Born in Breda, The Netherlands, in 1971
Lives and works in London
Graduated with a BA in Fine Art from Rietveld
Academy, Amsterdam, in 1990, and with a MA
in Fine Art from Chelsea College of Art & Design,
London, in 1996

Solo exhibitions include: *Trailer*, South London Gallery
(2005); Maureen Paley, London (2004); and *Now
that part of me has become fiction*, Kunsthalle St Gallen,
Switzerland (2004)

Group exhibitions include: *Into My World / Recent
British Sculpture*, Aldrich Museum of Contemporary
Art, Connecticut (2004); *Becks Futures*, Institute
of Contemporary Art, London (2004); and *Casino*,
SMAK, Gent, Belgium (2001)

In the films of Saskia Olde Wolbers the viewer is returned to low-tech routes into illusion as her footage disconcertingly unravels its secrets. This contrasts with contemporary game consoles and science fiction movies that deliver fantasy in hyper-real space, often with the aid of computer-generated imaging. The environments she creates are based on meticulously constructed sets of recycled and unlikely everyday objects that contain forms that shift and mutate in unsettling ways. As the contents transform into beguiling landscapes, some submerged and disintegrating before our eyes, we glimpse behind the fragile façade of the make-believe.

These shifting visual details echo the pace, intensity and locations of the tales told in Olde Wolbers' voiceovers that recount human frailties, failed endeavors and unrealistic aspirations that she gathers and re-imagines from the popular press, historical research and daytime television. Each tale exposes us to the progression our minds can make from accepted norms to a point where dreams can become more real than ordinary existence. Significantly these enchanted worlds are empty of people, leaving scope for the viewer to become implicit in the realisation of the tale. References to absence, vanishing and a dissolution of identity also recur throughout the narratives.

Placebo (2002) recounts the story of a young, comatose woman as she lies hospitalised by a car accident her lover has orchestrated to prevent her uncovering the truth about his identity. The white, mutating world of hospital wards and corridors guides us into increasingly abstracted spaces as her sense of reality dissolves and forms increasingly resemble genetic and organic shapes. *Interloper* (2003) provides an insight into the mind of the same woman's deceiving partner who, dissociated from his former self notes, 'I fear part of me has become fiction'. His story originates from newspaper coverage of the case of the Frenchman, Jean-Claude Romand, who masqueraded as a physician for the World Health Organisation and eventually murdered his family to prevent discovery.

A concern with parentage and the urge to connect more intimately with those only known through their screen presence recurs in Olde Wolbers' films. This is evident most recently in *Trailer* (2005), which expands on the anecdote of Clarke Gable's illegitimate daughter, who only knew her father through his films. A lone man in a small town cinema similarly comes face to face with his past, 'Watching the films, however, I realised a memory had slowly started to form ... And with it came an emotion forgotten since childhood. A woman in the shape of Elmore carrying me around on her hip in a moist green environment ... collecting Hummingbird eggs the size of tic-tac sweets. Was I building fiction in the void of reality or was this an actual memory?'

Clare van Loenen

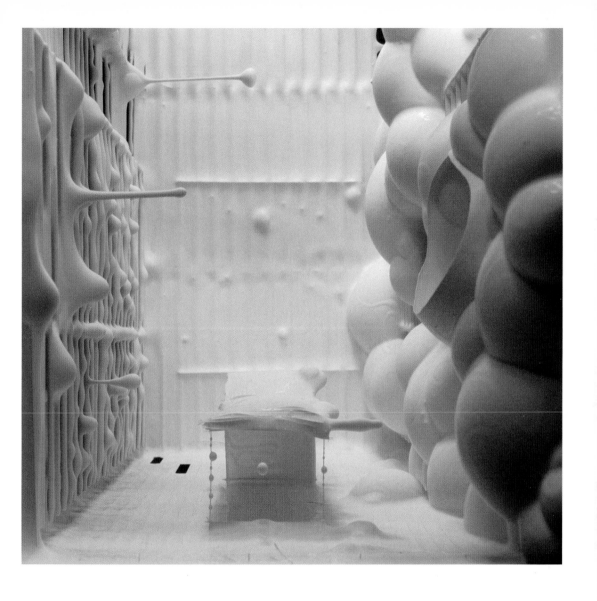

95
Saskia Olde Wolbers
Placebo, 2002 (still)
DVD

133

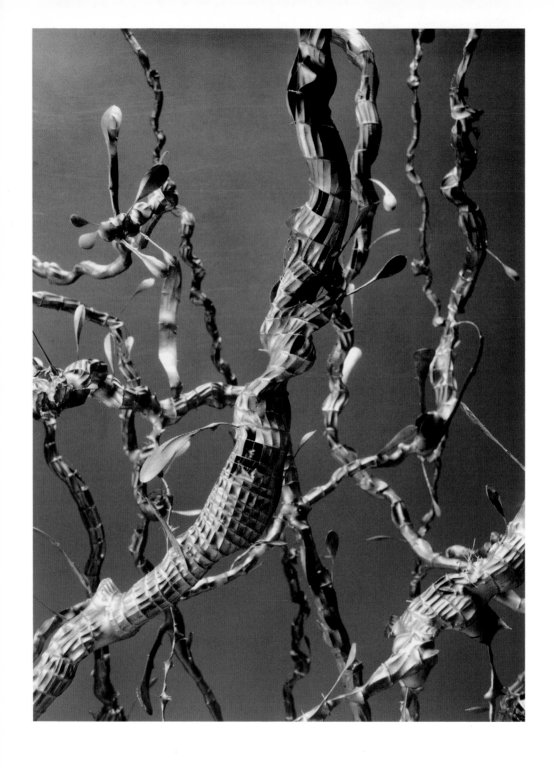

96
Saskia Olde Wolbers
Interloper, 2003 (still)
DVD

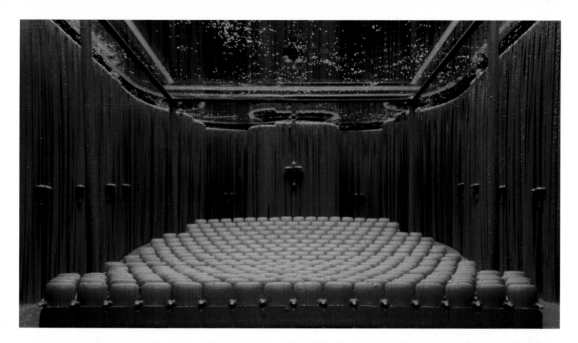

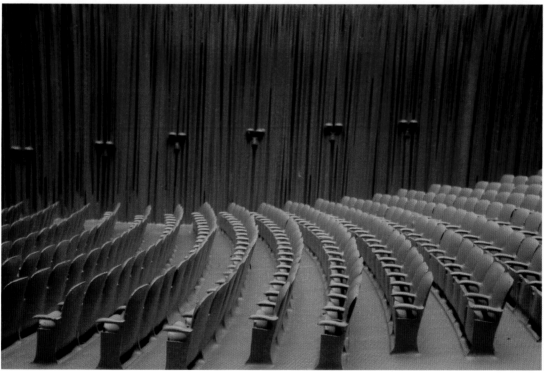

97
Saskia Olde Wolbers
Trailer, 2005 (stills)
DVD

GORDON CHEUNG

Born in London in 1975
Lives and works in London
Graduated with BA in Fine Art (Painting) from
Central Saint Martins College of Art and Design,
London, in 1998, and with a MA in Fine Art
(Painting) from the Royal College of Art, London,
in 2001

Solo exhibitions include: *Gordon Cheung*, Chinese Arts
Centre, Manchester (forthcoming 2007); *Gordon Cheung*,
Thomas Cohn Gallery, São Paulo, Brazil (forthcoming
2006); and *Hollow Sunsets*, Houldsworth Gallery,
London (2004)

Group exhibitions include: *Arrivals/Departures*,
URBIS Museum, Manchester (forthcoming 2007);
New London Kicks, Wooster Projects, New York
(forthcoming 2005); and *Art News*, Raid Projects,
Los Angeles (forthcoming 2005)

Gordon Cheung describes his other-worldly landscapes as reflections of the 'techno sublime'. They are created from complex combinations of computer-manipulated imagery, acrylic gel, spray paint and Chinese ink drawing, printed onto and applied over a meticulous collage of faded pink newsprint. Endless lists of stockmarket figures from *The Financial Times* form the background of his paintings. Against this blank verse of international high finance and global commodities, unsettling visions of cyberspace appear; alien worlds into which viewers find themselves lured like computer game characters. From a distance, the futuristic landscapes present vast, inhospitable expanses. Close to, the images become pixilated and fractured. The futures predicted by the cascades of digits and Space-Invader-type symbols are already ancient history.

Apart from the patchwork of *Financial Times* cuttings, which Cheung uses 'for the density of information and because in a sense it is a dream-world where investors chase after promises of fortune that affect all our lives', there are other traces of the known world. Beyond a border of carnivorous plants, *Underworld* (2004) features Le Corbusier's post-war housing block *Unité d'Habitation*, a vertical garden city containing all the elements of a small town in one building. Transplanted into this infernal region it staggers, warped and corrugated, on buckled legs, a collapsing utopian vision. The impetus for *Brueghel's Highway* (2004) was Pieter Brueghel the Elder's painting *The Fall of Icarus* (c.1555–58), which is both a parable for those who aim too high and an observation of the fact that momentous events often pass unnoticed, eclipsed by everyday activities. Cheung's extemporisation on this theme carries references to the information superhighway and alludes to the effects of 9/11.

Helen Luckett

25
Gordon Cheung
Skyscraper, 2004
Financial Times, acrylic gel,
ink and spray paint on canvas

24
Gordon Cheung
Brueghel's Highway, 2004
Financial Times, ink,
gloss paint, acrylic spray
paint and gel on canvas

Born in New York, USA, in 1969
Lives and works in London
Graduated with a BA in Music from Amherst College,
Amherst, Massachussets, in 1991, and with a MA
from Goldsmiths College, London, in 2003. Completed
an additional year as an Associate Research student
in 2004

Solo exhibitions include: *30,000 Bananas*, Trafalgar
Square, London (2004); and *dumbo Art Under the Bridge
Festival*, New York (2002)

Group exhibitions include: *a two-person show*, Program,
London (2005); *EAST International*, Norwich School
of Art and Design (2005); *Bloc*, County Hall Gallery,
London, curated by bowieart (2005); and *Beck's Futures*,
Institute of Contemporary Arts, London (2004)

Doug Fishbone's films utilise the language and methods of dissemination employed by
mass media in order to critique them. Appropriating imagery downloaded straight from
the internet, he sets it to a witty and sometimes outrageous narrator's commentary that
wallows in the grey area between copyright violation, obscenity and political incorrectness.
The films are structured around a slide show format and recall such well-known institutions
as the school lecture, the corporate presentation and the family vacation slide show.
The narrative serves to recontextualise the stolen images to point out some of the failings
of contemporary Capitalism. According to the artist, 'I am investigating the language
of mass media to highlight some of the more problematic aspects of our culture – greed,
violence, pornography and indifference – by using its own delivery of imagery as the basis
for the work. The images in the video turn the vulgarity of our society's freely available
visual language back on itself.'

Despite the seriousness of his work's intent, humour – which at times verges on
self-parody – is central to Fishbone's practice. 'Whether co-opting the strategies of stand-
up comedy, making posters out of Yiddish proverbs, or constructing ridiculous corporate-
style watches, I invite the viewer to consider some of the more unseemly aspects of modern
living in an amusing and disarming way.'

In addition to making films, Fishbone has produced sculptures and site-specific
installations that examine mass-consumerism by employing foodstuff as his material.
He has installed gigantic mounds of bananas (as many as 40,000 in some instances)
in public squares across the globe, inviting viewers to unmake his sculptures by taking
a banana away with them until the pile has disappeared. Initially exhibited in Ecuador
and Costa Rica (the world's leading exporters of the fruit), the work has also been shown
in New York, Poland and most recently in Trafalgar Square in London.

Emma Mahony

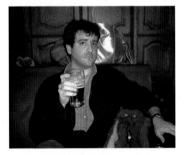

Right and overleaf
49
Doug Fishbone
*Towards a Common
Understanding*, 2005
(stills)
Digitally-produced video

The Doug Fishbone Watch

Designed for the art of living.

Priced from only 40 pounds sterling.

The Haggis

DOUG FISHBONE
Conceptual Art

LOVE AND WAR: GEOPOLITICS AND THE CAMERA

❉

INTRODUCTION
Alex Farquharson and Andrea Schlieker

Art over the last few years has undergone a process of re-politicisation, particularly evident in recent film and video, especially by artists who come from outside the traditional Western centres of the art world. Nowhere has this been more evident than in recent large-scale international exhibitions, *Documenta XI* (2002) being a case in point. The fact that Britain is more than ever home to a diverse international community, often attracting artists from countries with troubled political histories, has contributed significantly to these developments.

Politics in art is now global in scope: the war in Iraq and the invasion of Afghanistan, the trauma of 9/11, the troubled Balkans and the redrawing of the map of Eastern Europe, as well as the ongoing Israeli-Palestinian conflict and continuing violence in a number of African countries, all provide reference points and contexts with which, and within which, artists featured in *British Art Show 6* work. Issues of exile and return, of fragmented identities and cross-cultural negotiations, of memory and time, loss and hope, underlie much of the work, especially that informed by autobiography (Breda Beban, Ergin Çavuşoğlu, Rosalind Nashashibi, Zineb Sedira, Alia Syed). Stylistically, the languages of filmmaking the artists draw on are highly varied: they range from multi-layered interview formats to elaborate and elegiac fictions; from immersive installations to documentations of playful performances.

Some of the artists choose to work in flashpoints of conflict – Ramallah, Bogota, Belgrade, Kabul, Jerusalem or Baghdad – though focus is often diverted from the manifest troubles in these places and is directed instead towards the everyday, the mundane and the intimate. Sharing a family meal, having a hair-cut or taking part in a dance marathon are scenes that foreground basic human activities and emphasise the resilience of daily life away from TV news coverage. Music plays a major role for a number of artists (Breda Beban, Phil Collins, Rosalind Nashashibi), as global signifier, trigger for personal memory or cultural anchor. Familiar from political commentary, voice-overs (often in the artist's own voice and language, be that Urdu, French or Arabic) are given a narrative twist (Marine Hugonnier, Alia Syed), or they provide means for lacerating irony (Doug Fishbone).

In spite of apparent adherence to documentary traditions, much work is deliberately located on the cusp between fact and fiction, casting doubt on the truth claims of these ostensibly objective genres. Often our attention is drawn to the filmic languages through which events are narrated and mediated. Elsewhere, the objective and factual is interlaced with personal, lyrical, and sometimes intensely emotional moments.

Although film and video seem the preferred medium for this focus on geopolitics, sculpture, drawing and collage are also used to address these issues. In Lucy Skaer's deceptively decorative watercolours, innocuous still-life elements camouflage brutal images of war-zone atrocities culled from photo-journalism. Hew Locke's Arcimboldo-esque portraits of the Queen make exuberant yet tongue-in-cheek reference to colonialism and the iconic presence of the monarchy in his native British Guyana. In Gordon Cheung's paintings, modern buildings quake in desert landscapes painted on pages of *The Financial Times*. Nathan Coley, in his models of new Israeli settlements in the West Bank and 1930s *émigré* Modernism, reveals how architecture can be hijacked for political ends (the subject also of Marine Hugonnier's *Territory* film trilogy).

What is remarkable in so many of these works, whatever their medium, is the emphasis they place on the relationship between landscape and history, which tends to reflect, more generally, the interplay between aesthetics and politics. Most remain resolutely non-judgemental. This places the viewer in the position of having to actively formulate their own ethical response.

LOVE AND WAR: GEOPOLITICS AND THE CAMERA

ALEX FARQUHARSON AND ANDREA SCHLIEKER IN DISCUSSION WITH BREDA BEBAN, PHIL COLLINS, MARINE HUGONNIER AND ZINEB SEDIRA

Andrea Schlieker
Could we begin by asking you to say something about the operation of narrative in your works – specifically, the role of biography and autobiography in relation to memory and history?

> Zineb Sedira
> Many of my works look at autobiography, some more specifically use my parents' history of displacement and immigration. My parents became the starting point to explore some of these issues. By asking them about their familiarity with migration between Algeria and France and their colonial experience under French occupation, I was able to understand better my own French and Algerian identity. Because I have lived in London for 18 years, some of my work now engages with my British identity and looks at my own 'migration' from Paris to London. Since I have become a mother, I am interested in oral histories, and the question of how to pass on history, stories, tradition and language to my own children.

>> Breda Beban
>> My work is deeply personal and it deals with the formal and painful acknowledgment that whenever one wants to tell a story about oneself there are always other grander narratives looming over it.
>> As for storytelling in general, I'm interested in moments when consistent narrative conventions collapse into a world inhabited by chance and coincidence.

> Marine Hugonnier
> Writing or storytelling is central to my work. I sometimes use my own voice for the narration of my films. I write texts that are not aside from the films but are part of the works.

Phil Collins
In my recent work I would say that although I'm engaged with social and historical conditions, I'm not focused on biography or autobiography but am reflecting on modes of perception: the ways that we might see or think of another and the politics and problematics of these ways of looking.

Alex Farquharson
Breda and Zineb, you tend to have close family ties with the people and places you film, whereas this is not usually the case for Marine and Phil. How do each of you negotiate the different degrees of proximity and distance that lie between yourselves and your subjects? How do you get around the problem of objectification?

Zineb Sedira

As I mentioned earlier, some of my work has been inspired by my parents and my daughter: how they relate and communicate with each other in everyday situations. When making work, I tell my family what I have in mind and how the work might be produced. If they agree to take part, then I make the work as casually as possible. I use my own video camera and usually film in my parents' kitchen, a space that is neutral and intimate in some ways. I never film twice and whatever the footage, I keep it and work with it.

Objectification? I find this out of place because when I use my parents I see it as working with them. Often the work is a testimony to a situation or experience. I will share the result with other members of the family before it is exhibited in galleries or museums. Once the work is exhibited, I believe it does not belong to me anymore. I have to distance myself from the subjects and objects of the work. As I exhibit the work in different countries and social contexts, it is read differently, depending on the audience. The notion of objectification might enter, depending on the reading.

Breda Beban

I tend to film people and places I love. During the process of pre-production I often pre-design the film with rather strict formal rules. During production, however, these rules become something like a playground, a children's game and I'm in there waiting for happy accidents to occur. In retrospect I usually realise that during the process of filming, the notion of the self – myself – becomes completely dissolved in others. It reminds me of when I was little and lived in Skopje in Macedonia. Every night before I went to sleep I would imagine meeting someone in front of the house on the street and that person would always be the person I would love most at that given moment. I would then draw a circle with chalk around them, step inside and we would merge into one. Very often for me when I am in the process of production it is like entering that circle of chalk. The distancing, the objectification begins later, during post-production.

Alex Farquharson

Phil, in your case the work often becomes a means to create lasting relationships with people who begin as strangers – including your life partner.

Phil Collins

Yes, I always felt that art would help me to fall in love and make friends. I still believe the camera is quite simply a way of meeting people. But I am also interested in questions surrounding the objectification and, more pertinently, the exploitation of others. Once the work is placed in a public setting there is an incontestable element of exploitation. This is, in many ways, the heart of the matter. How do we go about betraying each other? How do our promises and relationships become objects of scrutiny and display? I think these complications run throughout journalism, film, documentary and television. With the portraits I have been taking more recently, I'm trying to articulate the desire of the viewer to occupy the space of the other.

Andrea Schlieker
But you often break down that barrier between proximity and distance by turning your subjects into active collaborators. What interests us especially about your and Marine's work is the fact that you always travel to and work in places that have undergone tremendous conflict and violence.

Phil Collins
Yes, but these are post-conflict situations. It actually takes very little to visit somewhere but incredible courage on the part of people who live through these conditions on a daily basis. And all of these places – Iraq, Palestine, Northern Ireland – have had immense, ongoing British involvement, occupation and commercial exploitation throughout the last century and beyond. Part of my work is about this aspect of neo-colonialism.

Marine Hugonnier
Well, I very much share your position. One of the reasons why I choose to go to these places is to investigate this kind of neo-colonial situation and how our perception of these cultures through that history unfolds today. I studied anthropology so I probably have a more structural and less emotional approach to these subjects and these places.

As a child I grew up in different countries so my perception of the other is the central question for me. From this awareness as a viewer who later became a filmmaker, I had to find solutions. My solutions, little as they are, are to make choices between different lenses and to choose points of view.

For Serge Daney cinema is 'to tirelessly touch with my gaze the distance from me at which the other begins.' This is what could be called a 'politics of vision' and this defines my work as an anthropology of images.

The question of the ethical and political implication of a particular kind of shot doesn't seem to me to be out of date. It remains, however, a complex and difficult issue as all images force a position on the viewer. *Territory I, II, III* specifically questions the act of looking. It places architecture and design as vehicles for ideologies. More precisely it looks at how architecture and its original ideological implication can be shifted, used and transformed to meet completely different political ends. The film reveals how utopian ideas of Modernism become a politicised promotional tool (the so-called Bauhaus style of Tel Aviv). From villages, which appear like oases of green in the desert (settlements in the West Bank), all the way to a traditional Arabic house whose architecture is mimicked by Israeli settlers in search of a sense of locality and authenticity.

What has impressed me during this shoot was not only the complexity of the layout of that conflict, the way architecture could become a military optical device, how the landscape could be therefore a complete construction, but more so the logic of appropriation that is the hallmark of colonialism.

Andrea Schlieker
Could each of you describe your works' relationship with reportage, newsreel and other documentary forms? The interview is a technique you use, for example, Zineb.

Zineb Sedira
My video/documentaries are also like family videos. There are no settings, backdrops, props. The work is frequently filmed in real time or using little editing. It is true that it is often devised using formal interview techniques, but the final product regularly ends up as a multi-screen installation or large video projection. So, although I use conventional documentary techniques to gather information and visuals, for me it is important to transgress these conventions by placing the viewer within the piece itself – literally letting him or her walk inside the projections and, via various audio devices, experience the sound and language. Currently, my work is becoming more filmic, using landscape as a means to explore issues of immigration, displacement and transportation.

Alex Farquharson
In *Mother Tongue* you leave what is said in the original languages, so that the literal meaning is inaccessible to most viewers.

Zineb Sedira
It is not so important to understand what is said in *Mother Tongue*, but to realise there are three languages spoken – Arabic, French and English – within one family of three generations of women – mother, daughter and granddaughter. Each woman speaks their respective mother tongue to each other. Another important element in the video is the collapse of verbal communication between a grandmother and granddaughter. I suppose I am asking people to observe the other levels of unspoken communication that are taking place, i.e., the look, the gaze. In *Mother, Father and I*, I have added subtitles because the content is very important. In this instance, the viewer must understand the stories being told if they are to understand the piece of work.

Marine Hugonnier
News coverage informs and influences my work. When I read *Le Monde* it triggers the desire to take a look at these places. *Death of an Icon* is very much the first film that is really news coverage. I was in Ramallah three days before the official announcement of Arafat's death. It was a political decision to delay the announcement. It was completely coincidental that I was there at that vital historical moment.

Alex Farquharson
You and Phil have both made works that feature film crews within them. In *Arianna* it's a fictional story of a film crew in Afghanistan; in Phil's *How to Make a Refugee* it's an actual film crew getting pictures of a wounded boy and his family, with shocking insensitivity, during the war in the Balkans.

Phil Collins

For me documentary is the kind of invisible parent behind a lot of the work that I do.
I find news programmes and documentaries incredibly seductive with their ability
to provide specific political fictions that inform our everyday decision-making about
far-away places. I'm also bothered by the documentary as, ultimately, a form of shame.

Andrea Schlieker

That moral ambivalence is an important part of your work. We're all familiar with the
conflict between attraction and repulsion when watching gruesome news coverage.

Phil Collins

I think there is a powerful, disavowed erotic element to the way we look at disaster
and conflict which underlies the particular grammar of popular reporting. There
seems to be a devastating need to be close to the action, to uncover the wound,
to film in extreme close-up, which paradoxically exposes the uncomfortable sides
of what is, for all intents and purposes, essentially a form of entertainment.

Zineb Sedira

Yes, TV news reporting is a compelling kind of voyeurism. Since I got satellite
television, I have been observing how news is reported across the world,
specifically on Arab channels. On many Arab channels they appear to show
you the footage uncensored: for example, the dead bodies as they have been
mutilated or beheadings as they are happening. Little discretion is applied
for the audience. An event that is already horrific becomes hard to watch,
so the news here appears much more gentle.

Marine Hugonnier

It seems to me that most of the time reportage and newsreels
are made to be informative and only that. People go far away,
put a camera on a tripod, and rarely question their point of view
and rarely think about the kind of imagery produced by their choices.
That is where the danger stands for me. While presented as 'objective',
the images are mostly ethnocentric and carry specific ideologies.
I feel negated as a viewer.

Breda Beban

I am interested in revealing stories that the official history was
or is unable to tell, but I resist going to post-conflict countries,
unless it is my own country of origin, because of the dangers
of art tourism. Also, I was once one of the people in a newsreel
and I am very cautious when it comes to representations of
other peoples' suffering. As for the documentary genre, I'm
interested in the personal documentary form where one can
tell one's own story, rather than becoming a character in
someone else's.

Alex Farquharson

The locations in your films tend to be associated with trauma, violence, turmoil and division,
and yet all of you avoid the explicit portrayal of conflict. You tend instead to focus on
the intimate or apparently humdrum aspects of everyday lives. What motivates this?

Breda Beban
Someone recently said that there is a need to tell new stories.
The old stories are about cruelty or about goodness, and give
badness all the best lines. We need new stories about kindness.
I see my work as an attempt at some kind of white magic.
I often take risks by positioning myself close to things that
are violent and potentially traumatising, but my desire is to
heal – whether I want to heal myself, people who are close
to me, or people that I meet through my work, I want to find
ways of turning these situations around. Most of all I want
my work to be tender.

Andrea Schlieker
Interesting that you speak about tenderness, kindness and healing as a response to
political upheaval. Similarly, Phil talked earlier about love in ways one wouldn't expect
in a discussion about geopolitics.

Breda Beban
Instead of talking about conflict and war it is probably more
useful to contemplate and articulate how one would behave
in a situation of war. The experience of war can charge
everyday life with an unexpected sense of urgency and a
realisation that, most of all, tenderness needs to be rescued.

Phil Collins
Regarding this emphasis on the everyday, I'm not sure my work asks or speaks about
this, in fact it frustrates that desire. When I use Western pop in my videos, it doesn't
just act as a symbol of a globalised product, it also begins to unpick our potentially
clichéd views of invisible places. Here our only understanding of Serbia or Iraq
in the 1990s was through the regime and military activity; we had a very limited
understanding of civilian dissent or alternatives within these countries at that time.

Andrea Schlieker
In *they shoot horses* and *el mundo no escuchará* we don't see the performers' environment
in Ramallah and Bogotá. Instead you place them in a fake studio setting with bright pink
walls and dance music, or tropical photographic wallpaper and The Smiths. You remove
them from their daily life and generate the action – a danceathon or karaoke – almost
like a circus master.

Phil Collins
The title *they shoot horses* is from a Horace McCoy novel written in 1935 and set
in Depression-era America, later made into a Hollywood movie. It features a dance
marathon as a spectacularised theatre of misery. The backdrop to *they shoot horses*
of course resembles those of cheap reality shows, which we have a surfeit of on
British TV. I was interested in applying these forms to places where we might
imagine they don't formally exist, and also seeing how they might create platforms
that might articulate not difference, but in fact a 'threat of resemblance'.
 In karaoke, the aim isn't just to deliver a tune but more importantly to
occupy the space of the singer: to re-stage or, better still, like a body-snatcher,
take over your idol. Your technical failures – not hitting notes, missing entire words

and phrases – lend a breath-taking tenderness and vulnerability to the performance, since it's impossible to sustain the illusory promise of completion that karaoke perpetually offers.

Andrea Schlieker
Music also plays an important role in Breda's work.

> Breda Beban
> I think whenever Phil and I want to move people without upsetting them, we use music.

Phil Collins
The reaction that I am sometimes looking for from the viewer is one of over-identification with the subjects of the film. How might primary desires override our basic understanding? What are the ethics of a British gallery-goer wishing that they were in a disco-dance marathon in Palestine or a karaoke in Colombia? And what are the problematics around this kind of seduction?

Alex Farquharson
How do these processes shape identity?

> Breda Beban
> I often feel there are so many things I wouldn't have found out about myself had I stayed where I come from. When we leave our own culture for another all familiar points of reference tend to disappear. What one is left with is an awareness of the fact that one cannot make assumptions anymore – there is nothing one can take for granted. During this process, which is not very easy to go through, one can either collapse dramatically under the weight of external influences or else one can make them work in a constructive way. I believe that the experience of exile can potentially become a balancing agent between the external and the internal influences and allow for us to come close to our desires.

Phil Collins
When we talk about the self being constituted through language, I often wonder if the camera itself acts in a similar way. It's such a basic mechanism for shaping us. In fact, there are aspects of ourselves which only come alive or indeed die in the presence of a camera.

> Marine Hugonnier
> I guess we are all thinking about the viewer and trying to claim back a decent position.

LUCY SKAER

Born in Cambridge in 1975
Lives and works in Glasgow
Graduated with a BA in Fine Art from Glasgow
School of Art in 1997

Solo exhibitions include: *The Sound and The Screen*,
Schnittraum, Cologne (2004); *The Opaque*, doggerfisher,
Edinburgh (2004); and *The Problem in Seven Parts*,
Counter Gallery, London (2004)

Group exhibitions include: *Edge of the Real*, Whitechapel
Art Gallery, London (2004); and *I Could Be Happy*,
Gagosian, London (2004)

In Lucy Skaer's large-scale drawings victims of war and political unrest occupy the same picture plane as wine glasses, heraldic masks and vessels from antiquity. Each of these elements seep into the next, so it's unclear where the blood from a cadaver stops and the ornamental patterning of a vase begins. This inter-layering of motifs disorientates ways of looking and classifying recognisable things. Concepts of disguise and transformation are central to Skaer's practice. Her main source of reference is archived and printed material; images loaded with political and cultural baggage. By tracing these images by hand and recombining them using other pictorial and factual motifs, she distances them from their original source and frame of reference and opens alternative interpretations. According to the artist, 'All the elements are familiar, the logic recognisable, the symbolism readable, but at the centre of the drawing is a value impossible to understand.'

In *Depth / River* (2005) a newspaper photograph of a family crossing a flooded river is the starting point for a vibrantly coloured drawing. The figures removed, the swirling surface of the water that surrounded them is the only recognisable element left of this captured moment. A complex geometric form, whose planes describe impossible perspectives, occupies the space where the family once stood, its dense red and green stripes giving rise to optical dazzle.

The Problem in Seven Parts (2004) is a series of drawings, each designed to be hung on a panel of a paravent, or screen. In *Part 1*, an image of a corpse is traced in four different places around a central motif of an empty wine glass. Each of the representations incorporate various stylistic tweaks that differentiate them from their photojournalistic source and apportion them a different pictorial weight. The other panels that form the screen continue a kind of riddle about the visual description of matter, exploring ideas of seeing and screening, transparency and blankness.

Emma Mahony

115
Lucy Skaer
Depth / River, 2005
Watercolour and pencil
on paper

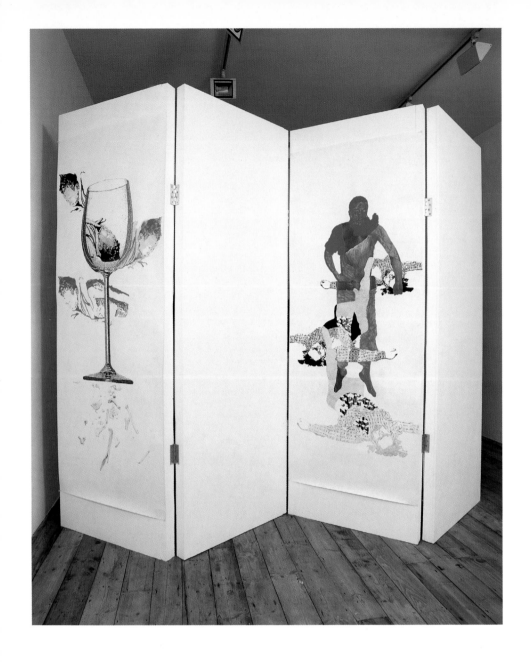

114
Lucy Skaer
The Problem in Seven Parts,
2004 (details)
Watercolour, indian ink
and graphite on paper

114
Lucy Skaer
The Problem in Seven Parts,
2003 (detail)
Watercolour, indian ink
and graphite on paper

ZARINA BHIMJI

Born in Mbarara, Uganda, in 1963
Lives and works in London
Graduated with a BA in Fine Art from Goldsmiths
College, London, in 1986, and with a Higher Diploma
in Fine Art from Slade School of Fine Art, University
College London, in 1989

Solo exhibitions include: inIVA, London (2004);
Matrix, Wadsworth Athenium Museum of Art,
Hartford, Connecticut (2003); and *Art Now*,
Tate Britain, London (2003)

Group exhibitions include: *Experiments with Truth*,
The Fabric Workshop and Museum, Philadelphia
(2005); *Stranger than Fiction*, Leeds City Art Gallery
(2004); and *In Our Time*, Works from the Moderna
Museet Collection, Stockholm (2004)

Zarina Bhimji's photography, film and installations provide a haunting narrative on beauty, landscape and time, often rooted in an intimate and personal engagement with place. Her sensory surveys of site convey layers of experience and symbolism that are redolent of untold stories, free from nostalgia and sensationalism. As the art critic Deepali Dewan has observed about Bhimji's practice, 'There remains an ambiguity, which like a mirror, deflects the focus of the work onto the viewer. The enduring effect is one of tenderness and beauty, conveying the complexities of human experience and emotion.'[1]

Bhimji's film *Out of Blue* (2002) collates landscape and interior views, which are encountered at a meditatively slow speed. Light shines through the windows to mould form and a sense of beauty is heightened by a juxtaposing air of oppressive confinement and decay. Bhimji's film footage is gathered as part of an instinctive and unfolding vision that is not rooted in a documentary tradition. Echoes, however, are still evident of the research that is so integral to her practice, into subjects such as J.M.W. Turner's vision of the English landscape, and debates around malaria and the history of guns. Sarat Maharaj vividly describes these atmospheric combinations, 'Somewhere in the soundtrack the mosquito's low whine-hum-drone: malarial sonics—fever, sweat, tropical hygiene, but also other contaminations, other transfusions of feeling and friendship.'[2]

The camera surveys the stillness of each location, with occasional shadows and silhouettes acting as reminders of those who have passed through them. Often interior walls appear insurmountable in scale, and barred openings and mesh fences segment the view. The walls have a skin-like texture that is stained and scarred. The soundtrack further heightens the film's potent communication of the physical sensation of terror, the smell of death and the games of fear, conveying them with both intimacy and aggression. There is no escape from these associations made palpable through the combination of mesmerising visual footage (a bush fire, an empty hall with neatly aligned sleeping blankets, graffiti, light and warm touch) with a correspondingly evocative soundscape (the voice of Sufi vocalist Abida Parveen, exhaled breath, the incessant whine of mosquitoes and the crackle of the radio).

Clare van Loenen

1 Deepali Dewan, 'Tender Metaphor: The Art of Zarina Bhimji', in *Fault Lines*, Gilane Tawadros
 and Sarah Campbell eds, inIVA in collaboration with the Forum for African Arts and the
 Prince Claus Fund Library, London, 2003.
2 Sarat Maharaj, *Documenta II platform 5*; Hatje Cantz, Ostfildern-Ruit, 2002.

22
Zarina Bhimji
Out of Blue, 2002 (stills)
Single screen installation;
Super 16 mm colour film
transferred to DVD

22
Zarina Bhimji
Out of Blue, 2002 (production still)
35 mm film

161

Born in Paris, France, in 1963
Lives and works in London
Graduated with a BA in Critical Fine Art Practice
from Central Saint Martins School of Art, London,
in 1995, with a MA in Fine Art in Media from Slade
School of Art, London, in 1997, and with a Research
degree in Photography from the Royal College of Art,
London, in 2003

Solo exhibitions include: OneTwenty Gallery,
Gent, Belgium (2005); Fri-Art, Fribourg, Swizerland
(2005); and *Zineb Sedira: Telling stories with differences*,
Cornerhouse, Manchester, and tour to the City Leicester
Gallery (2004)

Group exhibitions include: *Identità & Nomadismo*,
Centro Arte Contemporanea, Siena, Italy (2005);
Light Silver, Beaconsfield Gallery, London (2005);
and *Africa Remix*, Hayward Gallery, London, and tour
to Centre Georges Pompidou, Paris, and Mori Art
Museum, Tokyo (2005)

Zineb Sedira uses mixed media to investigate the shifting site of identity and ideas of origin. Her practice is frequently related to the documentary, showing the realities of the mixed histories and intercultural exchanges that characterise today's society. The viewer is not asked to determine any kind of truth, but rather called to witness. Sedira keeps her spectators at a distance, directing their gaze. Her video work *On a Winter's Night a Traveller* (2003) charts an aeroplane's flight, arrival and departure from London to Algeria; the focus is not the terrestrial geography, but rather the in-between space in the clouds, stimulating thoughts of confining borders rather than specific places. *And the road goes on...* (2005) is similar in approach. As Sedira writes, 'The film is slowed down at certain moments – focussing on a passerby or man on a bicycle – and the gaze of the viewer is heightened as people and moments, which ordinarily would not be noticed when in a moving car, become still and woven into the landscape. So again, the viewer is aware of their cultural frame, a tourist to a foreign landscape.'

Questions of place and, by association, language, are omnipresent in Sedira's work. *Mother Tongue* (2002) is a triptych video installation: three screens in a row, three conversations, three generations – grandmother, mother and daughter. Each talk about their childhood in their first language: Sedira herself in French, her mother in Arabic, Sedira's daughter in English. In two of the dialogues (grandmother/mother (left) and mother/daughter (centre)) each understands what the other is saying even though they don't speak the same language. In the third dialogue (right), grandmother and granddaughter struggle to engage with each other, looking at the camera with a combination of discomfort and pleading. Although comprehension is almost impossible they seem to be determined to converse. The artist is behind the camera, mediating even as she is silent. All the dialogues are set against a white wall, a blank canvas, and it quickly becomes apparent that the emphasis is not on what the women and girl are saying, but rather on their silences and bodily interactions. Everyone inherits and exists within language. Even if in this work verbal communication is denied, the viewer sees a clear example of cultural negotiation and the many layers that make the subjects aware of who they are and where they are from.

Rebecca Heald

Zineb Sedira
And the road goes on..., 2005 (still)
Single channel video projection
Running time: approximately
7 minutes
Commissioned by Beaconsfield
Gallery, London

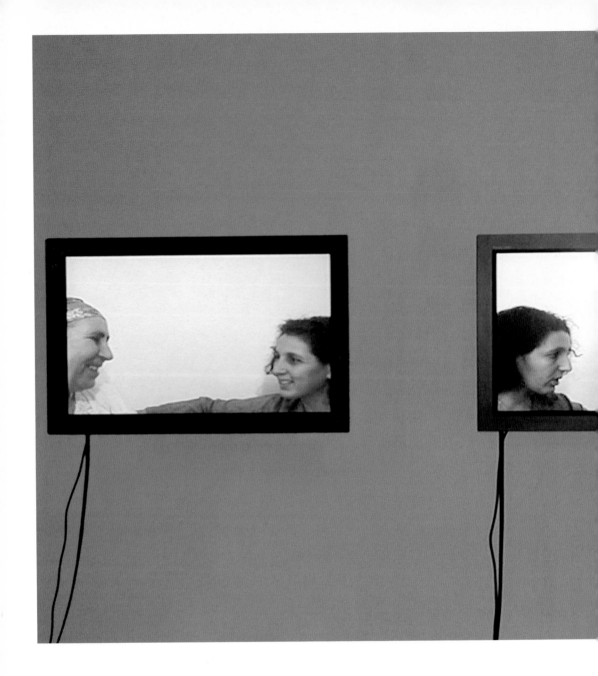

113
Zineb Sedira
Mother Tongue, 2002
3 videos

ERGIN ÇAVUŞOĞLU

Born in Tirgoviste, Bulgaria, in 1968
Lives and works in London
Graduated with a BA from The Faculty of Fine Arts,
University of Marmara, Istanbul, in 1994, and with
a MA in Fine Art from Goldsmiths College, London,
in 1995

Solo exhibitions include: *Poised in the Infinite Ocean
& Tahtakale*, Haunch of Venison, London (2004);
Entanglement, Dundee Contemporary Arts (2004);
and *Resonance*, Galerist, Istanbul (2002)

Group exhibitions include: *On Patrol*, De Appel Centre
for Contemporary Art, Amsterdam (2005); *Beck's Futures*,
Institute of Contemporary Art, London (2004); *3rd Berlin
Biennial for Contemporary Art*, Berlin (2004); and *Poetic
Justice, 8th International Istanbul Biennial*, Istanbul (2003)

Ergin Çavuşoğlu's multi-channel video installations explore the borders between the
public and the private, the visible and the invisible, the legitimate and the contraband.
He is drawn to filming in marginalised and fraught locations, often borders or no-man's
lands, where many of his films are shot under a mantel of darkness in order to create a
sense of dislocation. Recent films such as *Tahtakale* (2004) focus on scenes from the everyday
urban environment. While they employ the language of documentary filmmaking, they
utilise a more visual and poetic style and, in content, they are more abstract than descriptive.

An insight into the artist's upbringing reveals his interest in issues of transmigration
and surveillance. Çavuşoğlu grew up in Bulgaria as a member of the Turkish minority
during the Socialist regime, an experience that, according to the artist, 'enforced a
specific way of moving around that was out of my control'. He talks about how being
under surveillance makes one 'become conscious of your whereabouts, how you move
in that space. When I came to live in Turkey and then London, under totally different
conditions, I had to define a new territory, and define myself within that territory.'

Tahtakale gives us a glimpse of the activities of a group of currency traders on the
black market in an Istanbul bazaar, exploring how personal and cultural identities are
negotiated in this rather unique setting. It is a brusque and macho environment occupied
by gun-toting safe guards. In an installation that recreates the feel of the market, two
suspended screens depict the currency traders in the heat of flurried activity. A third
screen sited in between these two serves to interpret their activities with subtitles.
In a fourth, slightly removed screen, men carry heavy bottles of photographic fluid on
their backs. A recording of a male choir singing a piece of Byzantine music lends a sacred
atmosphere to the proceedings. In this instance, as with many of his films, the artist
substitutes the original soundtrack with one recorded elsewhere. This particular track
was chosen by the artist because it 'lends a notion of timelessness' to a work that reflects
upon economic and social activity that has been taking place for thousands of years.

Emma Mahony

Above and overleaf
23
Ergin Çavuşoğlu
Tahtakale, 2004 (stills)
4 screen video installation

ALIA SYED

Born in Swansea, Wales, in 1964
Lives and works in London
Graduated with a Postgraduate Higher Diploma
in Mixed Media from Slade School of Fine Art,
London, in 1992

Solo exhibitions include: Arts depot, London (2005);
Talwar Gallery, New York (2003); and The Glasgow
Museum of Modern Art (2002)

Group exhibitions include: *(DESI)ire*, Talwar Gallery,
New York (2005); *A Century of Artists' Films in Britain*,
Tate Britain, London (2003); and *Location UK*,
Gimpel Fils, London (2002)

Alia Syed is an artist and experimental filmmaker whose interest is in storytelling, time
and memory. Using 16 mm film, she explores ways in which language and form both define
cultural borders and boundaries and extend beyond them. Her films involve time-lapse,
multiple layers, collage and fractured and dislocated narratives in which one culture
speaks to – or over – another. 'Although all of my films have a beginning and an end,
they are cyclical', she notes. Meaning is constructed organically through the editing process:
'The narratives are all circular, not linear'. A significant part of her work stems from a
concern with oral history. 'Family history often contradicts dominant myths surrounding
class, race and gender; re-contextualising them within unexpected forms creates ruptures
in how we see and place one to the other.'

The 24-minute film *Eating Grass* (2003) revolves around five separate stories,
each relating to one of the five times of day prescribed for Muslim prayer. The narrative
sequence begins just before dawn and ends after sunset, but as everyone knows, 'what
comes around, goes around', and the film can be entered at any point within the cycle.
Filmed in Karachi and Lahore (Pakistan) and in London, the locations shift from quiet
interiors to the busy outside world and the syncopated voiceover switches back and forth
from Urdu to English. Words and images are equally impressionistic, constantly modulated
by rhythm, texture and pace, punctuated by sounds of everyday life and by the changing
light. Dawn shadows dissolve into shimmering sunlight, the daylight wanes and dusk
is overtaken by the bright lights of a city street, where colours fuse and explode in rainy
refractions. The journey and the day both over and done with, all is finally engulfed
by pure white light.

Helen Luckett

Above and overleaf
116
Alia Syed
Eating Grass, 2003 (stills)
16 mm film transferred
to DVD

171

ROSALIND NASHASHIBI

Born in Croydon, Surrey, in 1973
Lives and works in Glasgow
Graduated with a BA in Fine Art from Sheffield Hallam
University in 1995, and with a MA in Fine Art from
Glasgow School of Art in 2000

Solo exhibitions include: *Over in*, Kunsthalle, Basel,
Switzerland (2004); *Hreash House, Art Now, Lightbox*,
Tate Britain, London (2004); *Songs for home and economy*,
CCA Glasgow (2004); and *Humaniora, Visions for the
Future V*, The Fruitmarket Gallery, Edinburgh (2003)

Group exhibitions include: *Pass the time of day*, Gasworks,
London, and tour to UK venues (2004); *Expander*,
Royal Academy of Arts at 6 Burlington Gardens, London
(2004); and *Beck's Futures*, Institute of Contemporary
Arts, London (2003)

The focal point of Rosalind Nashashibi's work is everyday life, which she captures on
film in an incidental and reflective manner. Her films are largely about time and its passage,
how it is spent or just 'frittered' away. They are also about location, often concentrating
on geographical areas of contested space, like the no-man's land in *Dahiet Al Bareed* (2002)
or the politically contentious city of Nazareth – a Palestinian enclave in Israel – in which
Hreash House (2004) is set. But rather than representing the political and social upheaval
typical of these locations, her camera focuses on the mundane low-level dramas of life.
It is precisely these 'non-events' that she observes with a curiosity that maintains a
respectful distance even as it probes. Often her subjects are so involved, or preoccupied
with their own thoughts, that they appear indifferent to her gaze. The films are also
largely absent of language, preferring to incorporate a soundtrack in place of narrative
or commentary; in recent works she has digitally remixed and layered sounds recorded
on location. Where language is present, she resists the urge to translate or subtitle, feeling
that the image says enough. Nashashibi chooses to shoot her work on 16 mm film for
its lustre, colour and texture, but also because she finds the process of the shoot allows
for more unexpected results than video. The reel length also dictates the duration of
her shots. In the editing process, this results in a steady succession of individual frames,
each like an extended snapshot that appears to have no real beginning or end.

In *Hreash House* we follow the daily activities of an extended family living in
Nazareth over the course of a 24-hour period. Their home is a sprawling apartment block
which they have gradually extended upwards to accommodate their growing family. They
maintain a fairly normal and even mundane existence in the midst of political turmoil.
It is not often that an outsider sees this side of daily life, but as Nashashibi's camera shows
us, life goes on regardless. The women prepare food and wash dishes, the men drink cups
of tea and wash down the outdoor furniture while the children play. From time to time her
camera lingers on an impromptu still life of pots and pans or on one of the many intricately
patterned blankets and carpets that bring colour to the interior. It is as if she is transfixed
by the minutiae of domestic life, the symmetry of a cushion, the textures of ornate materials.
Her style owes something of a legacy to Dutch seventeenth-century still life painting,
as it does to recent developments in film and video.

Emma Mahony

Above and overleaf
92
Rosalind Nashashibi
Hreash House, 2004 (stills)
16 mm negative film transferred
to DVCAM

Born in Paris, France, in 1969
Lives and works in London
Graduated with a BA and a MA in Anthropology
and Philosophy from Tolbiac and Nanterre University,
Paris, in 1995

Solo exhibitions include: Center for Curatorial Studies
Museum, Bard College, New York (2005); Kunst-Werke,
Berlin (2004); and Dundee Contemporary Arts (2004)

Group exhibitions include: *Universal Experience: Art,
Life, and the Tourist's Eye*, Museum of Contemporary
Art, Chicago, and Hayward Gallery, London (2005);
Documentary Creations, Kunstmuseum, Lucerne,
Switzerland (2005); and *Territories*, Malmö Kunsthall,
Sweden, and Bezalel Academy of Arts and Design,
Tel Aviv, Israel (2004)

Marine Hugonnier's works are infused with a long-standing interest in anthropology.
Working with film and still photography, her work explores locations where a colonialist
heritage has strongly determined the way we perceive them.

Ariana (2003) charts the journey of a Western film crew to the Pandjsher Valley
in the North East of Afghanistan, to investigate how the unique landscape has determined
its history. Surrounded by the virtually impassable Hindu Kush mountain range, the
isolated geography of the valley – coupled with its lush and fertile topography – has
allowed it to resist the many insurgencies to which the rest of Afghanistan has fallen.
From the outset, the film's crew is intent on filming a panorama of the valley from the
highest vantage point but, when access to this point is denied to them, the crew begins
to contemplate the strategic value of this vista and question its implications. The film
becomes the story of a failed project that prompts a process of reflection about the
'panorama' as a form of strategic overview, bringing to mind its role as both a cinematic
camera move, and its origins as pre-cinematic mass entertainment.

Invited to participate in the exhibition *Territories* at the Bezalel Academy in
Tel Aviv, Hugonnier elected to make a work that responded to a series of events organised
around the opening of the exhibition. *Territory I (White lies)* (2004) is set in Tel Aviv, Isreal's
so called 'White city', and is named after a text by Sharon Rotbard, an architect and writer
living there. The film explores Tel Aviv's self image as a city defined by its Modernist
architecture. In 2003 the city was declared a world heritage site by UNESCO on account
of its so-called Bauhaus architecture, when it is in fact a diluted reinterpretation of the
style, thereby allowing a myth to enter the collective belief system. *Territory II (The Kissing
Point)* (2004) is the result of a collaboration with the Israeli architect Eyal Weizman,
who lives and works in London. The film was made during a bus tour organised around
the West Bank and focuses on the Jewish settlement of Har Homa (which in Hebrew
means the 'mountain of the wall') and the Palestinian town of Sur Baher. The film observes
the complexity of the geography of warfare, reflected through the architecture in both
sites. It reveals how landscape is constructed to embrace political ends, how the logic of
appropriation manifests itself when traditional Arab architecture inspires settler-builders,
and how Palestinian towns in turn mimic Modernist architecture. The third part of the
film, *Territory III (Alkdereh House, Ramallah)* (2004), was filmed during a walking tour through
the Alkdereh district of Ramallah and centres on a house built in 1865, one of the oldest
in town. For many years this was a community centre before it was closed in 2003. The flat
roof, high ceilings, thick walls and horseshoe-arched windows are the main characteristics
of its traditional Arab features.

Emma Mahony

59
Marine Hugonnier
Top: *Territory II (The Kissing Point)*,
2004 (still)
Bottom: *Territory III (Alkdereh
House, Ramallah)*, 2004 (still)
16 mm colour film

We wouldn't be able to shoot a panorama

An image would be missing.

The ones we would make of the valley now,
would remain incomplete.

Wasn't it also the sweet memory of a tourist attraction that wasn't to be missed on holidays when we were children?

Marine Huggonier
Ariana, 2003 (stills)
Super 16 mm film transferred
to DVD
Running time: 18 minutes
Photos: courtesy the artist and
Max Wigram Gallery, London

NATHAN COLEY

Born in Glasgow in 1967
Lives and works in Dundee, Scotland
Graduated with a BA in Fine Art from Glasgow
School of Art in 1989

Solo exhibitions include: Haunch of Venison, London
(2005); *Jerusalem Syndrome*, Cooper Gallery, University
of Dundee (2005); and The Fruitmarket Gallery,
Edinburgh (2004)

Group exhibitions include: *Thinking of the Outside*,
Bristol (2005); *Model Modernism*, Artists Space,
New York (2005); and *Reason and Emotion*, Biennale
of Sydney (2004)

Nathan Coley's public artworks, sculptures, photographs, slide projections, films and
installations explore particular places and buildings and the beliefs and aspirations that
surround them. His projects have focused on demolition sites, pigeon lofts, places of
worship, derelict buildings, contemporary 'Vicwardian'-style detached houses, and other
structures, both real and imagined. In the summer of 2000, he became an unofficial artist-
in-residence at the Lockerbie bombing trial, travelling from Scotland to Holland where
the Scottish court was temporarily instituted at Kamp van Zeist. His interest as an artist
lay not in the outcome of the trial but in 'working with ideas of doubt and uncertainty'.
In 2004 he visited Jerusalem to investigate 'Jerusalem syndrome', a rare form of religious
psychosis affecting visitors to the Holy City. In the resulting pair of films a psychoanalyst's
explanation of the syndrome is shown side-by-side with scenes of the city, where Jews,
Arabs and Christians pray and pursue their everyday lives.

Buildings, for Coley, are 'empty vessels given significance by their social history
and by the communities that populate them', and he sees the built environment as
'an illustration of who we are'. The illusory *Show Home* (2003), a public artwork featuring
a life-sized 'rural retreat' with an accompanying marketing campaign involving a lifestyle
brochure, website, flags and signboards, took up residence for a single day at three
separate locations in North Shields in May 2003. Entirely convincing from the front,
when viewed from the back the two-roomed cottage was revealed as a sham, as insubstantial
as a Hollywood set. *Tower and Wall (1937 prefabs)* (2005) and *Emanuel (1972 Settlement
Offensive)* (2004) are sculptures relating to homes built at two key moments in Israel's
history. Reproducing a colony established for Jewish immigrants during the settlement of
Palestine in the 1930s, the huddle of buildings with its watchtower and enclosing tarpaulin
bag seems especially provisional compared with the model of the house built later in
the Occupied Territories. The two works make no overt statement, but invite responses
to what has now become an urgent and highly-charged political issue.

Helen Luckett

Nathan Coley
Show Home, Royal Quays Marina,
North Shields, 2003
Painted wood, mixed media
Curated and commissioned by
Locus + / North Tyneside Council
Photo: Dave Harvey, courtesy
of the artist and Locus +

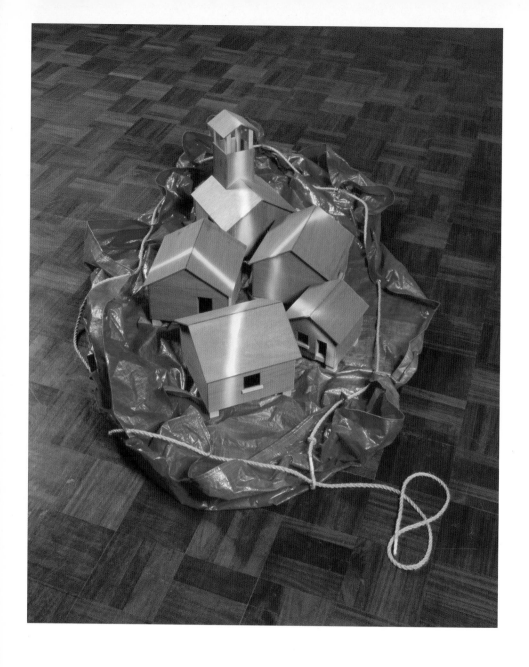

35
Nathan Coley
Tower and Wall (1937 prefabs),
2005
Painted plywood, rope, tarpaulin

34
Nathan Coley
Emanuel (1972 Settlement Offensive),
2004
Painted plywood

BREDA BEBAN

Born in Novi Sad, Serbia, in 1952
Lives and works in London and Sheffield
Graduated with a degree in Painting from Academy
of Fine Art, Zagreb, Croatia, in 1975. Studied as a
postgraduate on a DAAD grant at Hochschule der
Künste, Berlin, in 1984–85

Solo exhibitions and presentations include: Reina Sofia,
Madrid (2005); Mario Flecha Space, Jafre, Girona (2004);
and Peer & St Augustine's Tower, London (2003)

Group exhibitions include: *Premieres*, Museum of Modern
Art, New York (2005); *Artists' Film And Video, Art Now,
Lightbox*, Tate Britain, London (2003); and *A Century
Of Artists' Film in Britain*, Tate Britain, London (2003)

Exiled in stages from her homeland, Breda Beban's personal history is deeply interwoven
within her work. With the collapse of the former Yugoslavia she and her partner and
collaborator, Hrvoje Horvatic, traveled across Europe as refugees before eventually settling
in London where he died suddenly in 1997. Informed by these experiences, Beban's
work evokes the tenderness at the edge of things that binds past and present, history
and personal experience, loss and memory, in a transforming, visually poetic form. Using
film and photography she presents sequences of images that have symbolic significance
at both an intimate and political level in a format that is neither purely documentary
or fictional narrative but familiar enough to draw the viewer away from the expectations
of the newsreel or storyboard into a landscape that is both and melancholic and full of life.

In *Walk of the Three Chairs* (2003), Beban floats down the Danube on a barge
accompanied by a gypsy folk band. Positioned at a point in the river that is traditionally
thought to be the edge of Europe and the start of the Balkans, we see holiday dachas
nestled between green trees on the left bank and the contrastingly industrial landscape
of Belgrade on the right.

A man stands facing Beban and begins to call to her with the words of the love
song 'Who doesn't know how to suffer doesn't know how to love'. Initially she quavers
as she repeats the line back to him, but shouts from the riverbank join in and her voice
gains power. This exchange invokes the spirit of a past time and place rather than acting
as a conventionally romantic device. Beban steps onto the first of three chairs as the song
continues, re-enacting a celebratory ritual her grandfather used to do when winning at cards.
She moves forward and the chair behind is carried to the front of the chain allowing for
her careful progression along the boat. The combination of the music and motion as time
passes and the landscape shifts creates a greater act of remembrance, rooted within a sense
of who Beban is. She has said that, 'If I stayed where I came from I wouldn't have found
out so much about myself ... in being exposed to different cultures, different aspects of
my character have been highlighted.'

Clare van Loenen

Above and overleaf
21
Breda Beban
Walk of the Three Chairs,
2003 (stills)
Super 16 mm transferred
to DVD

Born in Runcorn, Cheshire, in 1970
Lives and works in Brighton
Graduated with a BA in English Literature
from University of Manchester in 1994,
and with a MA in Fine Art from University
of Ulster, School of Art and Design, in 2000

Solo exhibitions include: *yeah...you, baby you*,
Milton Keynes Gallery and tour (2005); *phil collins:
they shoot horses*, Wexner Center for the Arts, Columbus,
Ohio (2005); and *real society*, Ormeau Baths Gallery,
Belfast (2003)

Group exhibitions include: *Populism*, Stedelijk Museum,
Amsterdam, Frankfurter Kunstverein, Frankfurt,
and Centre for Contemporary Arts, Vilnius, Lithuania
(2005); *Istanbul*, 9th Istanbul Biennial (2005); *Universal
Experience: Art, Life and the Tourist's Eye*, Museum of
Contemporary Art, Chicago, and Hayward Gallery,
London (2005)

Phil Collins investigates the challenge of representation and the emotional force of such seemingly transparent media as video and photography. His work often originates in areas of conflict, shifting the focus from sensationalist news coverage and the associated cultural stereotyping to revealing unexpected aspects of life in contested territories – from Ramallah and Bogotá to Baghdad and Belgrade. Exploring the camera's potential as an instigator of relationships, Collins relies on gathering individuals together in processes and events that complicate both the idea of art as aesthetically autonomous and innately political. Collins' films, photographs and installations employ the documentary tradition and elements of popular culture, such as pop music and dancing, to establish an immediate and humorous connection with the participant and viewer.

They shoot horses (2004) is a two-screen digital projection of a disco-dance marathon produced in Ramallah with a group of young Palestinians. Its title is taken from a 1935 novel by Horace McCoy, which considers issues of mass entertainment and human exploitation in America's Depression era. After holding auditions at a local community centre, Collins filmed two groups over successive days, each in a single, eight-hour-long take, dancing against a candy-pink painted backdrop to a repertoire of hits from the past 30 years. Confined to a space tightly demarcated by a fixed camera range, the participants were encouraged to dance as long as they could endure. Throughout, the production was interrupted by power failures, technical problems and calls to prayer from a nearby mosque. Passing from exhilaration to exhaustion to a trance-like state of determination, the dancers appear removed from their immediate political context, yet the restriction of movement that they are subjected to reflects the sense of the confinement experienced within their daily lives.

Manchester is the birthplace of The Smiths, and it is their Colombian fans that Collins recruited in the making of *el mundo no escuchará* (2004). Based on the 1987 compilation album *The World Won't Listen*, the project – a fully-functioning karaoke machine – was originally produced in Bogotá with local musicians who re-recorded every track of the record note-for-note, and fans who performed their favourite songs. These karaoke sessions, shot against an idyllic mural of a tropical sunset or Mediterranean lake, introduce a selection of compelling and passionate performances that belie the incongruity of such an event in a place more commonly associated with corruption, guerrilla insurgence and drug trafficking. Collins' approach demonstrates how, despite karaoke's devalued entertainment format, it still manages to provide some possibilities for individual expression – the promise of becoming someone else – reflecting the agonies of striving for self-fulfilment and realising one's limitations.

Clare van Loenen

36
Phil Collins
el mundo no escuchará,
2004 (stills)
DVD

37
Phil Collins
they shoot horses,
2004 (stills)
DVD

RELATIONS: AUDIENCES, INSTITUTIONS, VALUES

❈

INTRODUCTION
Alex Farquharson and Andrea Schlieker

Debates about the contemporary role of artists, the function of art made now, and the question of art in the public realm, have witnessed many significant changes over the last few years. At a time of distrust in political systems, unease about deepening ecological malaise, and anger at the hubris of much property development and urban planning, many artists have extended their practice beyond the gallery walls and engaged directly with the public, whether in urban centres or remote countryside. From Mexico to Thailand, from Paris to Copenhagen, artists have abandoned the production of traditional museum objects, evolving instead social projects rooted in participation and inter-human activities.[1] Forging ever-closer relationships with the world, they are acting increasingly as service providers to the wider public, echoing the shift away from manufacturing in the broader economy. We can now benefit directly from the skills and services artists offer, be it a free session in conflict management (Carey Young), organically grown fruit and vegetables (Heather and Ivan Morison), proposals for alternative ecological systems (Nils Norman), a shamanistic séance (Marcus Coates) or specially designed mobile community spaces (public works). The boundary between art and life has never been less visible. Spectators are claimed as main players, and art is re-scripted as a dynamic model that unfolds through activist, convivial or performative encounters.

Many of these strategies recall and extend precedents of the 1960s and 1970s. Today some artists (for example, Carey Young's *Art and Life*, Janice Kerbel's *Bird Island* and Heather and Ivan Morison's long distance radio messages) exploit the global reach of the internet in much the way that conceptual artists experimented with printed matter and communications technology to democratise access to works that existed solely as information. Then and now these 'dematerialised' tendencies can be interpreted as ways of evading the market, though history shows that there is little, however physically slight, that cannot be converted into commodity. Although the internet remains relatively under-utilised as a site for art, it has exerted huge influence on ways of thinking and working, facilitating collaborations that span continents and disciplinary divides.

The move away from single, static objects is also reflected in critical investigations of the relationship between art and public space, as opposed to private and commercial space: Nils Norman's *Geocruiser* and public works' *Mobile Porch* represent two models of public sculpture that is mobile, functional and socially committed. This engagement with publicness extends to the art institution itself – the subject of, and site for, certain works

194

by Adam Chodzko, Neil Cummings and Marysia Lewandowska and Carey Young –
which can be related back to 'institutional critique' as practised in the 1960s and 1970s
by Michael Asher, Daniel Buren, Hans Haacke and others. Today, however, that critique
has been absorbed by institutions themselves. Some, together with artists, engage in forms
of self-critique or self-reflection, a tendency that has been called 'new institutionalism'.[2]
Where once the relationship was oppositional, now it is often constructive in its criticism:
artists are now more likely to renovate a gallery (i.e., public works and Gasworks) than
obstruct or conceal it (i.e., Robert Barry, Buren and Christo). Playfulness is a hallmark of
much recent work in this vein. This is evident in work that seeks to reveal the convergence
of the values of art institutions and those of other sectors once thought antithetical.

The turn towards social engagement in recent art has naturally fostered different
ways of working. Solitary time in the studio gives way to collaborations with a diverse
spectrum of specialists and professionals: architects and designers (public works, Nils
Norman); lawyers and businessmen (Carey Young); rose growers, birdwatchers and ice
fishermen (Heather and Ivan Morison); inhabitants of council blocks (Marcus Coates);
cloakroom attendants and shop workers (Paul Rooney); police officers and Managing
Directors of international corporations (Chris Evans); young would-be singer-songwriters
(juneau/projects/); Kurdish refugees (Adam Chodzko) or Polish amateur filmmakers and
the Bank of England (Neil Cummings and Marysia Lewandowska). Many of these works
can be read as exercises in participatory democracy. As such they sometimes recall the
protest and counter-cultural movements of the 1960s. The difference, though, is that these
new forms of community tend to be small and temporary – 'micro-utopias' (as Nicolas
Bourriaud puts it) in a post-utopian and increasingly virtual and mediated age. For other
artists, collectivity and inter-human exchange are not enough in themselves: the politics
of much recent work concerned with the social sphere is more precise than it was in
the 1990s, the social contexts within which artists work more loaded, and the relations
initiated more frictional.[3]

1 See Nicolas Bourriaud's much-discussed *Relational Aesthetics*, Les Presses du Reel, Dijon,
 France, 2002.
2 Rebecca Gordon-Nesbitt, 'Harnessing the Means of Production', in *New Institutionalism*,
 Office for Contemporary Art Norway, Oslo, 2003.
3 See Claire Bishop, 'Antagonism and Relational Aesthetics', in *October*, no. 110, Autumn 2004.

ALEX FARQUHARSON AND ANDREA SCHLIEKER IN DISCUSSION
WITH KATHRIN BÖHM AND TORANGE KHONSARI (PUBLIC WORKS),
NEIL CUMMINGS AND MARYSIA LEWANDOWSKA,
AND CAREY YOUNG

Alex Farquharson
There is a functional level or use value to all your practices (utility has conventionally been used to distinguish the so-called 'applied arts' from 'fine arts'). Could you talk about what has motivated you to work this way?

Kathrin Böhm
One of our projects, *Mobile Porch*, is a playful tool that travels neighbourhoods and functions for events and encounters in the public realm, but function is not our primary aim. The prime interest of our practice is to set up social dynamics and assist an exchange between the different users of public spaces, and between the users and the governing bodies of those spaces. We're using function in order to facilitate social environments.

Torange Khonsari
Public works is a collaboration of artists and architects. Conventionally the artist's practice is publicly seen as more thought-provoking or intellectual, and the architect's as problem solving and functional. Combining these two perceptions, our proposals create functional tools of engagement, such as *Park Products* and the *Mobile Porch*. Their functionality enables us to enter the everyday, within which we operate. These multi-disciplinary models become interesting in terms of how you challenge both disciplines and enjoy the new types of projects that emerge as a result.

Neil Cummings
I find it hard to draw this distinction between fine and applied arts. For instance, we made a project called *Not Hansard* at the Hansard Gallery in Southampton from a huge collection of amateur publications. To show this material we turned to library display technology, which seemed perfectly functional. But it also had a very particular aesthetic, which signified that the gallery had turned into a reading room. This distinction between function, ideology or aesthetics for me no longer holds – they are completely interpenetrative.

Carey Young
A lot of my work involves participatory processes that use tools and language lifted from the worlds of business and law. I wouldn't necessarily link that to applied arts, but to an interest in the inter-relationship of art and everyday life. It's important that the viewer feels a sense of recognition, that these elements are part of the familiar world. And yet they also feel unfamiliar, because they come from the territory of boardroom decision-making, a space in which most people don't have access or representation. I want to isolate these elements

from their everyday context so they can be examined as instruments
of control.

Andrea Schlieker
A lot of your work is situated outside the gallery context (as is that of public works).
It acts as a service provider, offering socially useful activities. For example, for *Conflict
Management*, you hired an expert in this field and positioned him in a city square,
inviting any passer-by to have their problems solved.

> Carey Young
> *Conflict Management* gave away a gift of free conflict resolution services to the public
> as a kind of 'temporary peace zone'. My works could often be seen as a service,
> but I'm more interested in the idea of an artwork as a system which one can access,
> participate within, or witness a part of.

>> Kathrin Böhm
>> The *Mobile Porch* provides a direct function but also generates critical
>> knowledge about a place, in particular about its informal networks and nature.
>> This knowledge is important in relation to the governance and development
>> of that space, and the formalised decision-making processes involved.
>> That's where our link with architecture comes in, which historically acts
>> more formally and in a permanent environment where this knowledge
>> can be applied; for example, within planning or design processes.

Alex Farquharson
The influence of your project obviously goes beyond the walls of the gallery, or beyond
the time-frame of an exhibition. For example, Carey, you offer certain skills to audiences
or art professionals that you work with.

> Carey Young
> Yes, several of my works have involved training sessions run by myself or specialists.
> I'm interested in the ways that an artwork can inhabit the spaces between the
> viewer, the artwork, the artist and the exhibition context in a performative way so
> that the piece seems to exist as much outside the exhibition context as within it.

Andrea Schlieker
You talk about your work having a 'viral' quality, meaning its power to disseminate –
perhaps undetected – into society, which also connects it to Neil and Marysia's practice.

>> Neil Cummings
>> Seeing our practice extending beyond the exhibition and
>> leeching out into different social spaces is very important
>> for us. This kind of dissemination principally happens
>> through collaboration. We have found an enormous benefit
>> in collaborating with different professionals, working with
>> a whole range of people, from enthusiasts to architects.

Andrea Schlieker
Regarding the collaborative practices of public works, you made *Fitting* (2002), a design
project to appropriate together with the fire fighters the newly built Fire Station 10 in

Munich, Germany, and *Layout Gasworks* (2002–04), the reconsideration and architectural restructuring of Gasworks Gallery as a local cultural institution here in London. In each case you were involved in problem solving and accomplishing concrete functional tasks, acting as negotiators between the public and institutions.

Kathrin Böhm
Problem solving and functional tasks are only one element of those projects. Both projects involved a long process of exchange between different partners and therefore differing views, intentions and interests. The developing overlap between all those interests creates the basis for our proposals, which often address institutional, social, programmatic, political, functional and architectural issues.

At the fire station in Munich we set up a communication process between the fire fighters, the architect Reinhard Bauer, the head office that commissioned the building and ourselves, in order to discuss the intention of the building and its partial failure during everyday life. A heated debate was followed by a long brainstorm and design workshop sessions that led to a number of proposals that articulate the needs and wishes of the fire fighters which weren't addressed by the building. Three proposals were finally produced, making use of internal resources such as carpentry, scaffolding and installation, and were implemented within the building. The project on the one hand facilitates the appropriation of an existing building by the fire fighters; on the other hand, it is a serious critique of current architectural production and the role given to its users.

Alex Farquharson
All of you work with different professionals (be they fire fighters, lawyers, leading executives, business theorists, Polish film groups, etc.), and in each case you are picking up on something that already exists as a knowledge base. You are learning from something pre-existent and responding to it. It turns into a mutual learning system.

Marysia Lewandowska
It's really from this experience of collaboration that we've learned the most. It was particularly challenging to approach the Bank of England as a partner in our project *Capital* at Tate Modern. We were interested in the different value systems at play in the respective economies of the Bank of England and Tate; Tate is founded on a gift, the Bank on a debt. Initially, we knew nothing! We needed to get informed about how financial economies work, how central banks function, and how value is restricted and released. We also had to overcome the Bank and Tate's preconceptions of what we do as artists, and why we wanted to collaborate with these institutions.

Carey Young
These types of collaborations are not necessarily arrogant, in fact the non-art collaborators I've worked with are often interested in exploring how their own expertise could become part of a work of art.

198

I've done research via employment that offered access to restricted places and knowledge, which would have been impossible to gain in other ways. For example, working for a left wing think-tank I learnt about anti-globalisation strategies at the level of research experts rather than street protesters, and these ideas have inspired me on an artistic level.

Alex Farquharson
Your work often positions itself between apparently conflicting value systems – for example, art and business, art and retail, the public and private. Do you regard these 'opposing poles' as having converged of late? What aspect of this situation particularly concerns you?

Neil Cummings
There has been without a doubt a convergence between aesthetic culture and retail culture, which is evident in the aestheticisation of business, and the commodification of art. You only have to visit any major public museum to see the pressures they are under, both financially and ideologically, to increase visitor numbers and become more user-friendly. Inevitably, they are becoming more like a shopping experience as that's a cultural experience that many people are familiar with. Four million people visit Tate Modern every year: that's not conventional museum exhibition behaviour, that's crowd management! The work that we have been doing more recently has been with amateurs and enthusiasts, those whose interests, practices, passions and obsessions are excluded from these powerful cultural spaces. This is beginning to sound like a manifesto...

Torange Khonsari
As the artist's profession cannot be labelled with a job description, it opens many more doors, enabling new types of artists' projects within different disciplines. I think this also gives artists a fantastic opportunity to reinvent their position in society. I'm very envious of artists for that.

Carey Young
To go back to Neil's point about convergence... since the 1980s there's been a huge increase in neo-liberalism, the idea that the free market can accomplish anything, and that the social contract should be eroded – since then the slippage between culture and business seems to have increased massively. This is the situation I'm interested in reflecting, plus the ongoing desire for resistance.

Andrea Schlieker
What is your own position *vis-à-vis* the use of strategies from the corporate and commercial sector? There seems to be a deliberate ethical ambivalence.

Carey Young
I think it was Hans Haacke who said that most Western art shows the common characteristic of 'controlled ambiguity'. In terms of ethics, I think that revealing corporate tactics is an ethically positive thing to do, but I tend to exclude my own

personal politics from the work in an overt sense. I'd prefer to try to promote discussion and a critical awareness in the audience. I believe that we are at a moment when the old binary positions may supply comfort but are not so relevant any more.

Andrea Schlieker
Virtually all contemporary art is made within the context of Capitalism. You often make this relationship the explicit subject of your work. What, for you, are the terms of engagement? What techniques do you use and what do you hope to reveal?

> Kathrin Böhm
> An aim of all of our projects is to find a way to articulate different values, often those which are not credited and valued within a monetary Capitalist system and a purely functional system. *Park Products*, for example, was all about revealing and articulating the different resources and capital within a public space, in that case Kensington Gardens. Together with different user groups of the park we developed and produced a range of 'products', which were later traded on a non-monetary basis with visitors of the park (i.e., making a squirrel jump through a hoop).

Andrea Schlieker
I'm particularly interested in the alternative economy you set up with *Park Products*. It reminds me of various idealist models evolved by nineteenth-century utopian socialists (i.e., William Morris' *News from Nowhere*). Was that kind of Socialist ideology something that informed your work?

> Kathrin Böhm
> Yes, by teaming up with the New Economics Foundation we developed the prototypical economic concept of the project. Our idea came out of the notion of establishing a social network that is not based on exchanging money but on exchanging values.

>> Torange Khonsari
>> Is it also about creating a very specific local identity. In contemporary Capitalist environments it is all about commodity, exchange and standardisation, which shape our neighbourhoods. The question is, how do you actually break that down and create something specific to a place? In our projects we pay close attention to how points of exchange create a specific locality/identity.

>>> Marysia Lewandowska
>>> The project we mentioned earlier, *Capital*, linked the symbolic economy of Tate to the financial economy of the Bank of England, via a gift. A beautiful limited edition print was given away to visitors by staff of both institutions, randomly for the duration of the project. We have never disclosed how limited the edition was, it could have been 50 or 50,000, so this immediately raises questions relating to value. Is it valuable because it's a gift, a beautiful print, or because it came via these two powerful institutions?

Neil Cummings

Many people (following the work of the sociologist Marcel Mauss, *The Gift*) think that gifts bind people into networks of obligation and prestige; that gift economies exist alongside the calculations of the purely financial, and might offer some resistance to Capitalism. A good contemporary example is Open Source software – code that is freely available to everyone to use, modify and redistribute – it's really thriving, and offering a real alternative to proprietary software. At some level, gifts as well as generosity drive Open Source communities.

Andrea Schlieker

Carey, the performance piece you did at Speaker's Corner was also a gift to the listeners. Here we no longer have an object, it's dematerialised into a gift of information or skill.

Carey Young

In that video piece, *Everything You've Heard is Wrong*, I offered corporate presentation skills to the public at Speaker's Corner (and by implication, to those watching the video in an exhibition context). The skills seemed to be offered altruistically but at the same time the questions for the viewer might be 'What does this new knowledge mean?'; 'What ideological basis does this information come from?'; 'Does that make me complicit in a process I'm not comfortable with?' In some sense, there are no boundaries between the artwork and the world outside the gallery.

Torange Khonsari

The ways in which artists are getting paid have become much more diverse. This enables you to give the art piece away as a gift and change its status. The question of who your client/audience is and, ultimately, who you feel a duty of care to, becomes a very relevant contemporary question when working within the public realm.

Kathrin Böhm

We never hide the fact that we are paid for our commissioned projects; we are not romantic about the idea of how we exist in society. At the same time we like to challenge a more general and efficiency-driven perception of what should be paid for. It's important that we get paid for hanging out, for example. It's also a strategy to apply value to processes and elements of the work that are normally regarded as useless or unproductive.

Neil Cummings

We also make clear that we try to negotiate a fee for every project, the fee acknowledges a shift to the service economy, we don't produce goods to be traded but provide various levels of service and consultancy. Sometimes the fee is appropriate remuneration for the labour invested, and sometimes it is nowhere near.

Andrea Schlieker

We have been talking about the dematerialisation of the art object in your practice, and about your collaboration outside the gallery space. This seems to suggest a deliberate turning

away from the museum as an institution – even though all of you engage with the museum. Do you see yourselves continuing that legacy of 1960s/1970s art? In which case, how have the circumstances changed since then, and what strategies do you employ that acknowledge that difference?

> Neil Cummings
> Yes, it is often a link we like to make ourselves, back to the work of the 1960s and 1970s, especially practices called institutional critique. Museums and galleries are still essential in authorising the work of the work of art. But the difference is that we are not interested in trying to change those institutions. When you work with museums and galleries you realise they're huge, bureaucratic and slow. We work with institutions, but mainly to get access to, and engage their audiences; it's within audiences that there is a tremendous potential for conflict, change, excitement, joy, generosity and so on.

Carey Young
For a while I've been exploring the links I perceive between the spread of Conceptual art of the 1960s and 1970s and current globalised business strategies, both of which can be read in terms of the commodification of dematerialised ideas rather than physical products, and also the marketplace's absorption of whatever tries to negate it. So that overlap has all these inherent problems, which I have tried to use as some kind of shorthand, there if people want to decode it.

Alex Farquharson
The first generation of artists associated with institutional critique tended to focus on the specifics of a given gallery or institution – its 'neutral' architecture, its business, its trustees, the provenance of its collection, and so on – whereas artists of your generation tend to create / reveal relationships between institutions of art and other cultural agencies.

> Neil Cummings
> Maybe there is a blurring now of the 'aesthetic experience', when perhaps in the 1960s there was a clear idea that it belonged to, and could be regulated by, museums and galleries. Art institutions now are riven by all kinds of sponsorship deals, advertising and so on, and none of us is sure anymore where the aesthetic experience starts and stops. And it can't be disentangled. When artists *really* engage with art institutions, they have to acknowledge all the forces that network into them.

Carey Young
I think right now there is a turning back to valuing the art institution as an autonomous space for experimentation and reflection outside the dominant ideologies of the marketplace. I tend to see this as wishful thinking because there has been a big rise in corporate sponsorship of art institutions, and an increase in the influence of art fairs and the art market in terms of what work becomes visible. For a while I've been interested in presenting gallery or art structures as equivalent to corporate structures, partly as a provocation and a warning.

Alex Farquharson
We now have an increasing number of institutionally critical institutions, which invite artists to do projects that reflect back on their own structures and networks. Are we in the situation now where we have a more collaborative relationship between the institutions and artists? I am thinking, for example, of your work, Carey, for the Munich Kunstverein.

Carey Young
Yes, there is more collaboration, but that does not mean there is less critique coming from the artists who work in this way, it has just taken a different form – the terms 'constructive' or 'soft' institutional critique have arisen elsewhere. I made several works for the Munich Kunstverein that intervened within, or existed in parallel to, their marketing and communications activities and commented on their history and activities. One piece, *Win-Win*, involved the entire staff of the Kunstverein being trained in negotiation skills. The work was then specified as 'existing' any time the skills were put to use. So, for example, the work spread into their relationships with the media, with artists and with each other.

Andrea Schlieker
Is a part of this new institutional critique also a critique of the commodity value of the art object, as it was in the late 1960s? Is the fact that your work is not easily commodifiable central to your whole practice?

Neil Cummings
Yes, it's more about selling a service which itself cannot be easily commodified.

Carey Young
I'd rather be careful about who buys my work than whether it is sellable in the first place. Fashions come and go in the art market. In my case I'm interested in the idea first and often work in a context-specific process-based way which reflects on processes of commodification in other ways, and if the outcome is unsellable work, or a project that offers free gifts to the audience, so be it.

Torange Khonsari
We are trying to use the gallery as a think tank, a laboratory, as a place where we can actually develop ideas; a place for collaborative projects, where architecture and art thinking come together – rather than showing a specific work in the gallery. The money that is raised for the show can then be used to develop new ways and approaches, new tools.

Marysia Lewandowska
Although we don't make artworks in the form of an object-commodity, we insist on exchanging something else. We trade ideas and services to people who are prepared to engage with the consequences of working in this way. To sell an object is a fairly straightforward operation, to exchange ideas, to support research or encourage a *real* creative engagement between an artwork and its audiences requires a much more demanding set of relationships.

ADAM CHODZKO

Born in London in 1965
Lives and works in Whitstable, Kent
Graduated with a BA in History of Art from University
of Manchester in 1988, and with a MA in Fine Art
from Goldsmiths College, London, in 1994

Solo exhibitions include: Carlier Gebauer, Berlin,
and Els Hanappe Underground, Athens (2004);
Herbert Read Gallery, KIAD, Canterbury (2003);
and Arizona State University Art Museum, Tempe,
Arizona, and Cubitt, London (2002)

Group exhibitions include: *Documentary Creations*,
Kunstmuseum Luzern, Switzerland (2005);
Perfectly Placed, South London Gallery (2004); and
Micro/Macro: British Art 1996–2002, British Council
curated, Mucsarnok Kunsthalle, Budapest (2003)

Adam Chodzko has been described as a 'fabulist of the everyday' and a 'media iconoclast'.
His practice is often close to that of an anthropological *agent provocateur*; or a catalyst
for other people's imaginations and fantasies. Projects – which have variously resulted
in sculpture, photographs, film or performance – have been initiated through advertisements
in *Loot*, newspapers, 'contact' magazines or fly-posters and more recently a phone call,
or a chance meeting with a stranger. These works have included 'God look-alike' contests,
an invitation to strangers to choose locations for the ending of a film, a reunion for the
teenage murder victims in a Pasolini film, an appeal to lighting technicians for advice
on how to illuminate heaven, and the transfer of a London gallery's archive to a group
of Kurdish asylum seekers to edit, hide and preserve outside the capital.

 Design for a Carnival (2002), an ongoing project, is concerned with the invention
of an elaborate ritual event for the future. Parts already realised include *Settlement*, the
legal purchase of a square foot of land as a gift to a stranger, and *Night Shift*, late night
tours by nocturnal animals to London's *Frieze Art Fair* in 2004. As a further episode in
this project, Chodzko has produced *M-path* (2005) for *British Art Show 6*. In the same
way that shoes are removed at the entrance to a mosque or temple, or exchanged for more
appropriate footwear in bowling alleys and ice-skating rinks, visitors to selected venues
of the exhibition will be invited to swap their shoes for a second-hand pair for the
duration of their visit; a costume for their tour. These shoes will have been sourced from
communities within the *British Art Show*'s host cities, their choice of donations directly
influencing the visitor's walk through the show. Chodzko asks, 'if you literally put yourself
in someone else's shoes do you perceive the world as they do? ... Can art only convey
meaning if the viewer is prepared first to make some kind of change?'

Helen Luckett

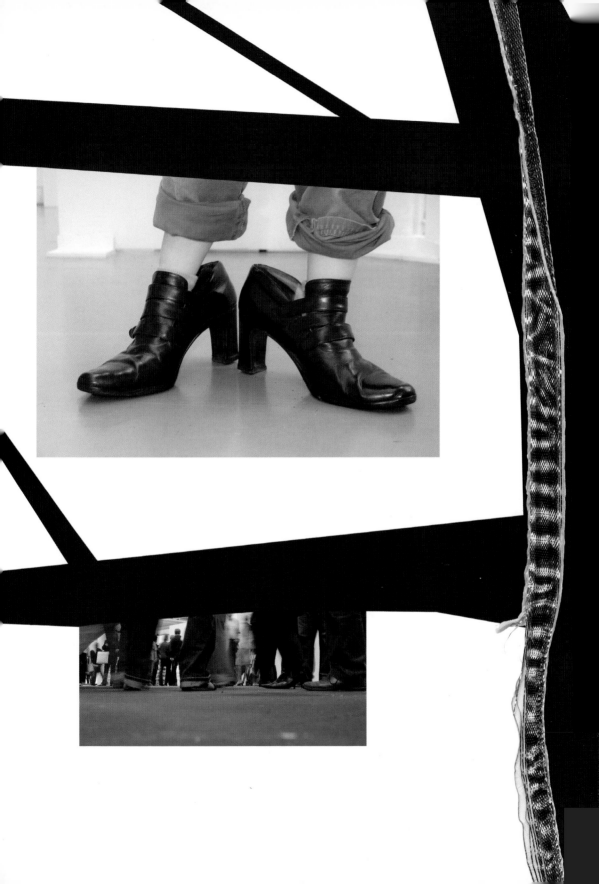

Previous page
Adam Chodzko
Sketch for *M-path*, 2005 (cat.29)
Donated second-hand shoes
to be offered as replacement
footwear to visitors upon entering
British Art Show 6 at selected venues
Courtesy the artist

Adam Chodzko
Sketch for *Night Shift*, 2004
Nocturnal tours of fair by wolf,
snake, skunk, stag, rat, toad
and scorpion, and double-sided
poster/map for *Frieze Art Fair*
42 × 62 cm
Courtesy the artist

206

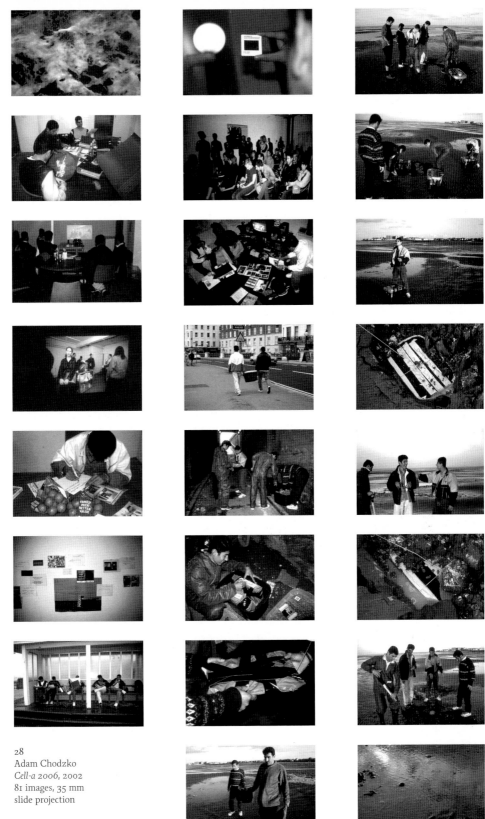

28
Adam Chodzko
Cell-a 2006, 2002
81 images, 35 mm
slide projection

Born in Eastrington, East Yorkshire, in 1967
Lives and works in London and Berlin
Graduated with a BA in Graphic Design from Leicester
Polytechnic in 1989, and with a MA in Fine Art
from Winchester School of Art, Barcelona, in 1993

Solo exhibitions include: Store Gallery, London
(2005); *The Rock & The Judge*, Galerie Juliette Jongma,
Amsterdam (2005); and *Radical Loyalty*, artconnexion,
Lille, France (2004)

Group exhibitions include: *In This Colony –*
Fortvijfhuizen, Vijfhuizen, The Netherlands (2005);
Other Criteria: Sculpture in 20th Century Britain, Henry
Moore Institute, Leeds (2003); and *Ill Communication*,
Dundee Contemporary Arts (2003)

Chris Evans works in the spaces where patronage meets art. Often offering himself as a
consultant, he facilitates dialogues with company directors, public bodies and individuals.
These dialogues result in artworks: anything from a chalky-looking sculpture of a rock to
an audio piece or a magazine insert. For *Gemini Sculpture Park* (2001), funded by the Henry
Moore Foundation, Evans became the 'UK Corporate Sculpture Consultancy' and worked
with small companies located in a 1980s business park outside Leeds. After conducting
interviews, Evans made suggestions for artworks to embody a core concept of each business
and which would stand near the car park. The proposals remain unrealised. But in his
ongoing project *Radical Loyalty*, Evans plans to carry through a similar process with a
concrete result – the creation of a sculpture park in an industrial town 80km south of
the Estonian capital Tallinn, due to open in 2006. Evans asked Managing Directors from
international companies such as Daimler Chrysler Finance, Schlumberger Oil and Starbucks
how each would envision loyalty and how loyalty might be thought of as radical. Kari
Vaiha of the Nordic telecommunications giant Sonera imagined a rat and a cockroach,
creatures known for their supposed resilience in the face of nuclear conflict. Screen-prints
and maquettes made by Evans following these conversations will inform a team of Estonian
artisans – responsible for building many of the country's monuments during the Soviet
era – recruited to make sculptures for the park.

Evans turns patronage on its head – sometimes he is the artist, sometimes the
patron, most often someone in-between. As critic Will Bradley has written, 'Very few
people actively aspire to being part of a society that's simultaneously oppressive, amoral
and dull, but most of the corporate or state structures we sustain have at least one of
these characteristics. Evans' work amplifies this paradox. It's like hearing a really good
joke and being trapped inside it, both at once.'[1]

Rebecca Heald

1 Will Bradley, 'The Freedom of Negative Expression', in Chris Evans, *Gemini Sculpture Park:
UK Corporate Sculpture Consultancy*, exhibition catalogue, The Henry Moore Institute, Leeds, 2001.

Chris Evans
Radical Loyalty, Jarvakandi,
Estonia, 2003
Polymer gravure print
64 × 90 cm
Photo: courtesy the artist

210

Top left
43
Chris Evans
Work from Radical Loyalty:
Adapt and Survive. Artist's impression
of sculpture proposed by board member
Kari Vaiha, Manager of Environment,
Sonera-Telia Telecom, Helsinki., 2003
Polymer gravure print

Bottom left
46
Chris Evans
Work from Radical Loyalty:
Egyptian Horses. Artist's impression
of sculpture proposed by board member
Martin Fehrmann, Managing Director
of Daimler Chrysler Finance, London,
2003
Polymer gravure print

Above
48
Chris Evans
Work from Radical Loyalty:
Three Pebbles. Artist's impression
of sculpture proposed by board member
Cliff Burrows, Managing Director
of Starbucks UK, 2004
Polymer gravure print

Born in Liverpool in 1967
Lives and works in Liverpool and Wolverhampton
Graduated from Edinburgh College of Art with
a BA in Drawing and Painting in 1989, and with
a MA in Fine Art in 1991

Solo exhibitions include: *Know Your Place*, firstsite,
Colchester (2004); *There Are Two Paths*, off-site
performance project, Ikon Gallery, Birmingham,
and Meadow Gallery, Shropshire (2003); and
The NWRA Variety Night Event, Cubitt Gallery,
London (2002)

Group exhibitions include: *Pass the Time of Day*, curated
by Paul Rooney, a collaboration between Gasworks
Gallery, London, Angel Row Gallery, Nottingham,
Castefield Gallery, Manchester, and Collective Gallery,
Edinburgh (2004–05); *Shrinking Cities*, Kunst-Werke,
Berlin, and tour (2004); and *Let Us Take You There*,
two person show with Susan Philipsz, Site Gallery,
Sheffield, and tour (2003–04)

Paul Rooney's videos could be described as meditations on the mundane and the deadpan.
His works are often the outcome of musical collaborations with disenfranchised members
of the community, inviting them to describe in detail their surroundings, jobs or dreams.
He then sets these 'streams of consciousness' to music which he juxtaposes with video
snapshots of their environments. His work portrays an unusually poignant and altruistic
sensibility. He believes that everybody has a story to tell and his work facilitates its telling.
 As a musician and artist Paul Rooney's music is integral to his artistic practice.
In 1997 he started releasing music under the name Rooney and around the same time
he began incorporating music into his art. The songs he composed for Rooney catalogue
everyday events: 'Pale Yellow' describes his failed attempts to tune a portable black-and-
white TV, a trip 'down the shops' is immortalised in 'Walked Round the Estate', and
in 'Throw Away' he chants about reusing old envelopes. In more elaborate compositions
he has taken extracts from internet chat room conversations and set them to music for
six vocalists.
 Many of his video works focus on individuals who play a marginal role in cultural
organisations, such as a gallery attendant at an art museum or audience members at a
recording of Top of the Pops. *Lights Go On. The song of the nightclub cloakroom attendant* (2001)
chronicles in song this particular job, perhaps the most boring and thankless position in
the establishment. In *In the Distance the Dawn is Breaking* (2004) static views of the interiors
of five shops are shown on a bank of five overhead monitors, reminiscent of a CCTV
system. They have been shot at night when these normally bustling environments revert
to an eerie stillness. Over each 'scene' is recorded a song, describing a shop worker's dream.
As the subjects sing their dreams, the five voices overlap in one multilayered chorus –
an anthem to their subconscious hopes, desires and fears.

Emma Mahony

109
Paul Rooney
Lights Go On. The song of the nightclub
cloakroom attendant, 2001 (still)
DVD

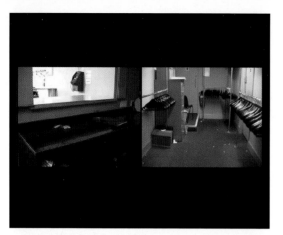
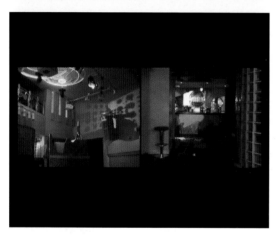

109
Paul Rooney
Lights Go On. The song of the nightclub
cloakroom attendant, 2001 (stills)
DVD

110
Paul Rooney
In the Distance the Dawn is Breaking,
2004 (stills)
5 DVDs

215

Born in London in 1968
Lives and works in Berwick-upon-Tweed,
Northumberland
Graduated with a BA in Fine Art from Kent Institute
of Art and Design in 1990, and with a Postgraduate
Diploma from the Royal Academy of Art, London,
in 1993

Solo exhibitions include: BALTIC Centre for
Contemporary Art, Gateshead (forthcoming 2006);
and *Journey to the Lower World*, Café Gallery Projects,
London (2004)

Group exhibitions include: *Hilchot Shechenim*,
Israeli Centre for Digital Art, Holon, Israel (2005);
Human Nature, Pump House Gallery, Battersea,
London (2005); *Further up in the Air*, Liverpool (2004);
Disguise, Manchester Art Gallery (2004); and Grizedale,
Ambleside, Cumbria (1999–2001)

Marcus Coates' art is concerned with trying to become animal. He explores his subjects
by imitating and literally inhabiting their skin. Working in a range of media from
photography and film to performance and sculpture, his work is embedded in a dialogue
with ornithology, zoology and anthropology. Humour is integral to his work and his
impersonations are often crude and highly comical. In an early self-portrait, *Red Fox,
Vulpes vulpes* (1998), he dons a red boiler suit and masquerades as a fox. His imitations
can also be quite visceral and many verge on the abject. The video piece *Deers* (2001)
captures the artist crawling along a forest track with the carcass of a red deer slung across
his back, and *Sparrowhawk Bait* (1999) sees him running through a forest with dead birds
entangled in his hair. In more recent works he emulates the wildlife calls of animals and
the pitch and tone of birdsong with extraordinary accuracy. In *Journey to the Lower World*
(2004) he performed a Shamanistic ritual to an audience of residents living in a condemned
tower block in Liverpool. The ceremony involved the artist talking to and obtaining
information from animal spirit guides to suggest a possible community strategy for the
soon to be relocated tenants.

In *Local Birds* (2001) the artist's enthusiasm for birdsong has become infectious.
A series of short vignettes focus on the inhabitants of an isolated village in the North
Pennines as they go about their daily routines. Suddenly, without warning, they burst
into birdsong. Coates has achieved this astonishing effect by slowing down recordings
of birdsong so that they have the same tonal range as the human voice. He then matched
the pitch of different birdsongs with the vocal ranges of his collaborators and filmed
them singing along to a slowed down version of the recording. The video footage was
then digitally sped up until it was in time with the pace of the original birdsong and,
by doing so, the physical movements of his protagonists were also accelerated and
became uncannily bird-like.

Coates' short film *Finfolk* (2003) enacts a folktale emanating from Northern
Europe. Finfolk, or Selkies as they are otherwise known, were purported to be human
embodiment of seals. In his amusing film Coates assumes the persona of a modern day
Selkie impersonating a human, appearing out of the freezing North Sea in ill-fitting
Adidas sportswear and clip-on shades. His tracksuit-clad protagonist is his idea of what
a seal would be like were it to become human: a slightly aggressive and objectionable
bloke who mutters gibberish to himself while pacing up and down the pier. When a
group of humans appear in the distance, he hastily retreats back in the freezing sea in
an effort to keep the myth intact.

Emma Mahony

32
Marcus Coates
Journey to the Lower World,
2004 (still)
2 screen DVD installation

31
Marcus Coates
Finfolk, 2003 (stills)
Single screen DVD

30
Marcus Coates
Local Birds, 2001 (stills)
Single screen DVD

Phil Duckworth
Born in Iserlohn, Germany, in 1976
Lives and works in Birmingham
Graduated with a BA in Fine Art from Coventry
University in 1999

Ben Sadler
Born in Birmingham in 1977
Lives and works in London
Graduated with a BA in Fine Art from the Ruskin
School of Fine Art, University of Oxford, in 1998,
and with a MA in Sculpture from the Royal College
of Art, London, in 2004

Solo exhibitions include: *stag becomes eagle*, RSPB
Aveley Marshes, Essex (2005); *driving off the spleen*,
f a projects, London (2004); and *motherf**king nature*,
The Showroom, London (2004)

Group exhibitions include: *Romantic Detachment*,
P.S.1, Long Island City, New York (2004); Q Arts,
Derby (2004); and Chapter, Cardiff (2004)

Formed in Birmingham in 2001, juneau/projects/ explores the role of technology within culture, and our increasing dependence upon it. Their performative works test the limitations of electronic equipment such as mobile phones, computer hardware, camcorders and CD Walkmans, by variously submerging them in water, freezing them, setting them alight, melting and grinding them down. Destroying in order to create, they often use the very technology they are demolishing to record the sound of its own demise.

They produce the majority of their performances in rural settings, where nature is pitted against technology. *The beauty royale* (2004) is set in a forest, where the artists feed lengths of wooden dowel, replete with contact microphones, through a wood chipper. The microphones amplify the sound of the chipper generating a deafening roar in the stillness of the forest. In *good morning captain* (2004) a scanner is dragged along a forest floor, documenting its own destruction with a series of blurred scans. For *my wretched heart is still aglow* (2004) the artists dangled live microphones over a fire, amplifying the sound of the crackling flames until they finally melted.

All of their performances are recorded on video and displayed within the gallery, surrounded by the residue of their making. The monitor displaying the *beauty royale* is surrounded by the wood shavings and pieces of dowel, and the wood chipper is also present with a text scribbled in pencil on the gallery wall describing how it came into the artists' possession: they bought it for five pounds from an elderly couple who had originally received it as a present from their son. In *good morning captain* scans of the forest floor together with the battered scanner are shown alongside the video of the performance. By displaying the detritus of the work's construction, the artists are emphasising the work's performative nature. This narrative thread is also evident in the interrelationship between various discrete works when they come together in one installation. The various elements displayed in *British Art Show 6* relate to episodes in a fictional narrative that centres around the personae of three fictional characters: The Mush, The Don and The Kingpin. References to these characters occur in different works, generating a conversation between them like characters in a Chaucerian narrative.

Emma Mahony

Above
65
juneau/projects/
good morning captain, 2004
DVD installation

Right
67
juneau/projects/
the beauty royale, 2004
DVD installation

LIVERPOOL JOHN MOORES UNIVERSITY
LEARNING SERVICES

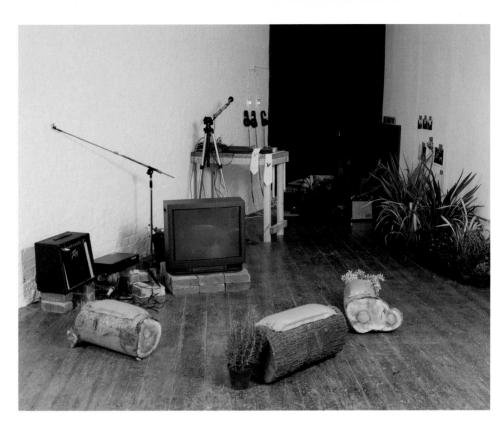

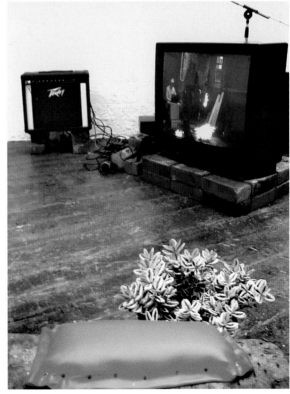

Top left
juneau/projects/
better off alone work station, 2004
CD and 12-inch vinyl installation
Dimensions variable
Photo: Daniel Brooke

Bottom left
68
juneau/projects/
the mush, 2004
Animation / installation

Above and right
66
juneau/projects/
my wretched heart is still aglow, 2004
DVD installation

Heather Morison (née Peak)
Born in Desborough, Northamptonshire, in 1973
Graduated with a BA in Fine Art from University
of Brighton in 1996

Ivan Morison
Born in Nottingham in 1974
Graduated with a BA in Critical Fine Art Practice
from University of Brighton in 1996, and with a MA
in Fine Art from University of Central England in 2001

Heather and Ivan Morison currently have no permanent
residence, and are working in the USA, Ecuador,
Canada and Birmingham, UK

Solo exhibitions and projects include: *Heather & Ivan
Morison are confused*, Danielle Arnaud contemporary
art, London (2004); *Still Life*, Resonance FM, series
of eight weekly radio programmes (2004); and *Heather
& Ivan Morison Hired an Aeroplane*, New Art Gallery
Walsall (2004)

Group exhibitions include: *Human Nature*, Pump
House, Battersea, London (2005); *Art of the Garden*,
Tate Britain, London, touring to Ulster Museum
and Art Gallery and Manchester City Art Gallery
(2004–05); and *Everything's Gone Green: Photography
and the Garden*, National Museum of Photography,
Film and Television, Bradford (2004)

Heather and Ivan Morison's artworks convey the simple pleasures and passions of their own endeavours and of those they meet, from amateur floristry to beekeeping. Their seemingly straightforward observations belie the meticulous attention to detail and consuming effort they take in acquiring new knowledge and skills. The formal outcomes of their investigations include postcards sent to a growing mailing list of interested parties, LED displays of text messages, slide shows, LP recordings of conversations, radio broadcasts, special one-off events and science-fiction novels written whilst in transit. Many of these blend factual recall with fictionalisation, merging information into a shifting narrative that builds on the mythology of Heather and Ivan Morison's lives and the lives of the people they encounter.

The two artists work from their overgrown allotment in Birmingham, though increasingly they roam more widely afield in a manner that recalls the nineteenth-century grand tour, but in a way that is conversely more attuned to the mundane than the epic. They make remarkable the everyday occurrences on the edge of people's public lives, where obsession and eccentricity have space to flourish. Text messages from their work *Global Survey* (2003) – where chance suggestions directed their travel itinerary – are used to develop a narrative on an outdoor LED display, with their frequency and content reflecting the pace and intensity of the Morison's distant lives.

The Morisons made the audio installation *Two Java Sparrows* (2003) while transporting their new birds across Beijing on the back of a bike. Later, when they were on holiday, the birds were eaten by a yellow weasel, having been left hanging outdoors in their cage whilst in the care of their neighbour, Mr Han. The event is recounted on one of their postcard artworks and recurs in the slide piece *Chinese Arboretum* (2003–04). This work clicks through images of 100 special trees that the artists sought out across China, and includes narrative titles. This format of presentation is likely to be adapted for the artists' planned encounter with Chilean rose farmers in 2005. The Morisons' tendency to present their observations in matter-of-fact, domestic scale formats is in tune with a past age of amateur pursuits, enjoyed as individually-motivated intellectual challenges, rather than pure leisure or professional activities.

Clare van Loenen

Heather and Ivan Morison
I put you on a mile long string,
but still you broke away, 20 July 2004
Members of Sheffield's Chinese
community flying a dozen Chinese
kites a mile high above the city,
Meersbrook Park, Sheffield
Photo: courtesy the artists

Heather and Ivan Morison
Stop, wait, go, Lui Chun repeats
in her head, as she directs traffic
from her platform. Above her
the traffic lights go on changing.
No. 91 in *Chinese Arboretum*
series, 2004
(installation view from
Greenland Road, Sheffield)
Photograph printed onto
billboard paper
300 × 600 cm
Photo: courtesy the artists

226

Heather and Ivan Morison
Study for *Starmaker*,
2005 (cat.91)
Twin medium format
slide projection

Born in Toronto, Canada, in 1969
Lives and works in London
Graduated with a BA in Anthropology from the
University of Western Ontario, London, Canada,
and the University of British Columbia, Vancouver,
Canada, in 1992, with a BFA (Studio) from Emily
Carr College of Art and Design, Vancouver, Canada,
in 1994, and with a MA in Fine Art from Goldsmiths
College, London, in 1996

Solo exhibitions include: Karin Guenther Gallery,
Hamburg (2004); *Home Climate Gardens*, Norwich Gallery
(2003); and *JK/JK*, Arnolfini Gallery, Bristol (2000)

Group exhibitions include: *Therefore Beautiful*,
Ursula Blickle Foundation, Kraichtal, Germany
(2005); *On Patrol*, de Appel, Amsterdam (2004);
and *Art of the Garden*, Tate Britain, London (2004)

Janice Kerbel's work utilises art as a tool for escape into the limitless horizons of the imagination. Her work functions like a conceptual *trompe l'oeil*, creating such detailed fictions that they are often more plausible than reality. An early work, *Bank Job* (1999), sets the tone for many of her subsequent projects. Posing as an architecture student, Kerbel staked out Coutts & Co, a private investment bank in London's Lombard Street. Her months of research resulted in a 'master plan', outlining in exhaustive detail how to rob it. She describes the security set-up, the criminal team needed for the heist, accomplices after the fact, diversions, and even getaway routes culminating in an eventual escape to Spain for a 'cooling off' period.

An interest in the undisclosed appears to be central to Kerbel's practice. In the past she has designed playing cards, *Three Marked Decks* (1999), where a subtle extension of a curlicue or the omission of a tiny detail of ornament indicates their value to a cheat, and in *Home Fittings* (2000 and ongoing), she has drawn plans to indicate how to navigate a room without making any sound or casting any shadows. For *Bird Island Villas* (2000) she advertised time-share apartments on a non-existent tropical paradise. Supposedly situated just above the Tropic of Cancer in the Exuma Cays her fictitious getaway came replete with geographical co-ordinates and vivid descriptions of the flora and fauna that is meant to grace its shores. She even invented the Exuma Emerald, a species of bird endemic to the island.

More recently she has been engaged with garden design. *Home Climate Gardens* (2004) is a series of digital drawings illustrating gardens devised for the interior of commercial and domestic spaces. The designs, which are determined by the architecture and prevailing climatic conditions such as light, temperature and humidity, include an open-plan office planted with orchids, a cactus grove for a student dorm, wall-mounted gardens for a council flat and a respiration garden for a gym.

It is not Kerbel's intention that any of her proposals be realised; in fact, in most cases, any attempt to do so would ultimately end in failure – the uninhabited island and its rare ecosystem would be destroyed by human habitation, and if anyone were to attempt the bank robbery, their every step would be second-guessed by the police.

Emma Mahony

FRESH AIR NIGHTLY
LOW FILTERED LIGHT

BEDROOM
WATER MODERATELY SPRING SUMMER

FRESH AIR DAILY
BRIGHT UNFILTERED LIGHT

KITCHEN
WATER MODERATELY YEAR ROUND

FRESH AIR INTERMITTENTLY
BRIGHT INDIRECT LIGHT

BATHROOM
WATER MODERATELY YEAR ROUND

COUNCIL
FLAT
WALL-MOUNTED GARDENS

AVERAGE SUMMER TEMP:	23.8°C
AVERAGE WINTER TEMP:	22.4°C
NIGHTLY TEMP DROP:	3°C
AVERAGE HUMIDITY:	38%

73
Janice Kerbel
Council Flat: Wall mounted gardens,
2004
Print on paper

W I N D O W

BRIGHT FILTERED LIGHT

SPARINGLY IN WINTER WET YEAR ROUND SPARINGLY IN WINTER SPARINGLY IN WINTER

W A T E R M O D E R A T E L Y

G Y M

RESPIRATION GARDEN

AVERAGE SUMMER TEMP:	23.3°C
AVERAGE WINTER TEMP:	23.3°C
NIGHTLY TEMP DROP:	4°C
AVERAGE HUMIDITY:	73%

74
Janice Kerbel
Gym: Respiration garden, 2004
Print on paper

BRIGHT UNFILTERED LIGHT

WATER GENEROUSLY YEAR ROUND

ROTATE BI-MONTHLY ON AXES

LAUNDERETTE
SUSPENDED GARDEN

AVERAGE SUMMER TEMP:	25.4°C
AVERAGE WINTER TEMP:	18.3°C
NIGHTLY TEMP DROP:	4°C
AVERAGE HUMIDITY:	68%

75
Janice Kerbel
Launderette: Suspended garden, 2004
Print on paper

Born in Sevenoaks, Kent, in 1966
Lives and works in London
Graduated with a BA in Fine Art Painting
from Central Saint Martins School of Art,
London, in 1989

Solo exhibitions include: Gallery Christian Nagel,
Berlin (forthcoming 2006); *The Homerton Playscape
Multiple Struggle Niche*, City Projects, London (2005);
and *Everything in the Future Will Necessarily Come:
Corporate Fairytales and Other Sculptural Manoeuvres*,
in collaboration with Stephan Dillemuth, Galerie
für Landschaftskunst, Hamburg (2004)

Group exhibitions include: *Headquarters: Artistic
Interventions in Social Space*, Contemporary Museum,
Baltimore (forthcoming 2006); *Invisible Insurrection
of a Million Minds*, Sala Rekalda, Bilbao (2005);
and *Beyond Green*, Smart Museum of Art Chicago,
University of Chicago (2005)

Nils Norman's work is informed by local urban politics and ideas on alternative economic
and ecological systems that operate within the city, merging urbanist utopic alternatives
with a humorous critique of the history and function of public art. His work often takes
the form of fictive proposals that critically highlight the role of city design and public
sculpture in the gentrification of city space. His proposals suggest the radical redevelopment
of existing urban areas into self-sustaining live/work spaces for utopian societies. Many
incorporate adventure playgrounds, 'edible parks and gardens', alternative energy systems
and urban agriculture.

Norman's animation *The Art of Urbanomics* (2003) is a rumination on the privatisation
of public space. It follows the French romantic poet Charles Baudelaire on a strange
journey through the streets of Paris and New York. His journey begins in Paris in 1850
subsequent to the city's radical redevelopment by city planner Georges Haussmann. As his
head floats through ever-changing landscapes, cities build themselves in front of our eyes
and public sculptures crash from the sky. Along the way he encounters characters such
as Friedrich Engels and Walt Disney – his head dripping with cryogenic slime.

For an off-site *British Art Show 6* commission in Gateshead, Norman has designed
a quasi-property developer's sign. *Deformed Hoarding, Gateshead* (2005) critiques the recent
flurry of property developments in this rapidly-changing cityscape, a process that is being
increasingly replicated in other cities across the country.

Emma Mahony

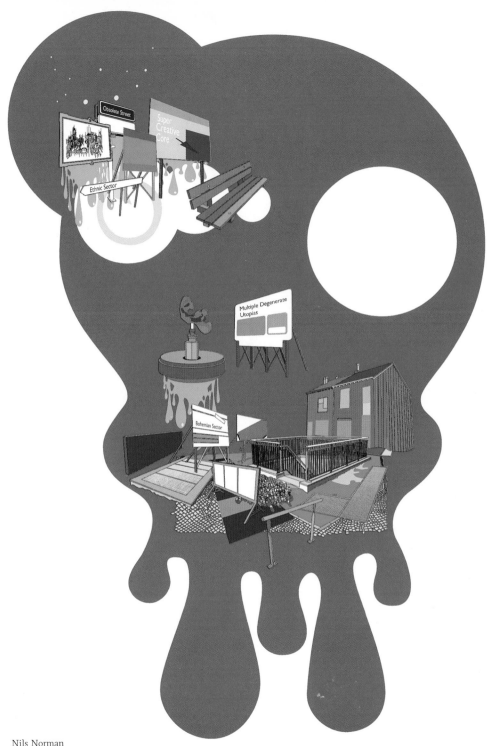

Nils Norman
Deformed Hoarding, 2005
Ultrachrome digital print
on aluminium
175 x 255 cm
Photo: courtesy the artist

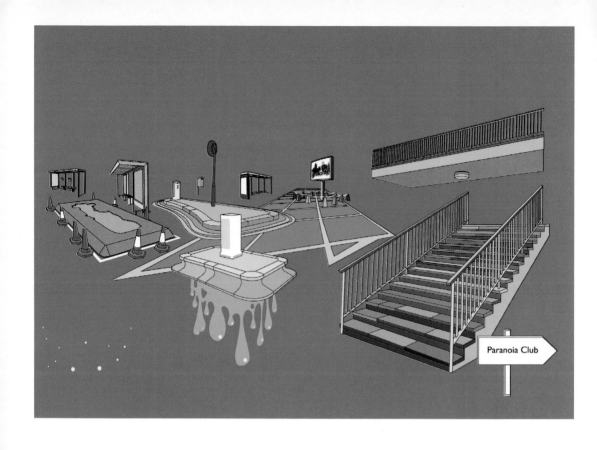

Nils Norman
Social Goo, 2004
Digital drawing
Dimensions variable
Photo: courtesy the artist

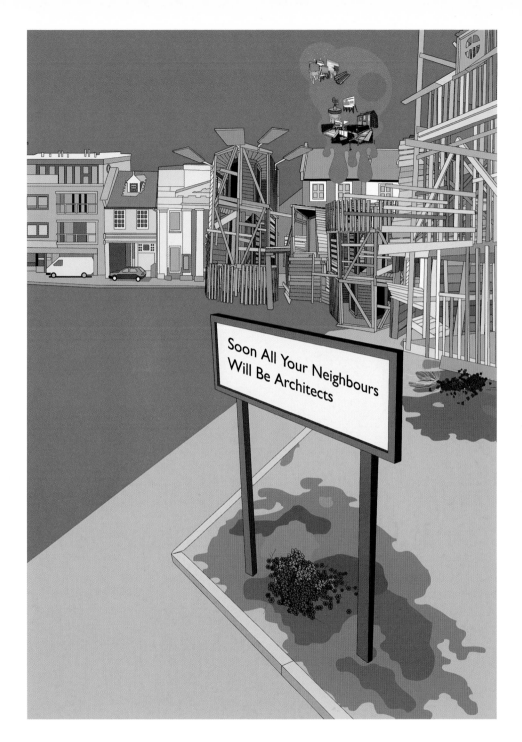

Nils Norman
Invitation card for the exhibition
The Homerton Playscape Multiple
Struggle Niche,
City Projects, Homerton,
London, 2005
Photo: courtesy the artist

Neil Cummings
Born in Aberdare, Wales, in 1958
Graduated with a BA in Fine Art from Maidstone
College of Art in 1981, and with a MA in History
and Theory from Chelsea College of Art and Design,
London, in 1991

Marysia Lewandowska
Born in Szczecin, Poland, in 1958
Graduated with a BA in Art History from Jagiellonian
University, Krakow, Poland, in 1978, and with
a MA in History of Art from University of Warsaw,
Poland, in 1981

Both live and work in London

Solo exhibitions include: *Enthusiasm*, Whitechapel
Art Gallery, London, and Kunst Werke, Berlin
(2005); *Free Trade*, Manchester Art Gallery (2002);
and *Capital*, Tate Modern, London (2001)

Group exhibitions include: *Industrial Town Futurism*,
Wolfsburger Kunstverein, Germany (2005);
The Commons, Liverpool Biennial International (2004);
and *The Gift*, Bronx Museum, New York (2002)

Neil Cummings and Marysia Lewandowska have been collaborating since 1995.
Their projects often focus on the relationships between art institutions and the political,
social and economic spheres. Their work may take the form of an exhibition, a collection,
a book, a conference or series of lectures or guided walks. Each project is developed
through a period of detailed research, during which they employ or allude to the
methodologies and languages of non-artistic fields, such as the economy, ethnography
or history. Issues of property, exchange and use values, community and popular culture,
are central to their enquiries.

　　Their project for *British Art Show 6* continues their exploration of themes related
to the value and management of creative production. All new creative works, they argue,
are born into copyright: every image, text or sound work is automatically designated as
the property of its author. Property rights are founded on the principle of exclusion –
what belongs to me is not yours. Through this exclusion, copyright removes works of art
from the public domain, denying the legal possibility of their creative re-use by others.

　　For this project, Cummings and Lewandowska have turned their attention to
material in film and television archives and collections in each of the four cities on
the *British Art Show 6* tour, whose copyright protection has expired. From this material,
they are producing a new artwork, which will be freely available at the participating
venues. Released into the public sphere under a Creative Commons Public Domain
Licence, the new work and its constituent parts henceforth become, in perpetuity, a legally
protected creative resource. Artists and others will be able to use and re-use the artwork
as material for future creative exchange, enriching rather than depleting the public domain.

Roger Malbert

Neil Cummings and
Marysia Lewandowska
*Enthusiasm. Films of Love,
Longing and Labour*, 2005
Club room
© chanceprojects 2005
Photos: courtesy the artists

Neil Cummings and
Marysia Lewandowska
*Enthusiasm. Films of Love,
Longing and Labour*, 2005
Top: *Love* cinema projection
Bottom: *Labour* cinema
© chanceprojects 2005
Photos: courtesy the artists

Neil Cummings and
Marysia Lewandowska
Enthusiasm. Films of Love,
Longing and Labour, 2005
Top: Archive Lounge
Bottom: *Longing* cinema projection
© chanceprojects 2005
Photos: courtesy the artists

Based in London and Berlin

Kathrin Böhm
Born in Bamberg, Germany, in 1969
Graduated with a BA in Fine Art from the Academy
of Fine Art, Nuremburg, Germany, in 1995, and with
a MA in Fine Art from Goldsmiths College, London,
in 1998

Sandra Denicke-Polcher (RIBA)
Born in Bad Homburg, Germany, in 1971
Graduated with AA Diploma and RIBA Part 2
from the Architectural Association, London,
in 1998, and a Dipl. Ing. from TU, Berlin, in 2001

Torange Khonsari
Born in Tehran, Iran, in 1973
Graduated with AA Diploma and RIBA Part 2
from the Architectural Association, London,
in 1998

Andreas Lang
Born in Oberhausen, Germany, in 1968
Graduated with AA Diploma and RIBA Part 2
from the Architectural Association, London, in 1999

Stefan Saffer
Born in Forchheim, Germany, in 1969
Graduated with a BA in Fine Art from the Academy
of Fine Art, Nuremburg, Germany, in 1997, and with a
MA in Fine Art from Goldsmiths College, London,
in 1998

Collaborative solo projects and commissions include:
Gasholder 8 KXC, a design study for a public park
in collaboration with GPA for Argent Kings Cross
(2005); *Picture Highhouse Purfleet*, access and audience
development study, Thurrock Council (2005); and
Park Products, Serpentine Gallery, London (2004)

Collaborative group exhibitions and projects include:
public works – out now, launch and exhibition, School
of Architecture, London Metropolitan University
(2004); *Rules for Boot*, as part of Shrinking Cities,
Kunstwerke, Berlin (2004); *Okkupationen*, part of
a public art programme for Neukölln, Berlin (2005)

Formed in 1998, public works' practice integrates the disciplines of art, architecture and
design to produce conceptual frameworks and physical structures that promote public
interaction. Situated on the threshold between formal and informal public space, where
community interests meet institutional structures, their projects grow out of dialogues
between these two parties.

 Mobile Porch (2000 and ongoing) is a mobile architectural structure or 'urban toy'
designed to roam the public sphere. Originally commissioned by the Westway Development
Trust to engage with the users of the public land underneath the M40 Westway flyover,
Mobile Porch is both a physical and a social structure that operates as a multi-purpose open-
air platform for public use. Comprising a durable aluminium drum clad in plywood that
rolls on two ball bearing wheels, the structure can be moved by two people and unfolded
into a number of different configurations depending on the needs of its users. In the past,
it has masqueraded as a cocktail bar, a swap shop, a stage, a workshop, a billboard, a meeting
place, a shed, a reception desk and a UFO.

 For *British Art Show 6*, public works have produced a new work to engage with the
touring nature of the exhibition. *The spatiality of informal networks* (2005) will revisit and
extend projects and networks they have previously developed in each of the host cities,
and initiate new ones. The work will include a specially-designed meeting space in each
city intended for workshops and brainstorming session with their collaborators, which
will also be made available for public debates on related issues. A growing archive will
travel with the exhibition, mapping and recording these various networks, and explaining
their nature and history. Their contribution for *British Art Show 6* will be an evolving
representation of their practice.

Emma Mahony

Top
public works
Picture High House, celebrating
local narratives – Purfleet, 2005
Commissioned by
Thurrock Council
© public works 2005
Photo: courtesy the artists

Bottom
public works
2nd Fitting, Fire Station 10,
Munich Riem, Germany, 2002
Commissioned by
kunstprojekte_Riem
© public works 2005
Photo: courtesy the artists

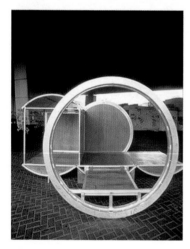

public works
Mobile Porch

Top: *roaming underneath the Westway* Bottom: *unfolding underneath*
flyover – London, 2000 and ongoing *the Westway flyover – London*,
Commissioned by North 2000 and ongoing
Kensington Amenity Trust Commissioned by North
Centre: *as part of Ambulantes*, Kensington Amenity Trust
CCAA, Sevilla, 2004 © public works 2005
Curated by Rosa Pera Photos: courtesy the artists

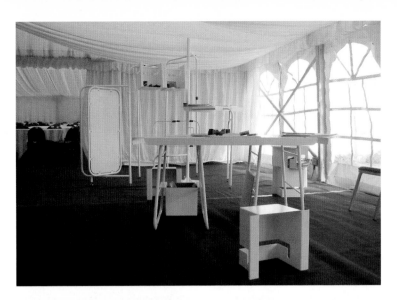

Top and centre left
public works
Future Gallery

Top: *Siemens Power Generation
– Newcastle*, 2005
Centre left: *drawing workshop
with Siemens Financial Services
– Oxford*, 2005
Commissioned by
Siemens Arts Program
© public works 2005
Photos: courtesy the artists

Centre right and bottom
public works
Park Products

Centre right: *mobile stall
roaming Kensington Gardens*, 2004
Photo: courtesy the artists

Bottom: *trading in Kensington
Gardens*, 2004
Photo: David Bebber
Commissioned by the
Serpentine Gallery, London
© public works 2005

CAREY YOUNG

Born in Lusaka, Zambia, in 1970
Lives and works in London
Graduated with a BA from the University of Brighton
in 1992, and with a MA in Photography from
the Royal College of Art, London, in 1997

Solo exhibitions include: *Disclaimer*, Henry Moore
Institute, Leeds & IBID Projects, London (2004–05);
Index, Stockholm (2004); and *Business as Usual*,
John Hansard Gallery, Southampton, and tour (2001)

Group exhibitions include: *Body: New British Art*,
Vancouver Art Gallery, and tour, co-curated with the
British Council (2005); *Critical Societies – Art, Critique
and the Promises of Capitalism*, Badischer Kunstverein,
Karlsruhe, Germany (2005); *A Short History of
Performance – Part II*, Whitechapel Gallery, London
(2003); and *Exchange and Transform*, Kunstverein
München, Munich (2002)

Carey Young's work plays upon the complex interdependencies between culture and commerce, questioning notions of 'inside' and 'outside' in terms of globalised Capitalism and the increasing commodification of everyday life. She has been employed by a management consultancy and leftist think-tank, and often utilises objects, processes and language from the spheres of law and multinational corporations within her works, which use a diverse range of media including video, performance, installation and photography.

A number of Young's projects have appropriated internal corporate methodologies and used the gallery as a place of public examination. The installation *Colour Guide* (2004) is centred on Corbis, the commercial image library founded by Bill Gates, which sells stock photography for use in the media, publishing and design. Pinned to the gallery wall was an email from Corbis to a hired photographer (known to Young) requesting them to use the company's 'colour guide' – a grid of 36 colours which are predicted to be popular within the marketplace. Young replicated the colour grid on the gallery's large window, effectively creating a 'light box' whose pixellated aesthetic seems both visually seductive and vastly reductive of the world outside the exhibition.

Other works have offered a variety of participatory and performative scenarios, including courses in negotiation, motivation and presentation skills variously offered to gallery visitors, staff of the commissioning venue, or to passers-by in public spaces. For *Incubator* (2001) she brought in a venture capitalist to run a 'visioning workshop' – designed to promote creative approaches to selling new products in the corporate sector – with the directors of a small commercial gallery. Documentation of the session was subsequently offered for sale in the gallery.

Debit and Credit (2003) was a 'loyalty card' scheme instigated by the artist which offered repeat visitors to the Kunstverein München a complimentary copy of Ulrich Kluge's *Die Deutsche Revolution 1918/19*, a book about Munich's short-lived Communist revolution in the period immediately following the First World War. *Win-Win* (2002) involved a training course in negotiation skills for the Kunstverein staff that was designed to resolve conflict through attempting a mutually beneficial, or 'win-win' rather than 'win-lose', approach. The work existed both physically in the documentation of the 'event', and conceptually at any time when the newly-acquired skills were put to use. *Win-Win* is, in the words of the artist, 'a process piece which has no site, no boundaries, and no defined end.'

Emma Mahony

Carey Young
Terms and Conditions, 2004
Single channel video; colour
Running time: 3 minutes,
25 seconds
Commissioned by Henry
Moore Institute, Leeds
Actress: Caron Darwood
Photo: courtesy the artist

Carey Young
Conflict Management, 2003
Professional arbitrator,
table, chairs, two noticeboards,
media advertising,
members of the public
Commissioned by Museum
Ludwig, Budapest
Photo: courtesy the artist

Carey Young
Incubator, 2001
Mixed media installation (table
and 3 stools, Evian water and
3 glasses, printed transcripts
and monitor showing video
documentation of 'visioning
workshop' held between Pol
O'Morain, a leading venture
capitalist based at Xerox Research
Centre Europe, and the directors
of the Anthony Wilkinson
Gallery, London)
Commissioned by Anthony
Wilkinson Gallery, London
Funded by East England Arts
Photo: courtesy the artist

Carey Young
Colour Guide, 2004
Translucent vinyl film applied
to window, framed email
printout on paper
Dimensions variable
Commissioned by Index,
Stockholm
Photo: courtesy the artist

Carey Young
Win-Win, 2002 (cat.127)
Negotiation skills course run
by professional trainer, staff
of the Kunstverein München,
verbal interactions, ink on paper
Commissioned by Kunstverein
München
Photo: courtesy the artist

All works are in centimetres,
height × width × depth.
Page references are to illustrations
in this book.

There may be additional works
at some venues.

TOMMA ABTS

1 (p.97)
Emo, 2003
Acrylic and oil on canvas
48 × 38
Courtesy Peter Doig

2 (p.98)
Nomde, 2004
Acrylic and oil on canvas
48 × 38
Private collection, London

3 (p.99)
Soko, 2004
Acrylic and oil on canvas
48 × 38
Courtesy Galerie Nourbakhsch /
Private collection, Berlin

HALUK AKAKÇE

4 (pp.109–111)
Birth of Art, 2003
Single channel projection DVD
Running time: 4 minutes
Courtesy The Approach, London

PHILLIP ALLEN

5 (p.51)
Beezerspline (Light Version), 2002
Oil on board
122 × 152
Courtesy The Approach, London

6 (p.53)
*Contacts and Beliefs
(Extended Version)*, 2005
Oil on board
152 × 183
Courtesy The Approach, London

7 (p.52)
Densequalia, 2005
Oil on board
51 × 61
Courtesy The Approach, London

TONICO LEMOS AUAD

8 (pp.32–33)
Aimless Drawing, 2004/05
Gold chains, pendant
Dimensions variable
Courtesy the artist and
Galeria Luisa Strina
Photo: Colin Guillemet

9 (p.31)
Skull Grapes, 2004/05
Grapes, grape stems,
gold sparkles
Dimensions variable
Courtesy the artist and
Galeria Luisa Strina
Photo: Colin Guillemet

10
New commission (title tbc),
2005
Carpet, carpet fluff
Dimensions variable
Courtesy the artist and
Galeria Luisa Strina

CLAIRE BARCLAY

11 (p.105)
Untitled, 2003
Black wool crochet over
aluminium pole
160 × 3.5 (height by diameter)
Paisley Museum and Art
Galleries, Renfrewshire Council

12
Untitled, 2003
3 leather clad hoops
100 × 100 each
Courtesy doggerfisher
and the artist

13
Untitled, 2005
Turned steel
10 × 6 × 6
Courtesy doggerfisher
and the artist

ANNA BARRIBALL

14 (p.28)
green + blue = cyan, 2001
2 single poise lights,
felt tip pen and paper
Dimensions variable
British Council Collection
Photo: Dave Morgan

15 (p.29)
Projection, 2003
DVD video projection
Running time: 5 minutes,
54 seconds
Courtesy the artist and
Frith Street Gallery, London

16
Untitled II, 2004
Ink and bubble mixture
on found photograph
11.4 × 8.8
Courtesy the artist and
Frith Street Gallery, London

17 (p.27)
Untitled III, 2004
Ink and bubble mixture
on found photograph
11.9 × 7.9
Courtesy the artist and
Frith Street Gallery, London

18
Untitled IV, 2004
Ink and bubble mixture
on found photograph
14.4 × 9.8
Courtesy the artist and
Frith Street Gallery, London

19
Untitled V, 2004
Ink and bubble mixture
on found photograph
8.7 × 6.1
Courtesy the artist and
Frith Street Gallery, London

20
Untitled VI, 2004
Ink and bubble mixture
on found photograph
13.5 × 8.5
Courtesy the artist and
Frith Street Gallery, London

BREDA BEBAN
21 (pp.187–189)
Walk of the Three Chairs, 2003
Super 16 mm transferred to DVD
Running time: 9 minutes,
53 seconds
Arts Council Collection,
Hayward Gallery, London

ZARINA BHIMJI
22 (pp.159–161)
Out of Blue, 2002
Single screen installation;
Super 16 mm colour film
transferred to DVD
Running time: 24 minutes,
25 seconds
Commissioned and co-produced
by Zarina Bhimji and *Documenta 11*
© DACS 2005
Photos: courtesy the artist

ERGIN ÇAVUŞOĞLU
23 (pp.167–169)
Tahtakale, 2004
4 screen video installation
Running time: 8 minutes,
1 second
Courtesy the artist and Haunch
of Venison, London

GORDON CHEUNG
24 (pp.138–139)
Brueghel's Highway, 2004
Financial Times, ink,
gloss paint, acrylic spray
paint and gel on canvas
165 × 220
Elspeth and Imogen Turner,
courtesy Houldsworth Gallery,
London

25 (p.137)
Skyscraper, 2004
Financial Times, acrylic
gel, ink and spray paint
on canvas
230 × 190
Courtesy the artist and
Houldsworth Gallery, London

26
Underworld, 2004
Financial Times, ink,
acrylic gel and spray
paint on canvas
138 × 225
Courtesy Simon Rumley

ADAM CHODZKO
27
The Gorgies Centre, 2002
81 images, 35 mm slide
projection (archive of MBLC
architects, Manchester, stored
for public research by the
family of Jo and Bridie Jones,
Fordwich, Kent)
Running time: 7 minutes

28 (p.207)
Cell-a 2006, 2002
81 images, 35 mm slide
projection (archive of Cubitt
Gallery, London, stored for public
research by Aram Rawf, Ahmad
Ali, Alan Hasan, Haval Hosain
Mohamod and Ibrahim Hussain,
in Margate, Kent)
Running time: 7 minutes

29 (p.205)
M-path, 2005
Donated second-hand shoes
to be offered as replacement
footwear to visitors upon entering
British Art Show 6 at selected venues
Courtesy the artist
New commission

MARCUS COATES
30 (p.219)
Local Birds, 2001
Single screen DVD
Running time: 8 minutes,
10 seconds
Courtesy the artist

31 (p.218)
Finfolk, 2003
Single screen DVD
Running time: 7 minutes,
30 seconds
Courtesy the artist
Photo: Mark Pinder

32 (p.217)
Journey to the Lower World, 2004
2 screen DVD installation
Running time: 30 minutes
Courtesy the artist
Photo: Nick David

NATHAN COLEY
33 (p.183)
Show Home, 2003
Painted wood, mixed media
Courtesy the artist and Locus +
Curated and commissioned by
Locus + / North Tyneside Council
Photo: Dave Harvey

34 (p.185)
Emanuel (1972 Settlement Offensive),
2004
Painted plywood
45 × 70 × 48
Courtesy Haunch
of Venison, London

35 (p.184)
Tower and Wall (1937 prefabs),
2005
Painted plywood, rope,
tarpaulin
Dimensions variable
Courtesy Haunch
of Venison, London

PHIL COLLINS
36 (p.191)
el mundo no escuchará,
2004
DVD
Running time: 1 hour,
9 minutes, 10 seconds
Courtesy the artist and
Kerlin Gallery, Dublin

37 (pp.192–193)
they shoot horses, 2004
DVD
Running time: 7 hours
Courtesy the artist and
Kerlin Gallery, Dublin

**NEIL CUMMINGS AND
MARYSIA LEWANDOWSKA**
38
Screen Tests 1/4, 2005
DVD projection with live sound
Courtesy the artists
New commission
Neil Cummings and Marysia
Lewandowska have worked in
collaboration with artists Eileen
Simpson and Ben White, as well
as James Patterson and Richard
Shenton at the Media Archive
for Central England, Nottingham,
Marion Hewitt at The North West
Film Archive, Manchester, and
Elayne Hoskin at The South
West Film and Television Archive,
Plymouth.

ENRICO DAVID

39 (pp.102–103)
Madreperlage, 2003
Mixed media
Dimensions variable
Courtesy Cabinet, London

40 (p.101)
Untitled (door), 2003
Glass, metal, paint
226 × 76
Courtesy Cabinet, London

CHRIS EVANS

41
*Meeting with residents of Järvakandi
at the premises of Radical Loyalty*,
2004
Photograph
22 × 30
Private collection

42
Signage for the site of Radical Loyalty,
2003
Steel, Perspex
90 × 120 × 2
Private collection

43 (p.210)
*Work from Radical Loyalty:
Adapt and Survive. Artist's impression
of sculpture proposed by board member
Kari Vaiha, Manager of Environment,
Sonera-Telia Telecom, Helsinki.*, 2003
Polymer gravure print
64 × 90
Commissioned by Peacock
Visual Arts and editioned
by Michael Waight
© Chris Evans 2005

44
*Work from Radical Loyalty:
Adapt and Survive. Bronze maquette
of sculpture proposed by board member
Kari Vaiha, Manager of Environment,
Sonera-Telia Telecom, Helsinki.*, 2003
Bronze with white patina
12 × 50 × 12
Private collection

45
*Work from Radical Loyalty:
Effectual versus Ineffectual. Artist's
impression of sculpture proposed
by board member William Davie,
Managing Director at Simmons
& Simmons, Aberdeen (formerly
Director of Knowledge at Schlumberger
Sema, Paris)*, 2004
Polymer gravure print
64 × 90
Commissioned by Peacock
Visual Arts and editioned
by Michael Waight

46 (p.210)
*Work from Radical Loyalty:
Egyptian Horses. Artist's impression
of sculpture proposed by board
member Martin Fehrmann,
Managing Director of Daimler
Chrysler Finance, London*, 2003
Polymer gravure print
64 × 90
Commissioned by Peacock
Visual Arts and editioned
by Michael Waight
© Chris Evans 2005

47
*Work from Radical Loyalty:
Neuron ("Faster than light or sound
it is us who have the gift to be wherever
we want with our thoughts and
reach the universe with our feeling."
M. Carvalho). Artist's impression
of sculpture proposed by board
member Susana Carvalho, President
of J. Walter Thompson – Portugal.*,
2003
Polymer gravure print
64 × 90
Commissioned by Peacock
Visual Arts and editioned
by Michael Waight

48 (p.211)
*Work from Radical Loyalty:
Three Pebbles. Artist's impression
of sculpture proposed by board member
Cliff Burrows, Managing Director
of Starbucks UK*, 2004
Polymer gravure print
64 × 90
Commissioned by Peacock
Visual Arts and editioned
by Michael Waight
© Chris Evans 2005

DOUG FISHBONE

49 (pp.141–143)
Towards a Common Understanding,
2005
Digitally-produced video
Running time: 12 minutes,
30 seconds
Courtesy the artist

SIOBHÁN HAPASKA

50 (pp.126–127)
Playa de los Intranquilos, 2004
Fibreglass, sheepskin, sand,
coconuts, artificial palm trees,
stainless steel fittings, concrete,
glass, LCD screen, speakers,
fluorescent paint
Running time: continuous
Courtesy Kerlin Gallery, Dublin
Commissioned by Peer, London
Photo: Hugo Glendinning

ROGER HIORNS

51 (p.70)
Discipline, 2002
Steel, thistles, copper sulphate,
Velcro
114 × 66 × 51
British Council Collection
Photo: courtesy Corvi-Mora,
London

52 (p.69)
Leaving London, 2004
Wood
69 × 42.5 × 15
Private collection, courtesy
Corvi-Mora, London

53
Untitled, 2005
Ceramic, compressors,
foam 3 parts:
38 × 30 × 30;
38 × 30 × 30;
86 × 30 × 30
Courtesy Corvi-Mora, London

MATTHEW HOULDING

54 (p.130)
Happy Ever After, 2004
Timber, heather branches,
cardboard, foam, plastic, paint
130 × 45 × 45
Courtesy the artist and
Buero Fuer Kunst, Dresden

55 (p.131)
*It was hard to believe that just
24 hours earlier I had been sitting
at my desk wrestling with the
next round of deadlines*, 2004
Timber, vinyl, cardboard,
foam, plastic, fibreglass tub,
model trees, paint
244 × 183 × 160
Courtesy the artist

RICHARD HUGHES

56 (p.44)
Roadsider, 2003
Resin
30.5 × 8 × 8
Courtesy the artist and
The Modern Institute, Glasgow

57 (p.43)
Untitled (Match), 2003
Mixed media
61.5 × 21.5 × 15.5
Courtesy the artist and
The Modern Institute, Glasgow

58
Wet Dream, 2005
Mixed media
Dimensions variable
Courtesy the artist and
The Modern Institute, Glasgow

MARINE HUGONNIER
59 (p.179)
Territory I, II, III (Whites Lies;
The Kissing Point; Alkdereh House,
Ramallah), 2004
16 mm colour film
Running times: 23 minutes,
50 seconds; 12 minutes,
45 seconds; 5 minutes, 3 seconds
Courtesy the artist and Max
Wigram Gallery, London
Shoot: Tel Aviv, Israel / West
Bank, Israel / Rammallah, Palestine
Stock: 64 Asa/ 7231-200
Asa / 7222
Camera: Éclair ACL
Aspect ratio: 1:66
Black and white
Lenses: 12.120 mm zoom,
17.85 mm zoom, 10 mm prime
Director of photography:
Nadav Arowitz / Marine Hugonnier
/ Cristian Manzutto
Executive production: Alec
Steadman / Del Ruby Winter
Editing: Helle Le Fevre
Sound: Cristian Manzutto
Text: Eyal Weizman /
Marine Hugonnier
Process and print: Soho images,
London
Grade: Soho Images, London
Projector: Elf
Produced and distributed by:
MW projects, London, UK

GARETH JONES
60 (p.23)
Untitled Structure,
1987–2005
Swiss cheese plant, pot
Dimensions variable
Courtesy the artist

61
Open Plinth, 1995–2000
Chipboard, emulsion paint, mirror
90 × 30 × 30
Courtesy the artist

62
Reversed Plinth, 2000–03
Chipboard, emulsion paint,
corner brackets, bolts
90 × 43 × 43
Courtesy the artist

63
Light Plinth, 2003
Chipboard, emulsion paint,
fluorescent light, timber
91 × 30 × 30
Courtesy the artist

64
Modular Plinth, 2003
Stained and lacquered
plywood, dowel pegs
6 parts, dimensions variable
Courtesy the artist

JUNEAU/PROJECTS/
65 (p.221)
good morning captain, 2004
DVD installation
Running time: 10 minutes
Courtesy the artist and
f a projects, London
Commissioned by
The Showroom, London
Photo: Daniel Brooke

66 (p.223)
my wretched heart is still aglow,
2004
DVD installation
Running time: 8 minutes
Courtesy the artist and
f a projects, London
Commissioned by
The Showroom, London
Photo: Daniel Brooke

67 (p.221)
the beauty royale, 2004
DVD installation
Running time: 6 minutes
Courtesy the artist and
f a projects, London
Commissioned by
The Showroom, London
Photo: Daniel Brooke

68 (p.222)
the mush, 2004
Animation / installation
Running time: 30 seconds
Courtesy the artist and
f a projects, London
Commissioned by
The Showroom, London

69
the don, 2004
Video installation
Running time: 1 minute
Courtesy the artist and
f a projects, London
Commissioned by
The Showroom, London

KERSTIN KARTSCHER
70 (p.77)
Mrs Radio, 2001
Ink marker on paper
70 × 100
Courtesy Thomas Hampel,
Hamburg

71 (pp.78–79)
Untitled (Target), 2001
Pigment ink marker
and hybrid pen on paper
70 × 100
Collection Stefan Maria Rother,
Berlin

72 (p.77)
Divine irresponsibility backed
by unlimited gold, 2003
Ink on paper
70 × 100
Courtesy Galerie Karin Guenther
Nina Borgmann, Hamburg

JANICE KERBEL
73 (p.229)
Council Flat: Wall mounted gardens,
2004
Print on paper
118.8 × 84
Courtesy Galerie Karin Guenther
Nina Borgmann, Hamburg
Commissioned by Tyndall Centre
for Climate Change Research

74 (p.230)
Gym: Respiration garden, 2004
Print on paper
118.8 × 84
Courtesy Galerie Karin Guenther
Nina Borgmann, Hamburg
Commissioned by Tyndall Centre
for Climate Change Research

75 (p.231)
Launderette: Suspended garden, 2004
Print on paper
118.8 × 84
Courtesy Galerie Karin Guenther
Nina Borgmann, Hamburg
Commissioned by Tyndall Centre
for Climate Change Research

MARK LECKEY
76 (p.85)
Made in 'Eaven, 2004
DVD
Running time: 2 hour loop
Courtesy Cabinet, London, Galerie
Daniel Buchholz, Cologne, and
Gavin Brown's enterprise, New York

77 (pp.86–87)
The Destructors, 2004/05
DVD
Running time: 21 minutes
Courtesy Cabinet, London, Galerie
Daniel Buchholz, Cologne, and
Gavin Brown's enterprise, New York

HEW LOCKE
78 (p.122)
Black Queen, 2004
Wood and cardboard base,
glue gun, screws, mixed
media (plastic, fabric)
290 × 160 × 60
Courtesy Hales Gallery
and Cherry Brisk
© DACS 2005

79 (p.123)
El Dorado, 2005
Wood and cardboard base,
glue gun, screws, mixed
media (plastic, fabric)
290 × 175 × 60
Courtesy Hales Gallery
and Cherry Brisk
© DACS 2005

CHRISTINA MACKIE
80
Falling Boundary, 2004
Mixed media
Dimensions variable
Courtesy Herald St,
London

81
Irrig, 2005
DVD loop
Running time:
approximately 1 minute
Courtesy Herald St,
London

82 (p.35)
Shakeman, 2005
Cedar wood, fabric,
Perspex, fittings
Dimensions variable
Courtesy Herald St, London
Photo: courtesy the artist

GOSHKA MACUGA
83 (p.19)
Arkhitectony – after K Malevich,
2005
Mixed media
2 parts: 600 × 100 × 100;
450 × 100 × 100
Courtesy the artist and
Kate MacGarry, London
Commissioned by Bloomberg,
London 2003

DARIA MARTIN
84 (pp.94–95)
Soft Materials, 2004
16 mm film
Running time: 10 minutes,
30 seconds
Arts Council Collection,
Hayward Gallery, London
Commissioned by The Showroom,
London

ANDREW MCDONALD
85 (p.41)
Lightning, 2002
Hand drawn animation
on DVD
Running time: 47 seconds
Courtesy the artist

86 (pp.39–40)
John's Country, 2003
Hand drawn animation
on DVD
Running time: 3 minutes,
25 seconds
Courtesy the artist

**HEATHER AND
IVAN MORISON**
87
*Mr & Mrs Morison would like
to inform you that...*, 2003
and ongoing
LED fitted with SIM card
Courtesy the artists

88
Bird Calls of North America,
2004
Audio CD
Running time: 75 minutes
Courtesy the artists

89
Foundation and Empire, 2004
Novel
Published by Article Press,
Birmingham
Courtesy the artists

90
Rare Bird Alert Hotline, 2005
Radio broadcast on Resonance
104.4 FM, London, and online
at www.resonancefm.com
from January – June 2006

91 (p.227)
Starmaker, 2005
Single screen, 2 medium
format slide projectors,
CD Player, amplifier, changer
unit, hanging projection screen
Running time: variable
Courtesy the artists

ROSALIND NASHASHIBI
92 (pp.175–177)
Hreash House, 2004
16 mm negative film
transferred to DVCAM
Running time: 20 minutes
Courtesy the artist and Counter
Gallery, London

NILS NORMAN
93
The Art of Urbanomics, 2003
Flash animation
Running time: 11 minutes,
30 seconds
Courtesy the artist and Galerie
Christian Nagel, Berlin
Commissioned by Hayward/
Bloomberg Artists' Commission

94
*Deformed Hoarding,
Gateshead*, 2005
Digital print on aluminium
with steel support structure
c.170 × 400
Courtesy the artist and Galerie
Christian Nagel, Berlin, Germany
New commission

SASKIA OLDE WOLBERS
95 (p.133)
Placebo, 2002
DVD
Running time: 6 minutes
Courtesy Maureen Paley,
London, and Galerie Diana
Stigter, Amsterdam

96 (p.134)
Interloper, 2003
DVD
Running time: 6 minutes
Courtesy Maureen Paley,
London, and Galerie Diana
Stigter, Amsterdam

97 (p.135)
Trailer, 2005
DVD
Running time: 10 minutes
Courtesy Maureen Paley,
London, and Galerie Diana
Stigter, Amsterdam

SILKE OTTO-KNAPP
98 (p.90)
Fans, 2004
Watercolour on canvas
101 × 132
Collection Philipp and Christina
Schmitz-Morkramer
Courtesy Galerie Daniel Buchholz,
Cologne, and greengrassi, London

99 (p.91)
Showgirls (Blue), 2004
Watercolour on canvas
98 × 98
Collection of Lulu
Norman, London
Courtesy Galerie Daniel Buchholz,
Cologne, and greengrassi, London

100 (p.89)
Golden Garden (Conifers), 2005
Watercolour and gouache
on canvas
130 × 120
Courtesy Galerie Daniel Buchholz,
Cologne, and greengrassi, London

TOBY PATERSON
101 (p.75)
Station Stairs, 2004/05
Acrylic on Perspex
120 × 195 × 5
Courtesy the artist and
The Modern Institute,
Glasgow

102
Brutalist Church, 2005
Acrylic on Perspex
12 × 17 × 5
Courtesy the artist and
The Modern Institute,
Glasgow

103
Market Way, 2005
Acrylic on wood
50 × 80 × 2.5
Courtesy the artist and
The Modern Institute,
Glasgow

104
New commission for BALTIC,
Gateshead, and Urbis, Manchester,
2005
Wall painting
Dimensions variable
Courtesy the artist and
The Modern Institute,
Glasgow

105
Pedestal, 2005
Acrylic on wood
75 × 40 × 30
Courtesy the artist and
The Modern Institute,
Glasgow

106 (p.73)
Rotterdam Relief, 2005
Acrylic paint on Perspex
100 × 100 × 1
Arts Council Collection,
Hayward Gallery, London

107
Unileverhaus, 2005
Enamel on Perspex
26 × 26 × 20
Courtesy the artist and
The Modern Institute,
Glasgow

PUBLIC WORKS
108
The spatiality of informal networks,
2005
Courtesy the artists
New commission

PAUL ROONEY
109 (pp.213–214)
*Lights Go On. The song of the
nightclub cloakroom attendant*, 2001
DVD
Running time: 8 minute loop
Courtesy the artist

110 (p.215)
*In the Distance the Dawn
is Breaking*, 2004
5 DVDs
Running time: 3 minutes
Courtesy the artist

EVA ROTHSCHILD
111
Heavy Cloud, 2003
Wood, plastic (cast resin), paint
200 × 190 × 175
Arts Council Collection,
Hayward Gallery, London

112 (p.81)
High Times, 2004
Leather, steel support
434 × 40 × 40
Courtesy Stuart Shave /
Modern Art, London

ZINEB SEDIRA
113 (pp.164–165)
Mother Tongue, 2002
3 videos
Running time: 5 minutes,
4 seconds
Courtesy the artist

LUCY SKAER
114 (pp.156–157)
The Problem in Seven Parts, 2004
Watercolour, indian ink
and graphite on paper
7 parts; 207 × 84 each
Courtesy doggerfisher

115 (p.155)
Depth / River, 2005
Watercolour and pencil
on paper
150 x 170
Courtesy doggerfisher

ALIA SYED
116 (pp.171–173)
Eating Grass, 2003
16 mm transferred to DVD
Running time: 22 minutes,
30 seconds
Courtesy the artist and
Talwar Gallery, New York

DAVID THORPE
117
The exiled flower is Great Libertie,
2005
Watercolour on paper
84.5 × 65
Collection John A. Smith
and Vicky Hughes

118
You Are Nothing, 2005
Oil on paper
100 × 74
Courtesy Helen Thorpe

MARK TITCHNER
119 (p.119)
Resolving Conflict by Superficial Means,
2002
Concrete, carved wood,
electric motor, paint
200 × 160 × 80
The Saatchi Gallery, London

120 (p.117)
Tomorrow Should Be Ours, 2005
Duratrans in lightbox
150 × 100 × 15
Private collection, London

121
Untitled, 2005
Billboard posters for sites
across the cities of Newcastle
and Gateshead
Courtesy the artist
New commission

REBECCA WARREN

122 (p.65)
Journey into the Heart of the Night,
2000
Unfired clay, neon, mixed media
44 × 140 × 39
Courtesy Arts Council Collection,
Hayward Gallery, London,
and Maureen Paley, London

123
TLGEIAFDP, 2005
Reinforced clay
185 × 24 × 104
Courtesy Maureen Paley,
London

GARY WEBB

124 (p.47)
Mrs Miami, 2005
Steel, Q-cell, glass,
electronics, speakers
173 × 170 × 107.5
Private collection, London
Courtesy The Approach,
London

125 (p.48)
Dom, 2005
Aluminium, spray paint,
fabric
187 × 212 × 100
Courtesy The Approach,
London

126
New work (title tbc), 2005
Courtesy The Approach,
London

CAREY YOUNG

127 (p.247)
Win-Win, 2005
Negotiation skills course run
by professional trainer for the
curators of *British Art Show 6*
and staff at the Hayward Gallery,
London
Courtesy the artist
New commission
With thanks to the Directory
of Social Change, providers of the
negotiation skills training course